faces of hope

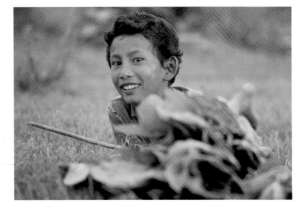

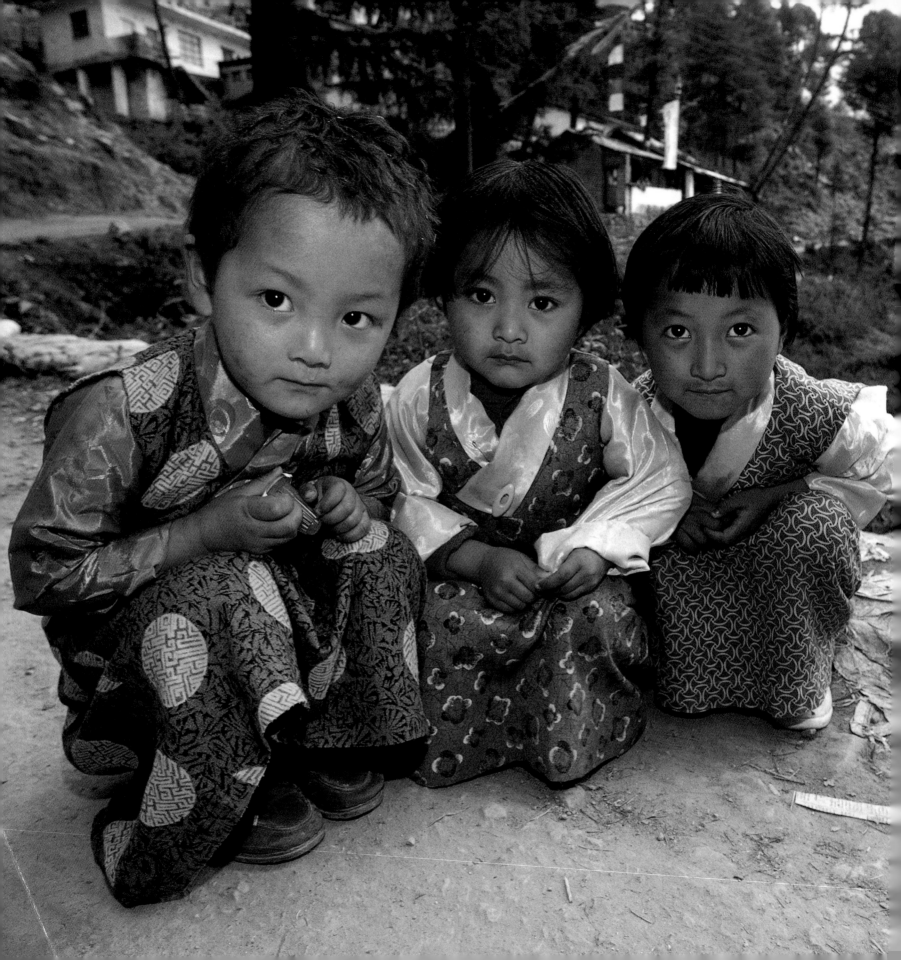

faces of hope

CHILDREN OF A CHANGING WORLD

Alison Wright

foreword by
Marian Wright Edelman

NEW WORLD LIBRARY
NOVATO, CALIFORNIA

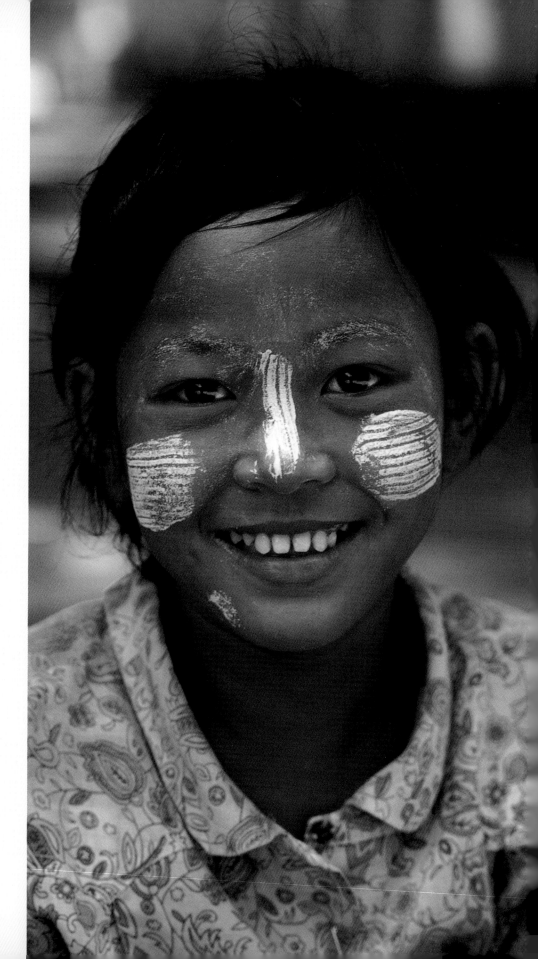

 New World Library
14 Pamaron Way
Novato, CA 94949

Cover and interior design by Mary Ann Casler

Library of Congress Cataloging-in-Publication Data
available on request

First printing, October 2003
ISBN 1-57731-223-6
Printed in Singapore on acid-free, partially recycled paper
Distributed to the trade by Publishers Group West

10 9 8 7 6 5 4 3 2 1

PAGE **i**

Boy playing in a cabbage field. Kathmandu, Nepal.

PAGE **ii**

Three Tibetan girls in their traditional dresses or *chubas*.
Dharamsala, India.

PAGE **iv**

Girl wearing *tanaka*, a sandalwood paste to protect her
from the sun. Mandalay, Burma.

PAGE **vi**

Two brothers lighting butterlamps in a Buddhist
ceremony at the Boudhanath Stupa. Kathmandu, Nepal.

foreword

MARIAN WRIGHT EDELMAN

In this collection of extraordinarily beautiful and moving photographs, Alison Wright has indeed brought us hope. Through her pictures and thoughtful reflections, Wright takes us with her on her remarkable journeys across the developing world. We visit children in isolated rural and remote villages and crowded urban slums, and share some of the everyday moments that make up their world. We see them at work and play, worship and rest, celebrate with them and join their mundane routines of life. These children live in very difficult circumstances — circumstances forced on millions of children in our global village Earth. But the hope of childhood remains and these portraits share a common beauty, dignity, and — far more often than not — joy.

One of the reasons I believe so many millions of children in our world are left behind is that too many in power and of privilege distinguish between their own children and other people's children. I agree with Mahub Ul Haq, a creator of the World Human Development Index, that we should "remind all nations of this world that abolishing poverty in the twenty-first century must become a collective international responsibility since human life is not safe in the rich nations if human despair travels in poor nations. Let us recognize that consequences of global poverty travel across national frontiers without passport in the form of drugs, AIDS, and pollution and terrorism." How prescient his words were.

Alison Wright's book clearly reminds us that these children she photographed are *our* children. In the faces of children half a world away we will never meet are reflections of the faces of the children we know and love best in our own families and communities. Even in the middle of so much that is different, the essence of Wright's portraits show us how much about childhood remains familiar everywhere. The hopes and dreams we have for our own children are the same hopes and dreams we should have for every one of the children we are privileged to meet here.

Every nation and adult has to learn to recognize and honor and respect the sacredness of each and every child. Children — *all* children — are the world. Children are hope and life. Children are our immortality. Children are the seeds and the molders of history and the transmitters of our values — good and bad. Nothing can exist without them. Every human being began as a baby — Abraham, Moses, Mohammed, Buddha, Jesus Christ, Albert Einstein, Eleanor Roosevelt, Marie Curie, Barbara McClintock, Mother Teresa, the sacred Marys of the Bible, Harriet Tubman, Nelson Mandela, César Chavez, Chief Joseph, Desmond Tutu, and Martin Luther King Jr. When are we going to wake up and open our hearts to all of God's precious child gifts of life and love? When are we going to act to build a world fit and safe for and worthy of our children and grandchildren? When is the United States' moral and social leadership for children going to match our military and economic leadership in a twenty-first century world in desperate need of hope and peace and justice?

At a February 2003 rally in Porto Alegre, Brazil, writer Arundhati Roy told listeners: "Another world is possible. She is on her way. And if you listen carefully on a quiet day, you can hear her breathing." This is the new world, the fairer and more just world, the better world, that all of the children in *Faces of Hope* — and *all* children — deserve and are waiting for. May this book inspire its readers to help bring it into being — *very soon!*

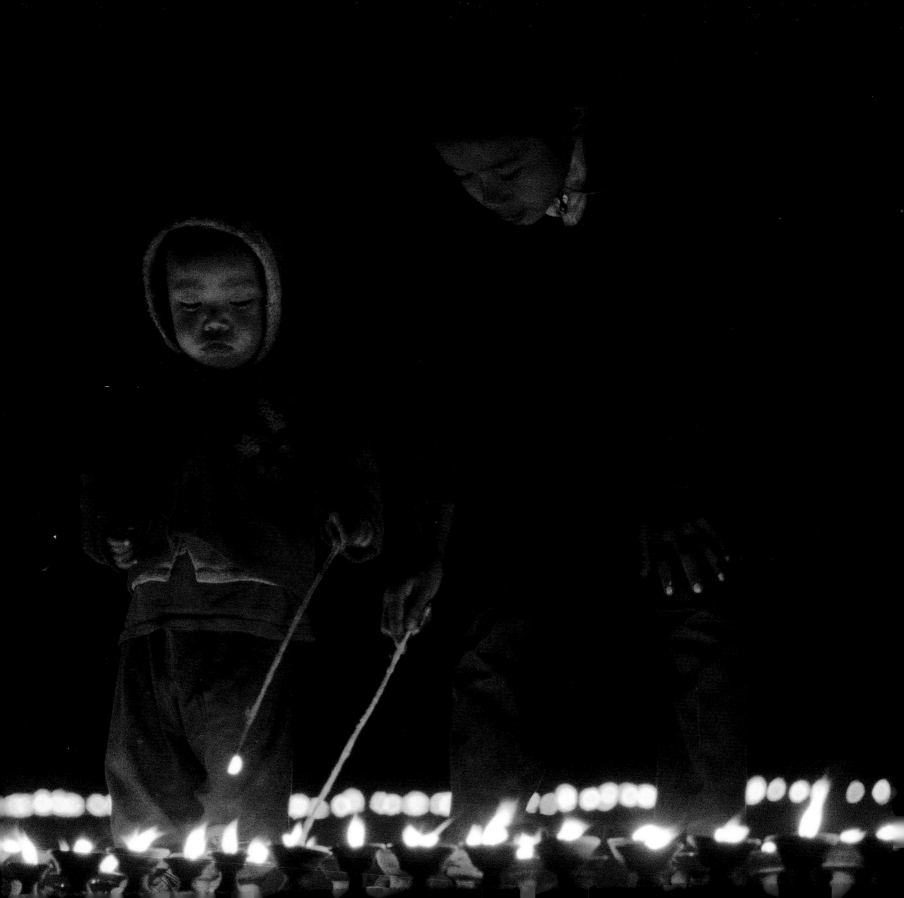

introduction

ALISON WRIGHT

Easter Sunday: Mother Teresa came to visit her Calcutta orphanage and attend mass. It was hard to believe that this small shrunken woman from Albania, a face full of wrinkles, had become maybe the most prominent symbol of all that is good in the world. Gliding into the room, she gave me a blessing and slipped me a silver medallion of Mother Mary to wear around my neck. With a knowing smile she encouraged me to come across town to see her Home for the Destitute and Dying. Just to visit.

I went for an hour, but I stayed for a month. I befriended an Irishman named Andy who was working there. One day he asked me to help him bathe a frail young boy who was too weak to move. We nicknamed him Toro, "small one." I tried to feed him, but it was no use. His skin was peeling away from malnutrition and he had a hacking, bloody cough from tuberculosis. He was so ill that layers of his skin came away as Andy and I pulled off his bandages. My heart broke as I held his bony body in my arms, trying to absorb his pain. With barely the strength to wince, he put his head on my lap and whimpered. "Poor thing, he just wants a mum to hold him," said Andy. I spent long hours with Toro, praying for him to die, but his will was much stronger than his sickness. After many hours of agony, though, I heard the rattle of death gurgling in his small chest. His eyes gave me a last look before they rolled back into his head and I felt his body go limp. That tiny bit of life in my arms was now free.

"What an honor," said Andy. "He chose you to help him die." I did feel blessed, but I also felt overwhelmed with sadness.

I frantically looked around for a nurse, but they were all too busy to deal with this common occurrence. I thought about Andy's words. This was my responsibility. I wrapped Toro's small body in the still warm sheet, using a pin from my camera bag to close it up. Andy helped me carry him the short distance down the road to the Ganges River. We said a small prayer and dropped the body into the water. Such is the spirit of India, where death is an accepted reality of daily life. In that moment I learned that hope starts with just one child.

One person can't save the world, but if you can touch just one other person, that makes life worthwhile. With each morning's newspaper, the world's problems can seem so horrific, so immense. Where do we put our hearts that day? It's easy to feel overwhelmed, to become paralyzed, to do nothing when confronted by the problems of the developing world, especially those facing its children.

Yet if we overlook their suffering today, how can we expect them to be our friends tomorrow? They are both potential leaders and adversaries. With 95 percent of all new births occurring in the world's poorest countries, and half of those in dense urban areas, these children are not just our future, they are now. In order to help this new global generation to find its place, we must strive to understand their cultures and current situations. Their fate will be determined largely by how we choose to nurture and guide them in our evolving world.

Television, tourism, and larger economic forces are creating a global village. From Africa to Asia, the children of these emerging regions are confronting the challenges of having one foot in the modern world and the other in the rapidly eroding world of their own traditional cultures. These young people

want more than to work the land or herd cattle as their parents did. A Bedouin mother in Jordan told me that she doesn't want her six children living in nomadic tents tending goats. She wants them to go to school, to be doctors and engineers.

We ended the twentieth century passing the United Nations' Convention on the Rights of the Child in every country but two: Somalia and the United States. This mandate states that every two years countries around the world must report to the United Nations what they are doing for the betterment of their children.

I hope the faces in this book will serve as a reminder of what this convention actually means. These children had no choice about where they were born, but they do have basic rights. The greatest lesson I learned in putting this book together is that despite our political differences, people the world over are the same in wanting what is best for their children: a sense of identity, health, safety, education, religion, freedom, and well-being. We can all work to make that happen. It is what will bring our world together.

I have tremendous faith in the children of today, especially the forgotten ones, who must overcome such enormous obstacles in their lives. From landmine atrocities in Cambodia, Vietnam, and Laos; to child labor in Nepal and India; to political repression in Tibet, China, and Burma; to displacement in refugee camps wherever there is war; to the struggle with the AIDS pandemic in Africa and other parts of the developing world, these children have survived in dire situations with a tenacity and resiliency that never ceases to inspire me. Their courage and optimism is impressive, their enthusiasm, delightful. I don't have children myself, but after every trip it seems that I come home with a backpack full of them.

I first decided to travel to the developing world while I was in college. I was drawn to India's spirituality and wanted to explore the human extreme. My parents were apprehensive. They felt it was too far, too strange, too dangerous. They encouraged me to backpack in Europe instead. This didn't sound nearly as compelling, but I agreed. From Spain I had

someone send postcards back home to my family telling them how much I was enjoying the beaches. Instead, I jumped on a boat and traveled to North Africa. Those first glimpses of overwhelming poverty and children in need became etched in my mind during that brief visit. It was a defining experience, and I knew then that it was their lives that I cared about and wanted to document.

I have since covered the world in more than two decades of travel as a photographer and writer, and children have been a constant theme. In those early years I lived out my cowgirl dreams, moving to the dusty isolated outback of Australia. I learned how to ride horses and taught local children in a one-room schoolhouse. Back in the United States I spent two years working as a newspaper photographer in San Diego. Often, I crossed over the border into Mexico, photographing orphanages and the plight of destitute children right in my backyard.

One day while thumbing through a magazine, I found myself mesmerized by the pools of light reflecting from the eyes of Indian children staring back at me from the pages. I realized that Asia still beckoned me. I called the photographer to tell him how much I loved his photographs. He happened to work for UNICEF and told me that if I was ever in New York to come by and show him my portfolio. I bought a plane ticket and went to see him the following week. After looking at my photos, he asked me if I wanted to go to Nepal to photograph children. It was exactly what I wanted to do.

I went for what was supposed to be a month-long assignment, although I was so captivated by the magic of Asia that I stayed for more than four years and have continued to return there nearly every year since. I worked not only for UNICEF but for other relief associations such as CARE, ILO (The United Nations International Labor Organization), Save the Children, USAID, Seva, the Helen Keller Foundation, as well as many other smaller but significant grassroots programs. I photographed children and refugees in all aspects of their daily lives: playing, working, worshipping, learning.

Children are often the most honest reflection of the society

in which they live, and I hope this book offers a small insight into their lives through my encounters with them. As I continue my travels, I marvel at the hospitality I have encountered even in the most remote regions of the world. From the African plains to the Amazon jungles, I have been welcomed into people's homes. Despite their sometimes meager living conditions, I am struck by the unfailing generosity of people who have so little yet are so willing to share, not only with me but with those around them. With their emphasis on family and community, their time-honored philosophies and wisdom, these indigenous cultures have so much to offer the world.

As I venture through their homelands, which are often in flux, economically impoverished, or suffering the effects of war, I witness brief moments in the lives of these children whose openness and laughter has touched me to the core. There is such simple joy in the faces of playing children. Whether they are pulling cigarette boxes on strings, flying plastic bags like kites, or spinning tire hoops with a stick, they emanate a purity and contentment that is often lost in the children of the West. This book's purpose is not to document the suffering of the world's children or their daily struggle to survive, but to celebrate their spirit and the heritage being passed down to them.

On a recent trip to Laos I got off a riverboat and wandered around the small village of Nong Khiaw. It was my birthday, two days before Christmas, and I was feeling one of those twinges of loneliness that sometimes accompanies life on the road in a distant country. Just as I was wondering what my friends back home were doing, a tiny girl raced up to me to shyly hand me a flower. She wanted nothing in return. As she grinned, I noticed her teeth were rotted to little stumps and her long dark hair was matted. She arrived at just the right moment. I often look at that photo that I snapped of her. To me it shows hope. It shows beauty in a world of chaos and is a reminder that the little things in life are most precious. Never is it so apparent as through the eyes of a child.

If we are to achieve a richer culture, rich in contrasting values, we must recognize the whole gamut of human potentialities. We must weave a social fabric in which each diverse human gift will find a fitting place. Never doubt that a small group of thoughtful, committed people can change the world. Indeed, it is the only thing that ever has. — MARGARET MEAD

Children are born with fundamental freedoms and the inherent rights of all human beings. This is the basic premise of the Convention on the Rights of the Child, an international human rights treaty that is transforming the lives of children and their families around the globe.

 People in every country and of every culture and religion are working to ensure that each of the 2 billion children in the world enjoys the rights to survival, health and education; to a caring family environment, play and culture; to protection from exploitation and abuse of all kinds; and to have his or her voice heard and opinions taken into account on significant issues.
— FROM UNICEF'S CONVENTION ON THE RIGHTS OF THE CHILD

And God says, I have a dream. I have a dream that all of my children will discover that they belong in one family — my family, the human family — a family in which there are no outsiders. — ARCHBISHOP DESMOND TUTU

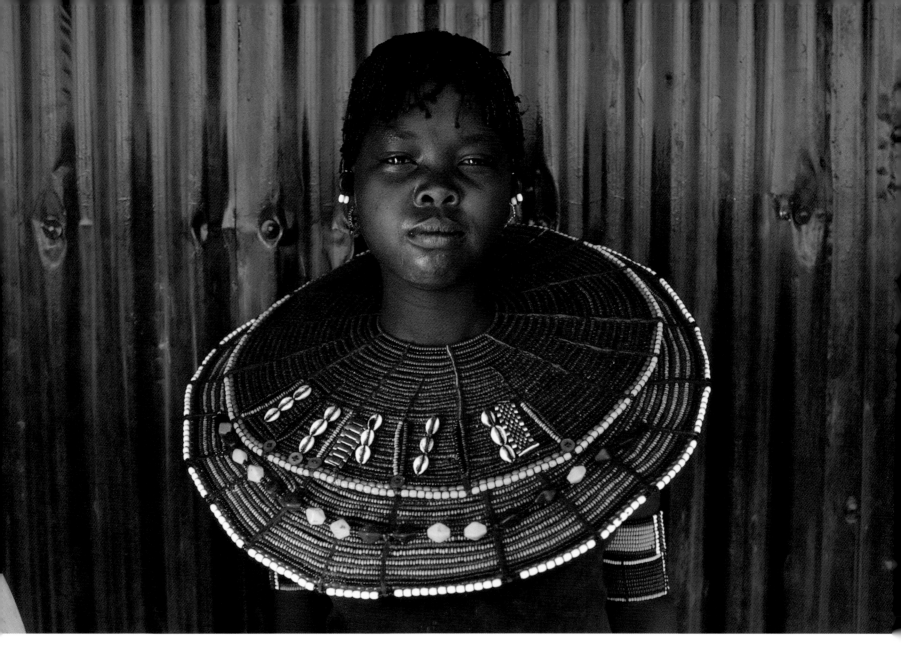

Sisters Slindy and Sandy, with their friend Zoldwa. Inanda Township, outside Durban, South Africa. I stayed overnight with a family in this all black township where Gandhi lived for fourteen years. As I walked the main road the next morning, a police car came to a grinding halt in front of me. "Do you know where you are!?" the white policeman asked me incredulously. "Do you see that you're the only white person around? In my thirty years on the force you're the first I've seen walking around here alone — and a woman!"

He encouraged me to ride with him, which I did for the next two hours. The next street over we came across two black policemen tending a man who had just been shot dead, empty bullet casings strewn around his body. They, too, were astounded to see me there. After two hours of carjackings and robberies streaming over the police radio, it was hard not to feel discouraged. The policeman admitted that he alone had shot twenty-five people during his career. Still, as I watched these children walking to school I felt that somehow their education and hopeful view of the future would help bridge the racial and economic divides left by apartheid.

◀ Chepaka, a twelve-year-old Pokot girl. Kenya. When Pokot children go to school, they are required to change out of their traditional clothes. I found this girl outside the school in Nginyang village. She still wears her ornate necklace because she stays home to help her family. I noticed their tribal jewelry now combines traditional shells and beads with present-day found objects such as batteries and watch-bands.

▼ Arami, a Maasai woman and her baby, Tajiri. Looloomeei Maasai Village, Kenya. I wasn't sure how the Maasai would react to a white woman pulling up in a Land Rover and pitching a tent in the middle of the Masai Mara. I knew I had been accepted when the headman from the closest community came to visit and presented me with a tightly packed ball of fur the size of a baseball. He informed me that it was a hairball coughed up by a lion. His wife then gave me a warthog tusk, and they invited me back to photograph in their village. In the following days Moran warriors lined up outside of my tent, all wanting their picture taken.

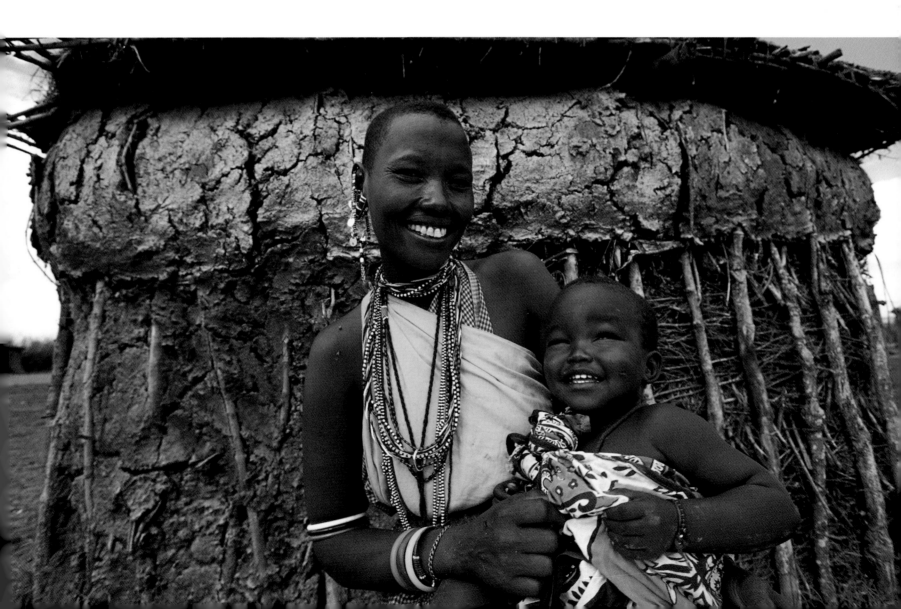

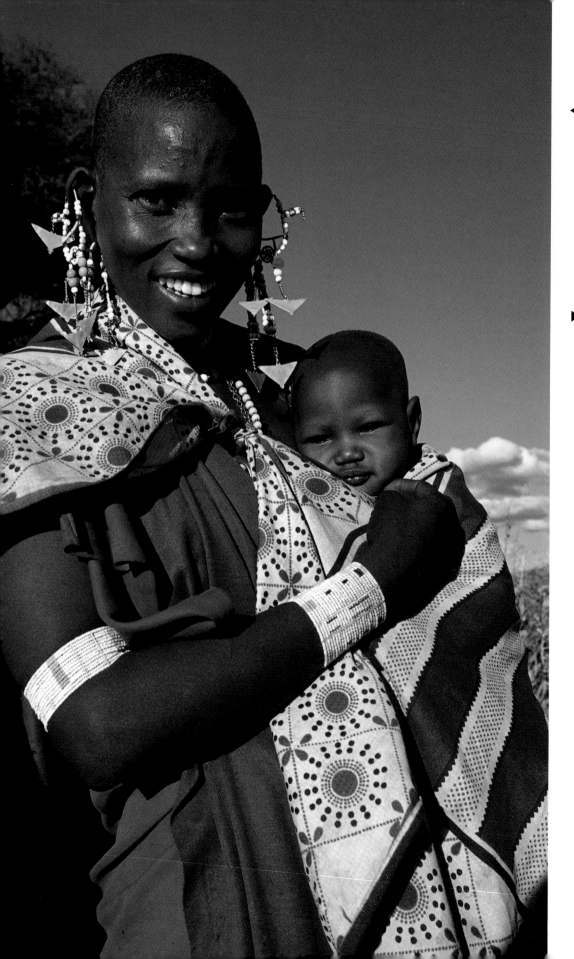

◀ Noorkishon, a Maasai woman with her baby, Maria. Oltepessi Maasai Village, Tanzania. In Noorkishon's smoky hut we shared a cup of fresh milk mixed with cattle's blood, a staple of the Maasai. In Maasai society the women and girls do all the milking.

▶ Ndogodo, a four-year-old Maasai girl with her goat. Oltepessi Maasai Village, Tanzania. I set up my small tent to camp alone beneath the shadow of Longido Mountain. That night Maasai men sat with me by the fire and taught me how to roast goat on a stick. I reciprocated by showing them how I cook bread on a stick (toast). I shared photos of my family with them and they introduced me to theirs. They challenged me with evocative questions: "How big are oceans and what do they look like? What does snow feel like? What is cold?"

The next morning the men asked if I wanted to go to the local outdoor market. A barrage of painted warriors piled into the Land Rover, spears sticking through the sunroof. Just when I thought we couldn't possibly fit anyone else, another would squeeze into the back seat or onto the roof. I was amazed when they stopped for an old man with a plough, taking the time to hoist it onto the hood with ropes. As we drove along I excitedly jumped out to photograph a giraffe, my first wild animal, but to them as common as squirrels in New Jersey. Their giggling as I returned to the truck dispelled any intimidation I might have felt from these fierce warriors.

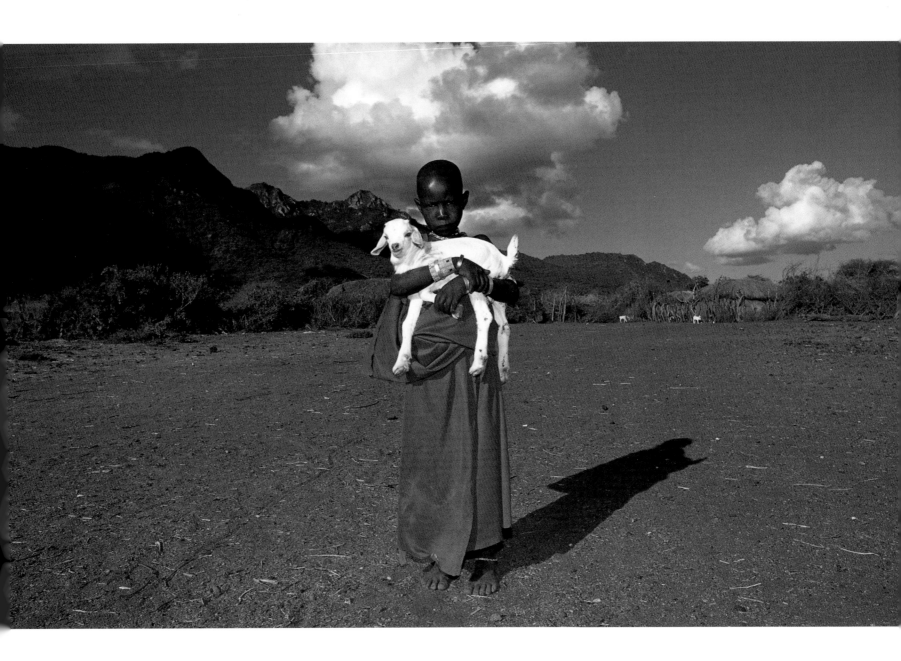

▶ Maasai boy herding cattle. Oltepessi Village, Tanzania. The small children who care for the goats eventually graduate to watching cattle as they get older.

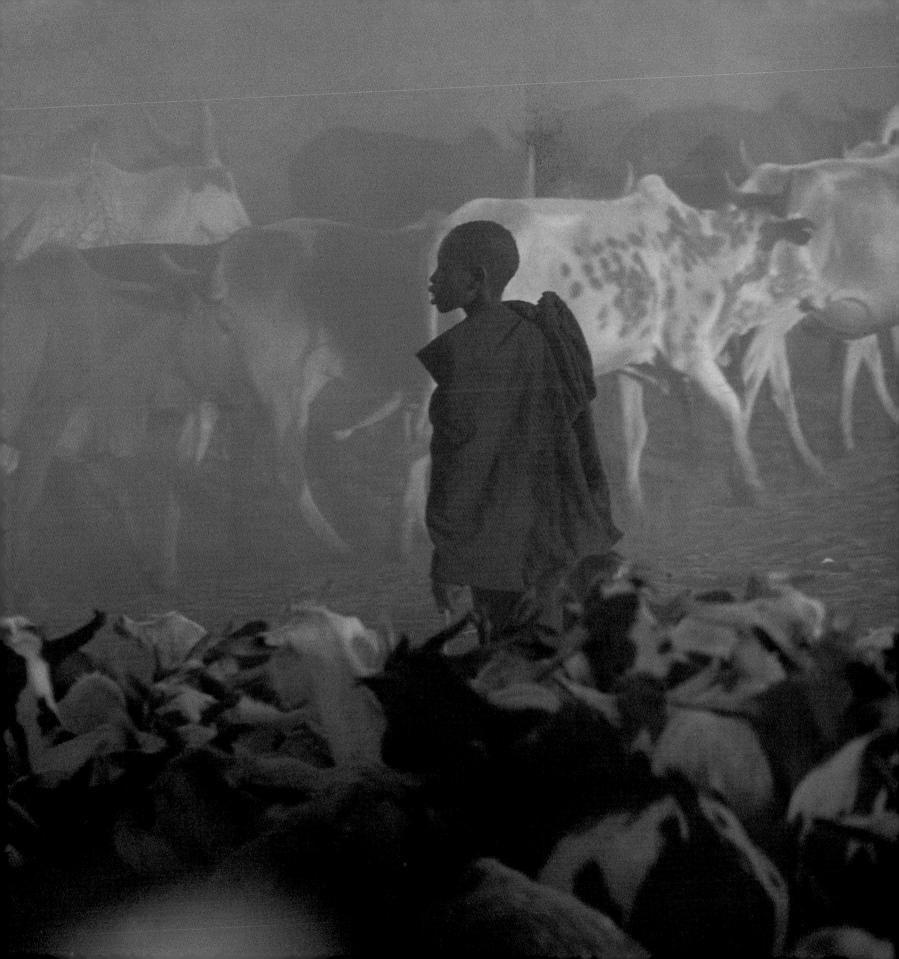

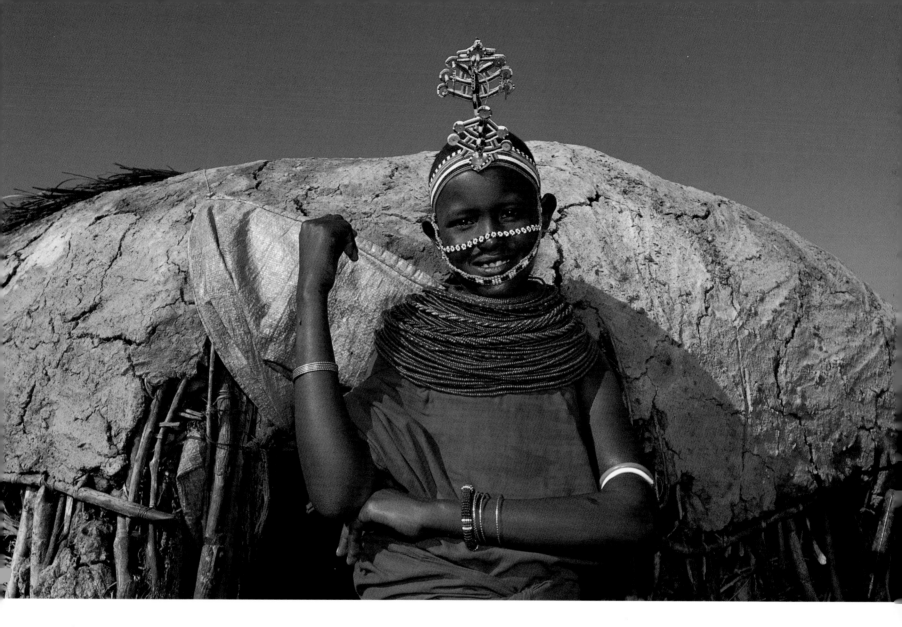

▲ Soole le Kotip, a thirteen-year-old Samburu girl in bridal headdress. Sypalek Village, Kenya. The Samburu are similar to the Maasai, and in fact speak the same language, although definite territorial tensions exist between them. As with many Kenyan tribes, the Samburu practice circumcision with both sexes. Samburu girls are circumcised on the day of marriage, usually when they reach puberty. Much controversy has surrounded ideas of banning this painful practice. Surprisingly some girls insist on their circumcision because they feel tribal men won't marry them without it.

The ceremony for a boy becoming a warrior begins with circumcision at age fourteen. Then the boys are sent from their home to build a village (manyata). They must fend for themselves for months and sometimes years before returning home to marry.

8

▼ Samburu warriors and women performing mating dance. Sypalek Village, Shaba National Reserve, Kenya. I was warned that armed robbery can make the Shaba area of Kenya dangerous. Cattle raiding is also common, especially between the Samburu and the Maasai. Guards at the gate to Shaba Reserve insisted that as a woman traveling alone I hire a couple of soldiers to escort me during my stay. Dressed in full camouflage gear and brandishing AK-47 automatic weapons, they regaled me with stories of bandits they had shot. One stayed at camp to guard the tent while the other accompanied me throughout the day in my Land Rover.

One day I visited this village just as these young warriors were performing their jumping mating dances in hope of enticing one of the young girls into marriage. The girls responded by singing deep from their throats.

That evening one of the pregnant women from the tribe went into labor and asked me to drive her to the hospital. She writhed in pain in the passenger seat, while her husband and the soldier rode in the back. The soldier's rifle banged the roof every time we hit a pothole. The woman was so grateful that she named her baby after me — probably the first "Alison" Samburu.

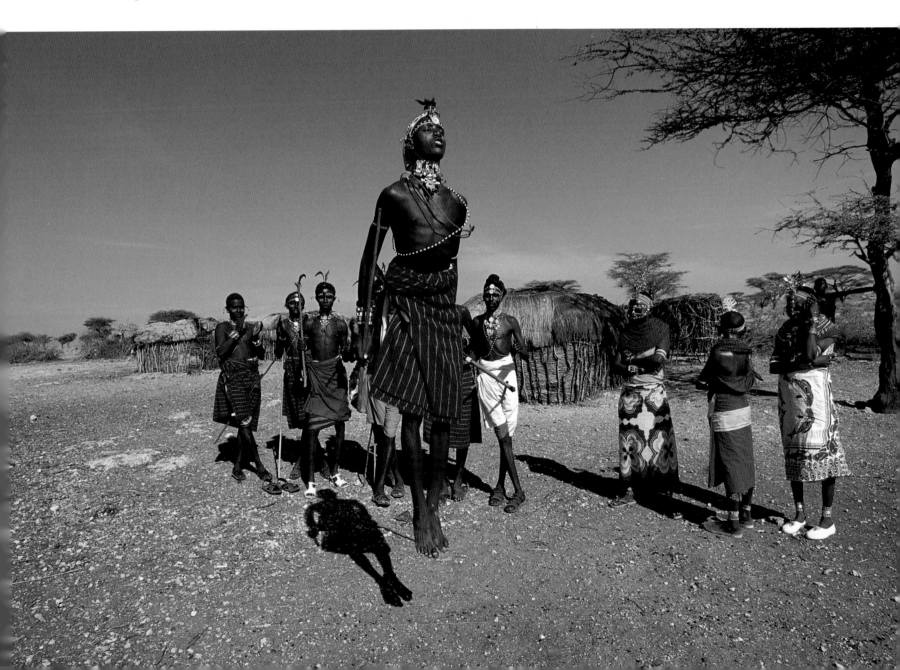

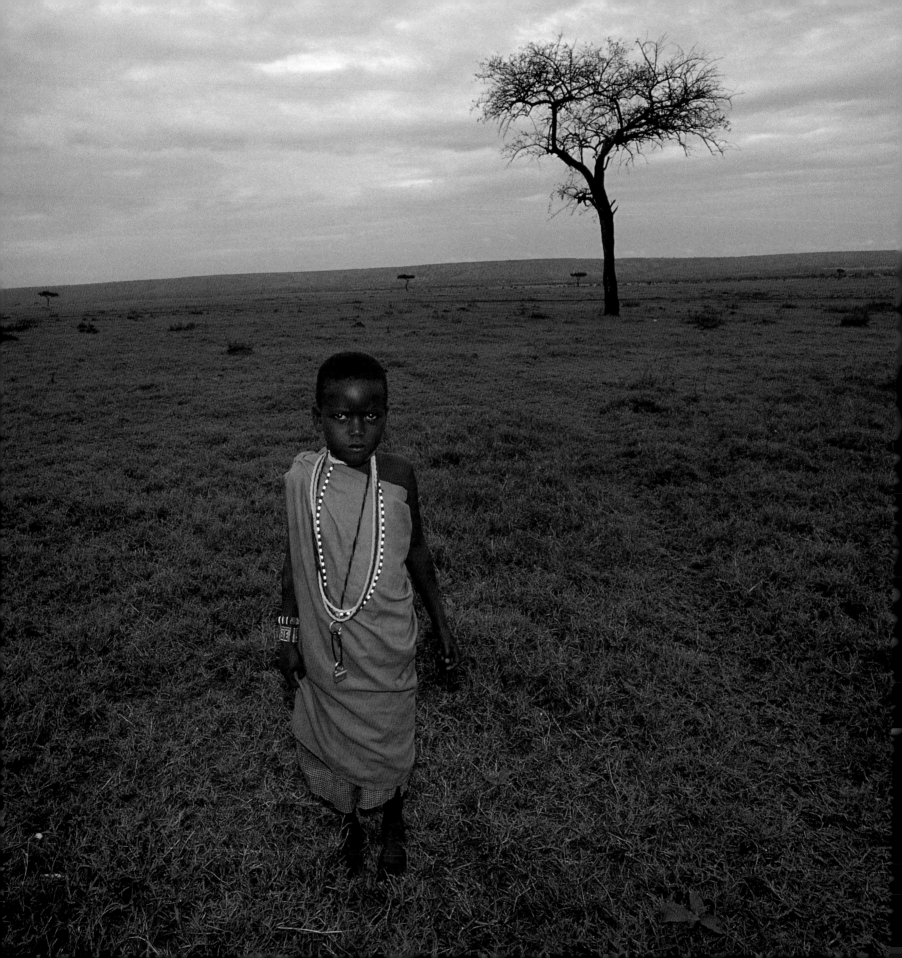

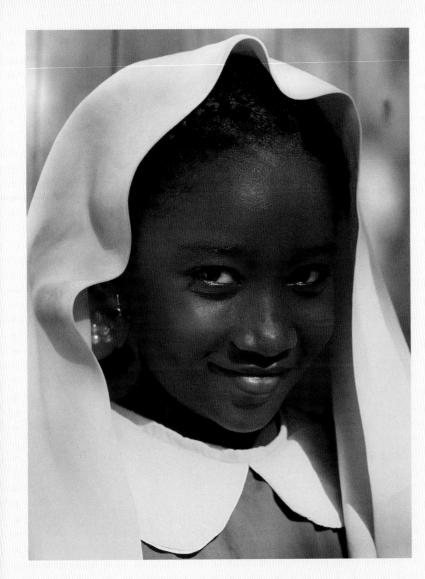

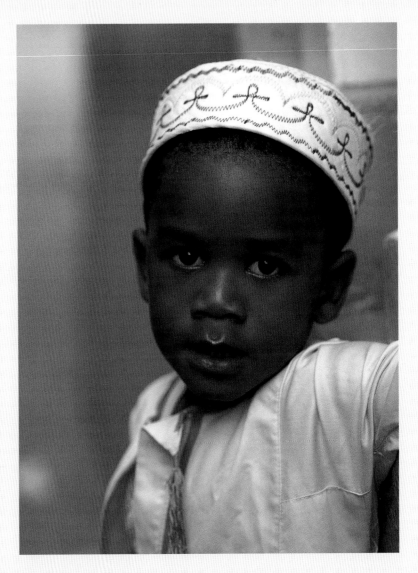

▲ Eight-year-old Amina Ali, a Muslim girl in Lamu, Kenya. The headmaster of the predominately Muslim Shela Primary School greeted me warmly and invited me into his school. Here I photographed Amina in her school uniform.

◄ Wombain, a four-year-old Maasai girl. Masai Mara, Kenya. Having made my camp in the middle of the night during a rainstorm, I awoke and emerged from my tent to find myself a definite object of curiosity.

▲ Mohammed, a three-year-old Muslim boy. Stone Town, Zanzibar, Tanzania. Trade from the east brought Islam to the "spice island" of Zanzibar. Every morning I'd watch hordes of children on their way to attend school at the mosques.

An old-world mix of cultures, Zanzibar is a trading city that sits at the crossroads of Mediterranean, Indian, and African traditions. Men still wear full-length white robes (*khanzus*) and *kofia* caps, while women wear the black *bui-bui* covering as they do in other Islamic cultures.

▼ **Pokot children at Nginyang school, Kenya.** This desert area is dry and barren; tumbleweeds roll through the dried-up rivers. In response to a several-year drought that is starving the people, a relief organization has been supplementing food as an incentive for the children to attend school. After three years this program is about to end in the hope that the tribe will become more self-sufficient. The headmaster, a Pokot tribesperson himself, is worried the children will stop attending. Education is their only hope, he tells me.

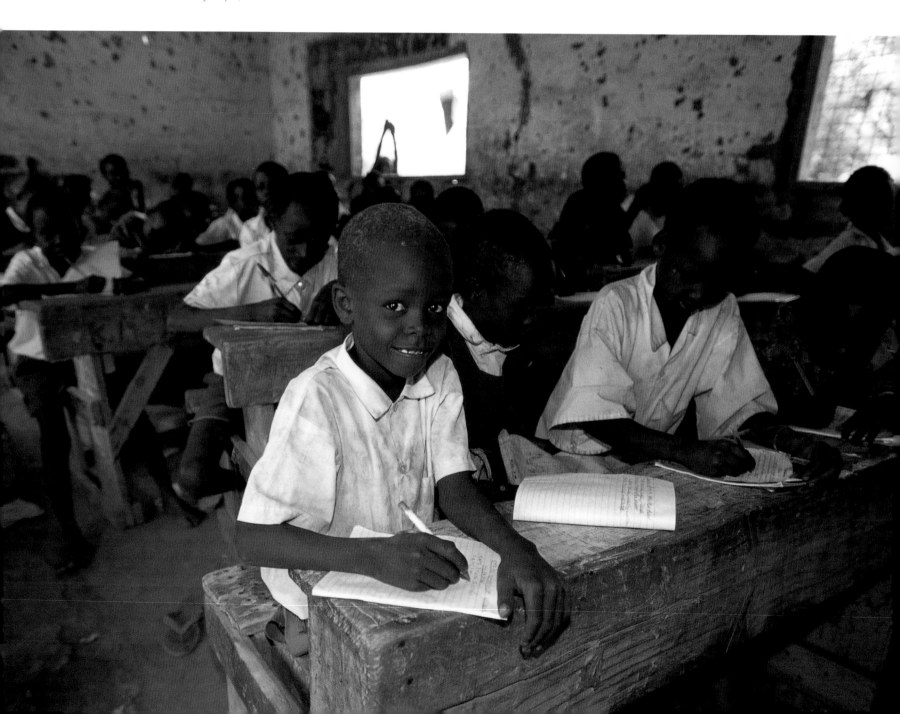

► Seven-year-old Maimlina Chepkemoi in class.
Rhonda slum, Nakuru, Kenya. Maimlina's
twenty-two-year-old mother has disappeared,
leaving her and her sister with their grandmother,
who works as a vegetable seller. They have
never known their father.

When I first visited the Rhonda slum at Lake
Nakuru, I was struck not only by the beauty of the
children who lived there but by their optimism and
determination in overcoming the adverse condi-
tions surrounding them. Most of these children
have been affected in some way by the AIDS
epidemic. Many are orphaned or living with
grandparents in shanty houses that cost about
five dollars a month to rent.

Aid organization Learning and Development
Kenya (LDK), which is run almost solely by the dedi-
cation of Philip Ndeta, initiated the Rhonda
Children's Home and Learning Center in the
Rhonda slums. Like an oasis, this school teaches
children of all abilities to help them eventually
merge into some sort of educational system. The
organization also offers community support to their
families.

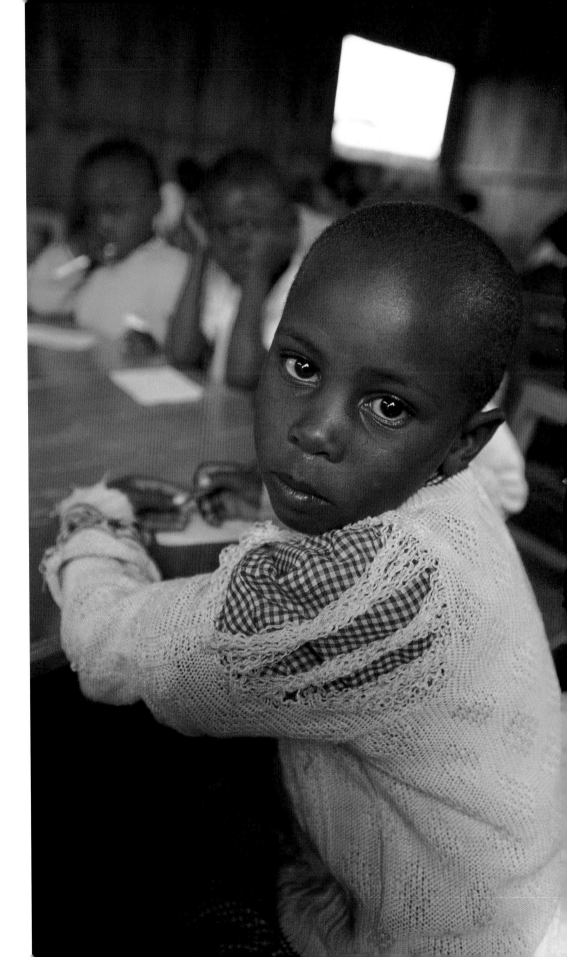

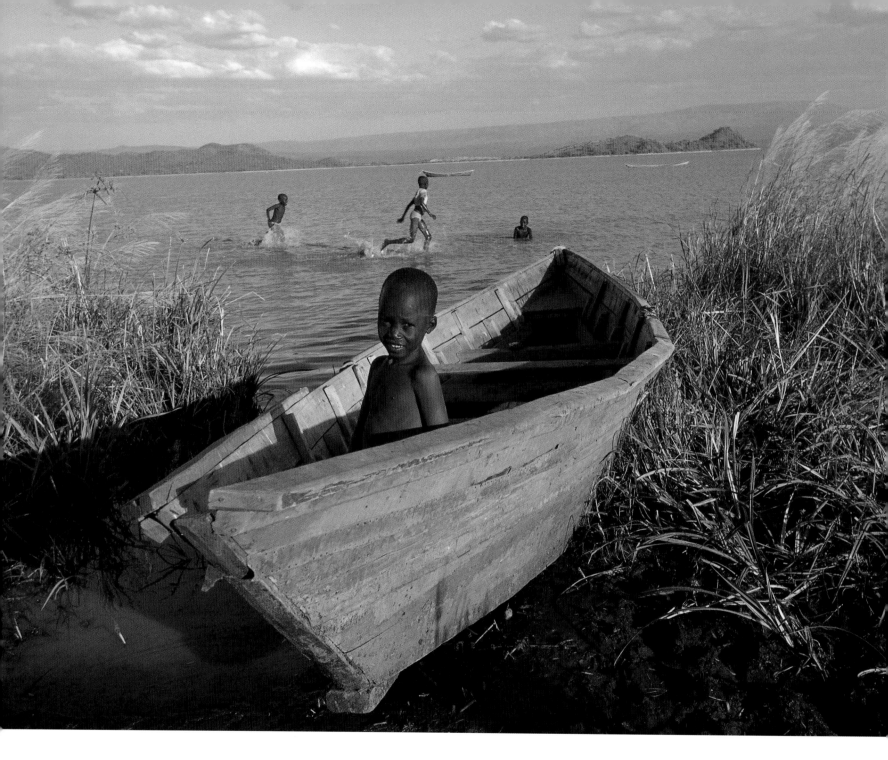

▲ Children playing in Lake Baringo. Kenya.

▼ Children jumping on a trampoline for a few cents a jump. Khutsog black township, near Carleton, South Africa. At the onset of apartheid in 1948, with few jobs and little housing available, blacks created their own communities in shantytowns throughout South Africa. Even though apartheid ended with the election of Nelson Mandela as president in 1994, many of these segregated townships still exist today.

▶ Six-year-old Lini eating a popsicle. Knysna black township, South Africa. Some of the more enterprising tour companies have started "Township Tours" as a way of showing tourists where and how South African black people are living. Although I often stayed in the townships on my own, I tried a couple of these tours. As voyeuristic as they sound, I felt they were a good learning experience. Otherwise it is very easy to travel through South Africa without seeing the whole picture.

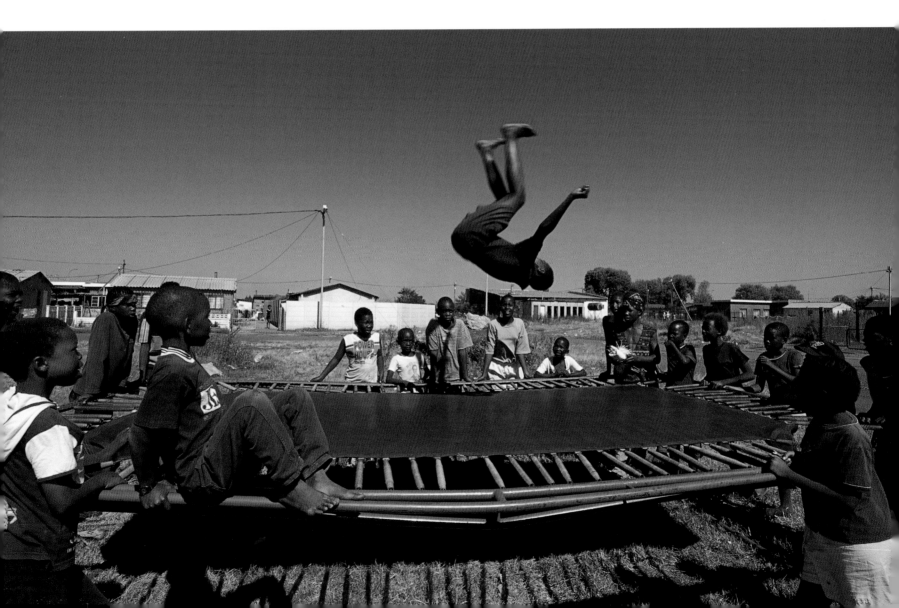

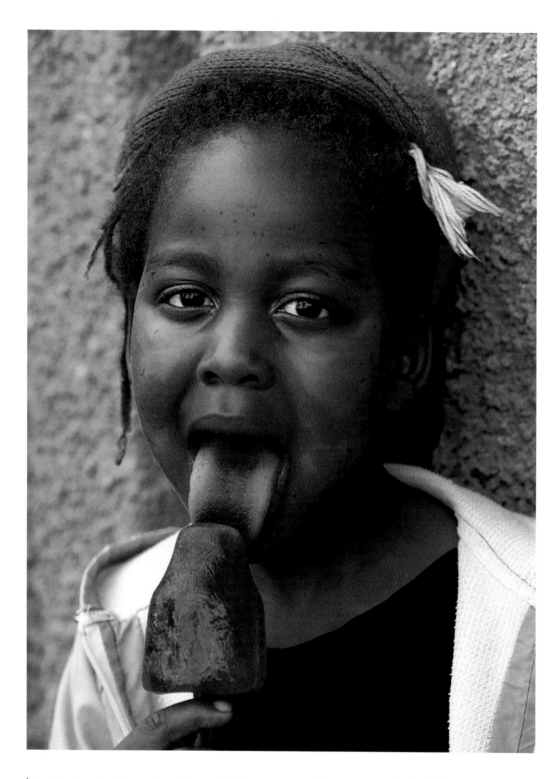

▶ Noel, a Rastafarian boy. Knysna black township, South Africa. These children are part of a Rastafarian community. While visiting Knysna's black township I attended a packed Easter service at the Holy Rosary Catholic Church. I was the only white person there. The congregation held hands and sang to the heavens with the most angelic voices I had ever heard. Afterward dozens of people came by to give me a hug and thank me for coming. The priest told me they bury fifteen people a day from AIDS in this township.

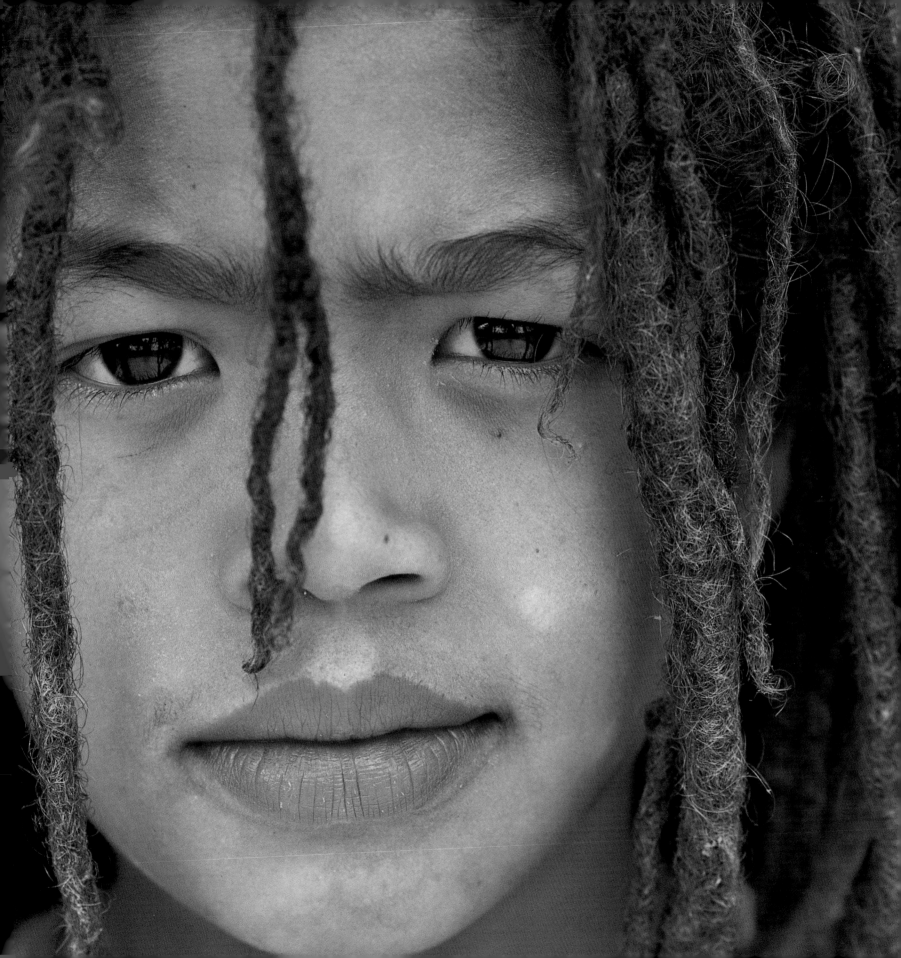

▼ Rose and her four-year-old daughter Esther. Korongocho slum, Kenya. More than 2 million African children are HIV-positive. Both this mother and child have AIDS. I was surprised when Rose told me her small baby was four years old, until the child started talking. An open sewer of contaminated water runs along the dirt floor where they sleep. The Nyumbani Outreach Program, known as Lea Toto, sends workers into these slums to help people living with AIDS. As we pulled up in the organization's vehicle, people ran away out of fear of being associated with the program and the disease it fights. Healthcare workers bringing supplies must discreetly enter the patients' homes. Such is the stigma of AIDS in this country.

Started by Father Angelo D'Agostino, Nyumbani is a special home in Nairobi to care for AIDS orphans. Although all children admitted here have tested HIV-positive, many of them are just carrying their mother's antibodies. Father D'Agostino's program has shown that proper food and appropriate drugs can turn this disease around. Three out of four children at Nyumbani test negative to the virus within eighteen months.

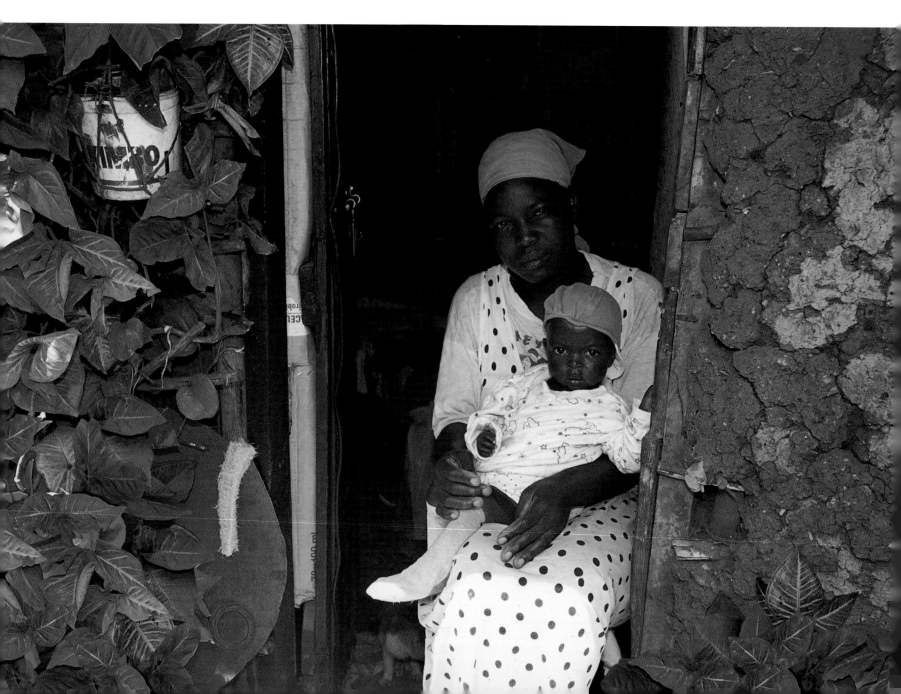

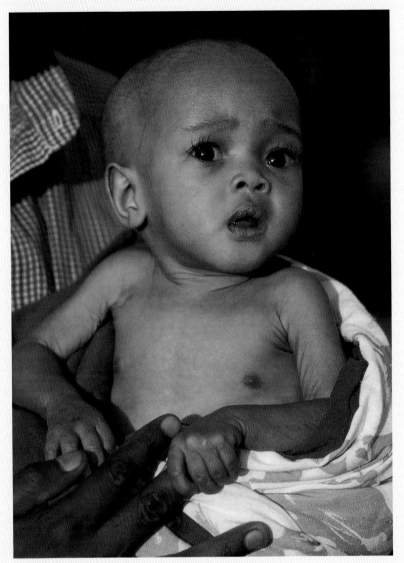

▲ Six-month-old Nomxebo, which means "conqueror," an orphaned baby with AIDS. Bethesda Orphanage, Soweto, South Africa. Although the AIDS epidemic is starting to affect many children in developing countries, it has become a crisis in Africa. So far 17 million people have died from AIDS in sub-Saharan Africa, more than 4 million of them children. An additional 12 million children have been orphaned.

▲ Orphaned baby with AIDS. Bethesda Orphanage, Soweto, South Africa. South Africa has more HIV-positive people than any nation in the world, an estimated one out of every nine people. One thousand South Africans die of AIDS every day and about seventy thousand children are born HIV-positive each year. These children could be protected from the disease for about four dollars each if their mothers were given a relatively simple drug called nevirapine. The government has suggested that it isn't cost effective to save these children when their mothers are doomed to die, creating a generation of orphans. The government has only recently cleared the drug for very limited use.

19

▼ Girl carrying sugarcane. Northern Province, South Africa.

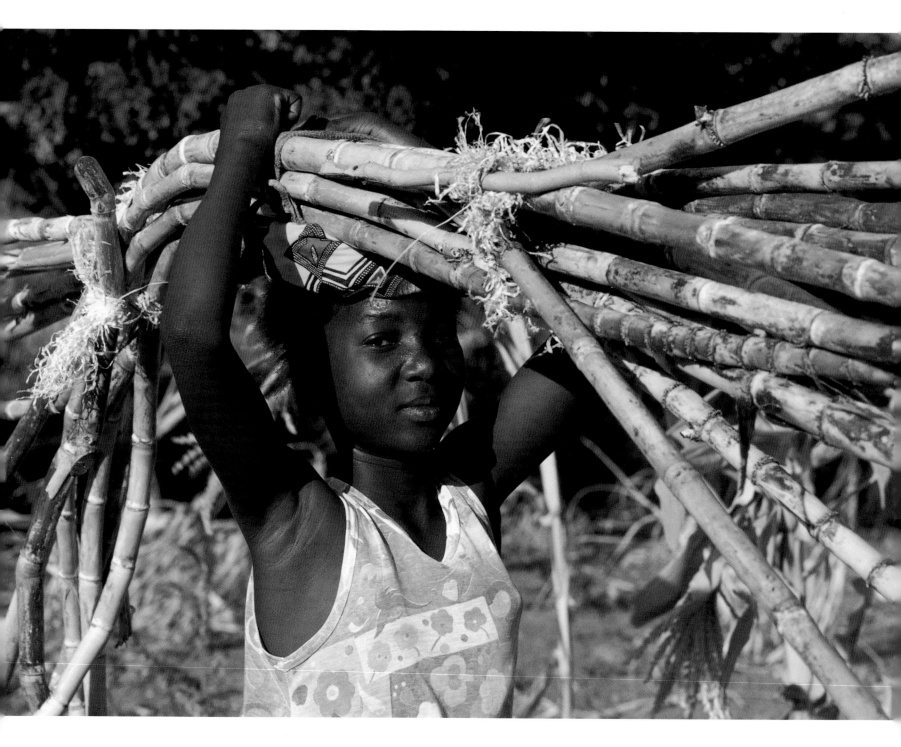

20

▼ Robert with his surfboard. Durban Beach, KwaZulu-Natal, South Africa. Ten-year-old Robert rushes to school after finishing his daily training for the South African Lifeguard Championships.

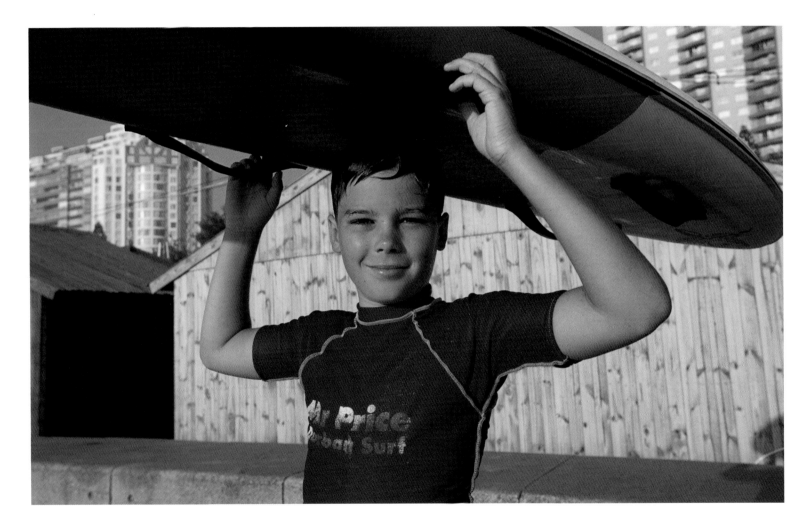

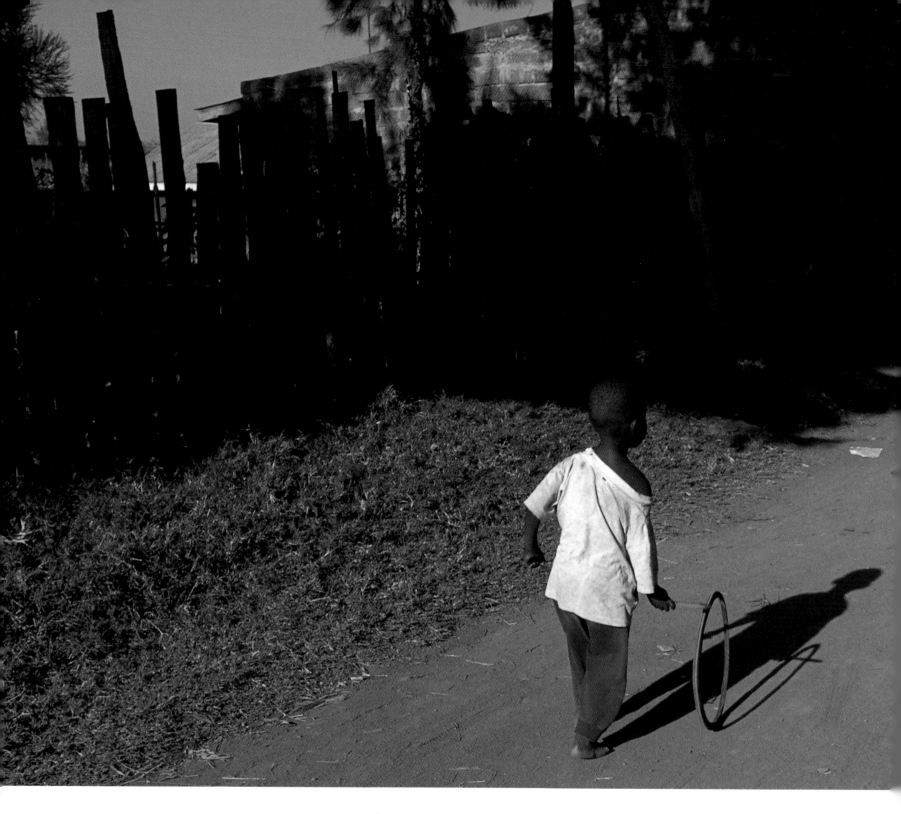

▲ Children playing with hoop tires. Nakuru,
Rhonda slum, Kenya.

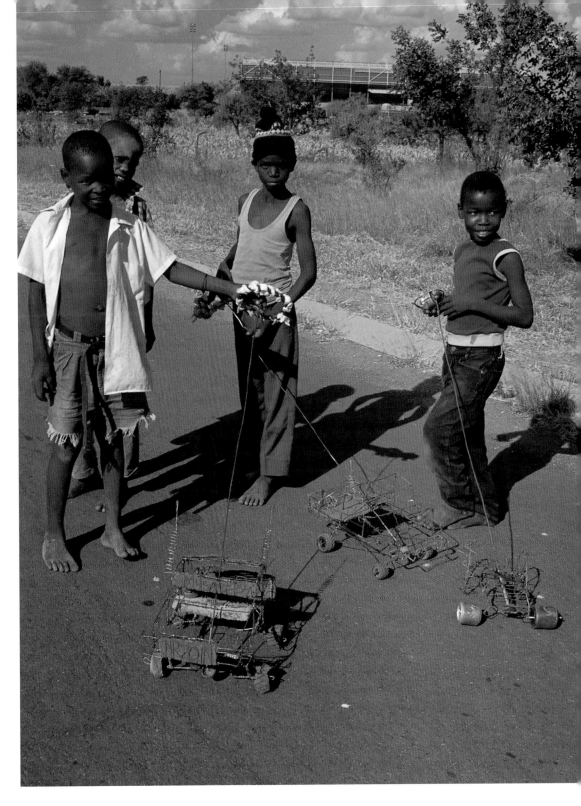

▲ Boys playing with their creatively built wire cars.
Lulekani Township, South Africa.

Jeanette, or Mpho (her Zulu name). Kuntsog Township, near Carleton, South Africa. Mpho's father left when her HIV-positive mother was pregnant with her. Their home has no water or electricity. I traveled here with Project Heartboat, which delivers food to orphaned children, many who are now living at home alone and raising themselves.

▲ Grandmother with her two grandchildren.
Mamelodi Township, Pretoria, South Africa.
Many grandparents have inherited the job
of caring for their children's children,
orphaned mostly by AIDS. The disease has
in some way touched everyone in South
Africa.

▼ Eve, five, and Thembela, four, playing together. Sun City, South Africa. With the end of apartheid in 1994, the hope is for this generation of all colors to grow up playing together without discrimination.

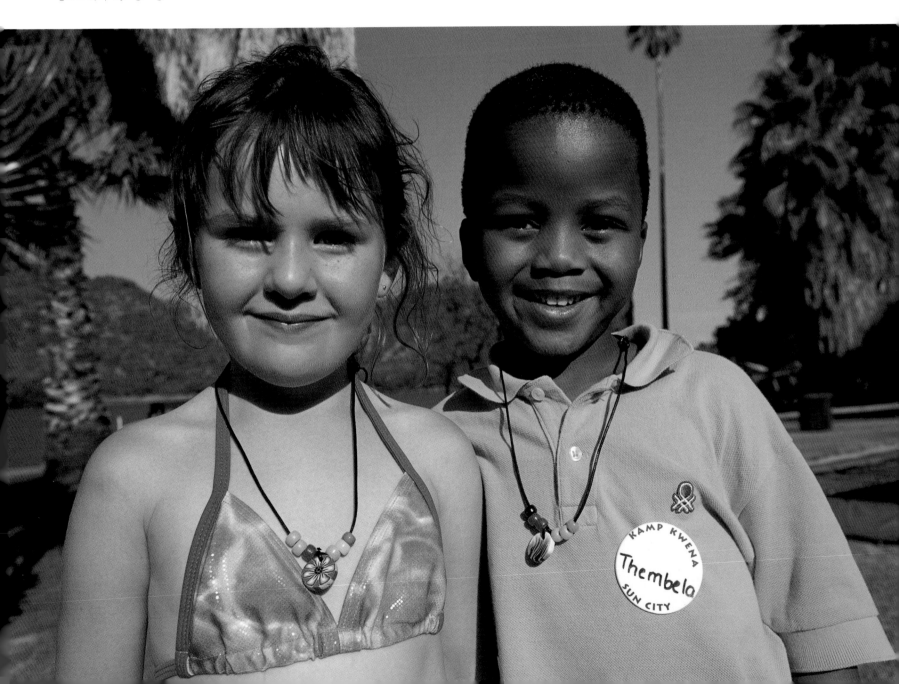

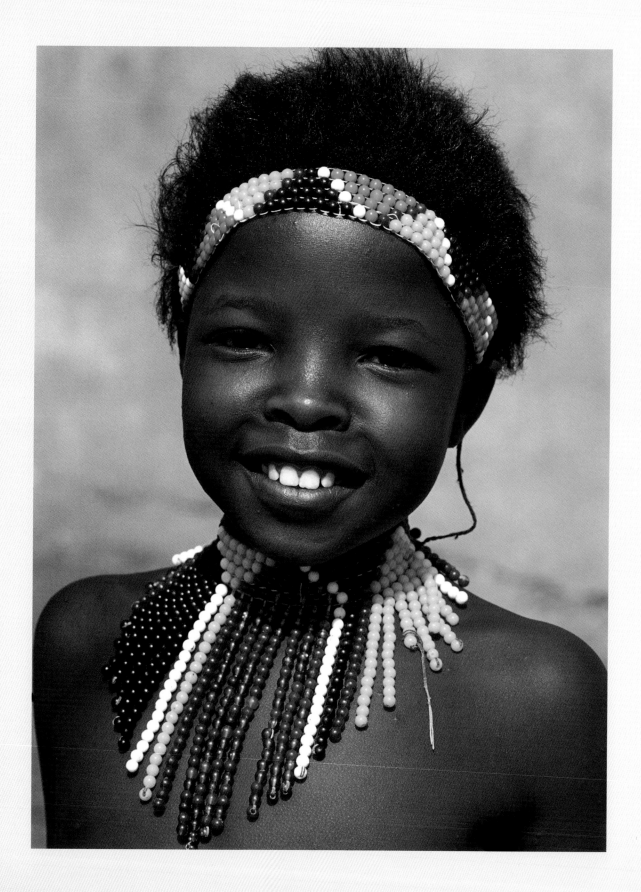

28

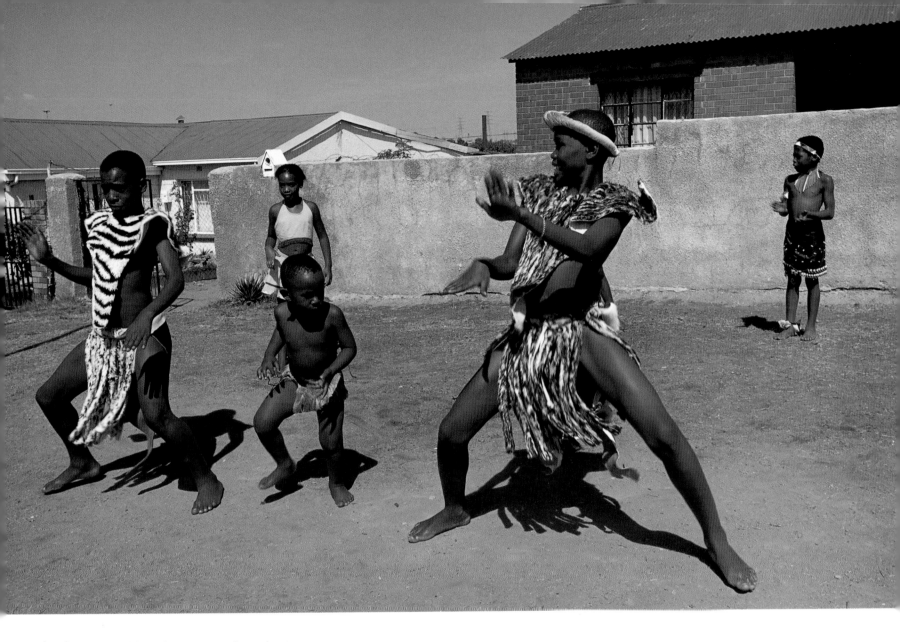

◄ ▲ Zulu children dancing in traditional cos-
tumes. Soweto Township, South Africa. This
thriving black township of more than 2
million people is really a small city outside
of Johannesburg. Enterprising Zulu children
dance for the tourists visiting the former
homes of Desmond Tutu and Nelson
Mandela, who lived on the same street in
Soweto for many years.

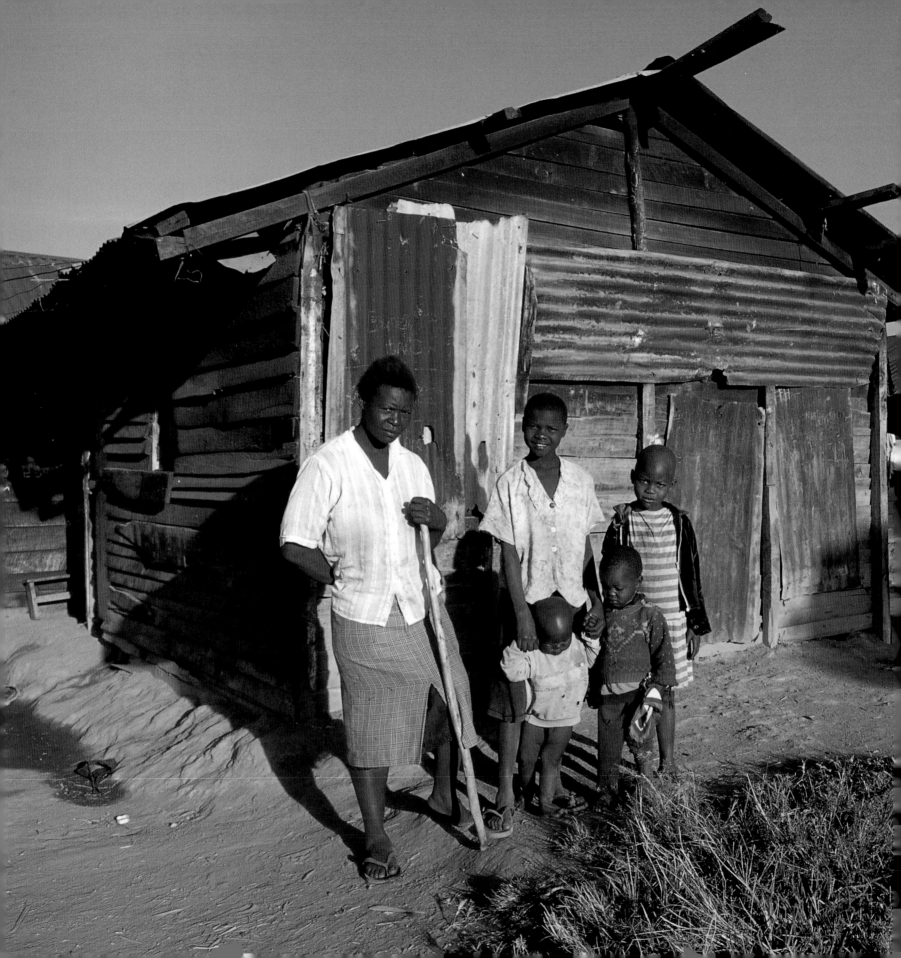

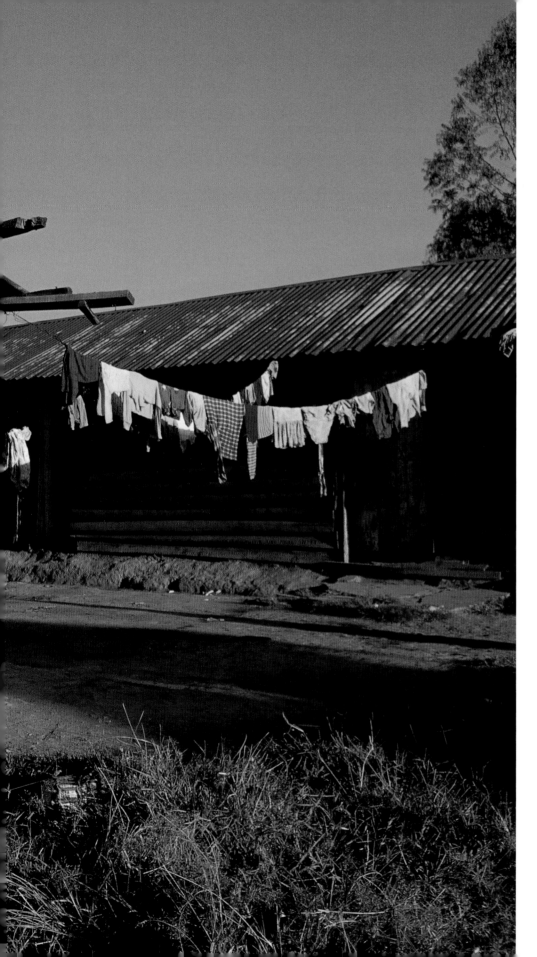

◀ Violet and her children. Rhonda slum, Nakuru, Kenya. Violet Mahonja is disabled from polio. She has four children and no husband. Her home is scraped together from salvaged materials, with sheets of plastic lining the walls to block the wind. Despite her hardship, she greeted me with a huge smile and invited me to meet her family. I wondered, how does she ever find hope, day to day, in a situation like this? This is the only life she knows, and maybe the only life her children will know. It is this next generation that symbolizes hope for countries like Kenya. Touched by her determination, I couldn't help slipping a twenty-dollar bill into her hand as I left.

▼ Girl carrying her sibling on her back. Rhonda slum, Nakuru, Kenya.

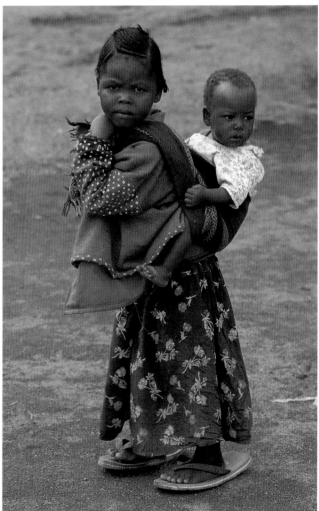

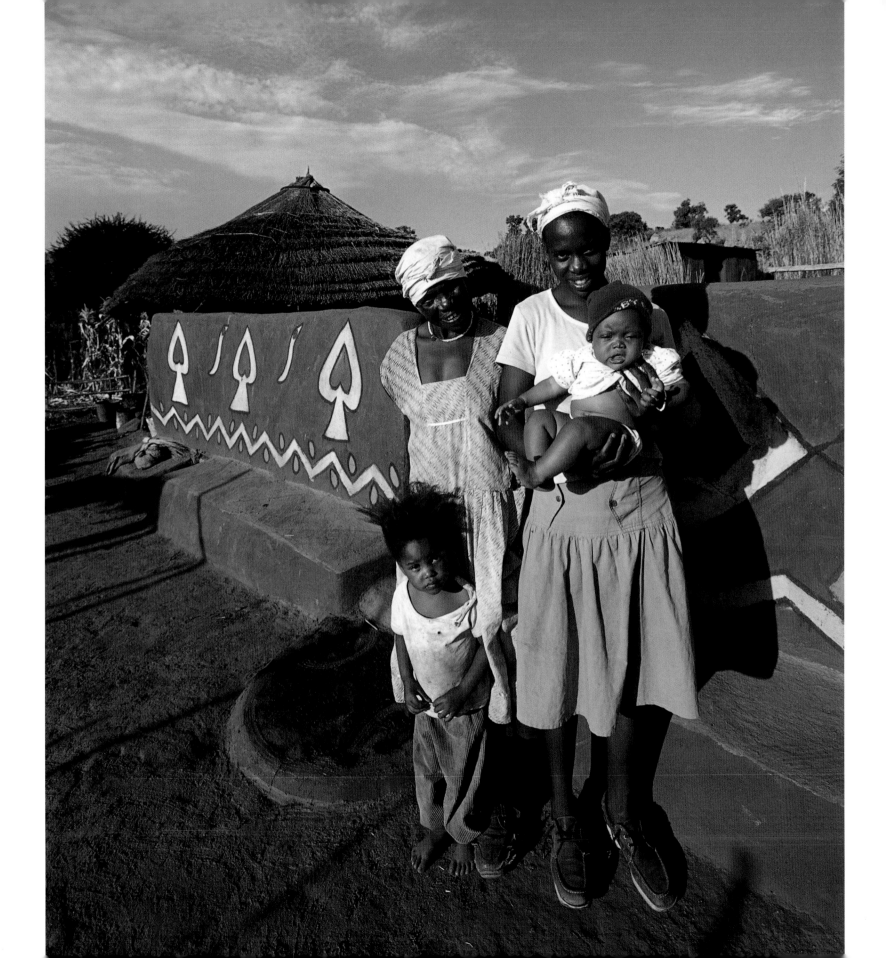

◄ Ndebele family. Northern Province, South Africa. Makapansgat is a national heritage site inhabited by a community of former farm workers with no means to support themselves. Here I met Ron, the head of the South African Heritage Resources Agency (SAHRA), who inspired this small village of 250 people to paint their houses in their traditional Ndebele, Sotho, and Shagaan designs for an annual contest. I joked with the women that they should keep the prize money for themselves, as they were doing all the work while the men watched.

► Ndebele girls show their paintings. Siyabuswa region, South Africa. The colorful painted houses of this region are a traditional art form. Esther Mahlangu, who is famous for her painting, teaches the young children of the community to practice on boards so that they may one day be good enough to also paint the houses.

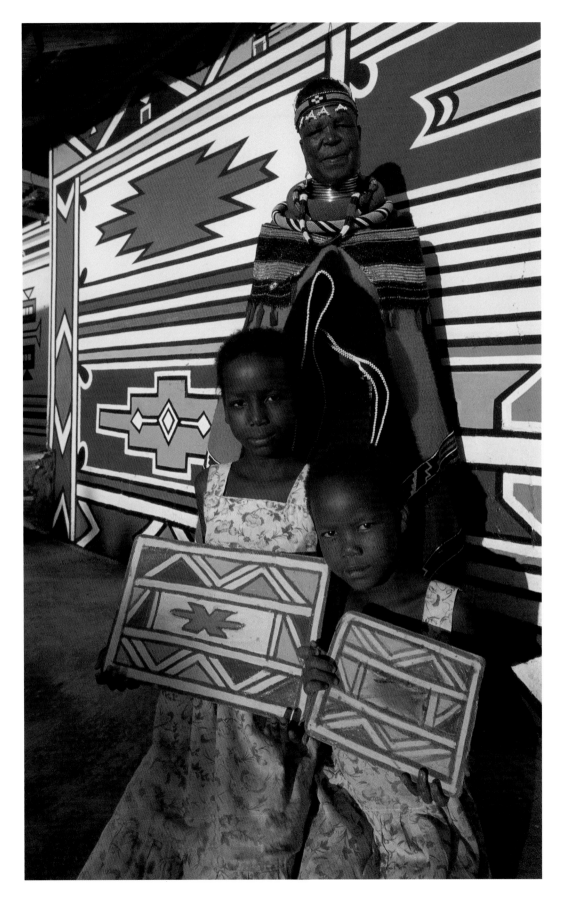

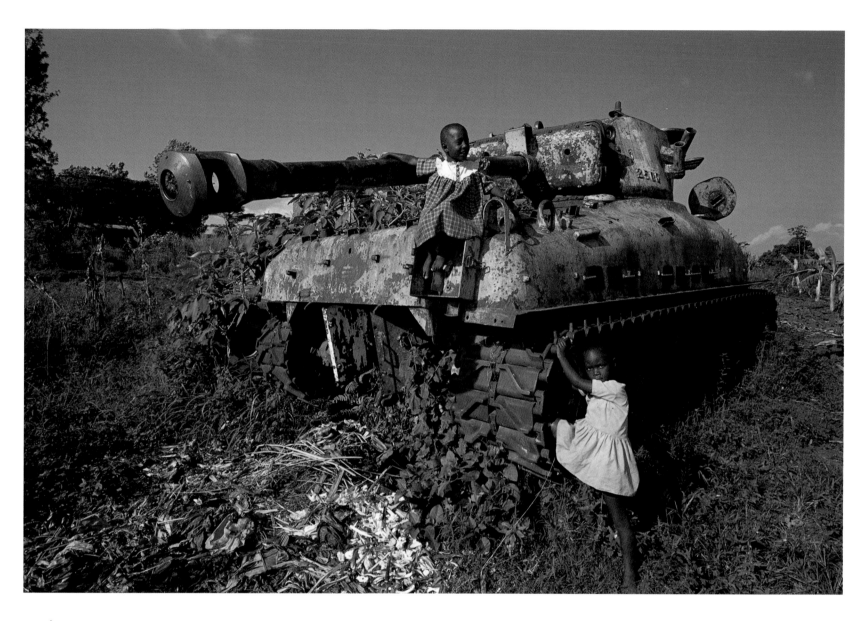

▲ Young girls playing on an army tank abandoned by Idi Amin's army. Kampala, Uganda. The use of children as combatants, called "kadogos" or the little ones in Uganda, is an increasing reality in today's warfare. As many as 350,000 people were murdered during Idi Amin's rule from 1971 to 1979 and even more after president Milton Obote was reinstated. Now that the orphans of the war are adults, a larger number of AIDS orphans — nearly 2 million in 2000 — are replacing them. Although AIDS is killing Ugandans at an alarming rate, the country has been acknowledged for being the first African nation to cut back high infection rates with aggressive, government-supported prevention strategies.

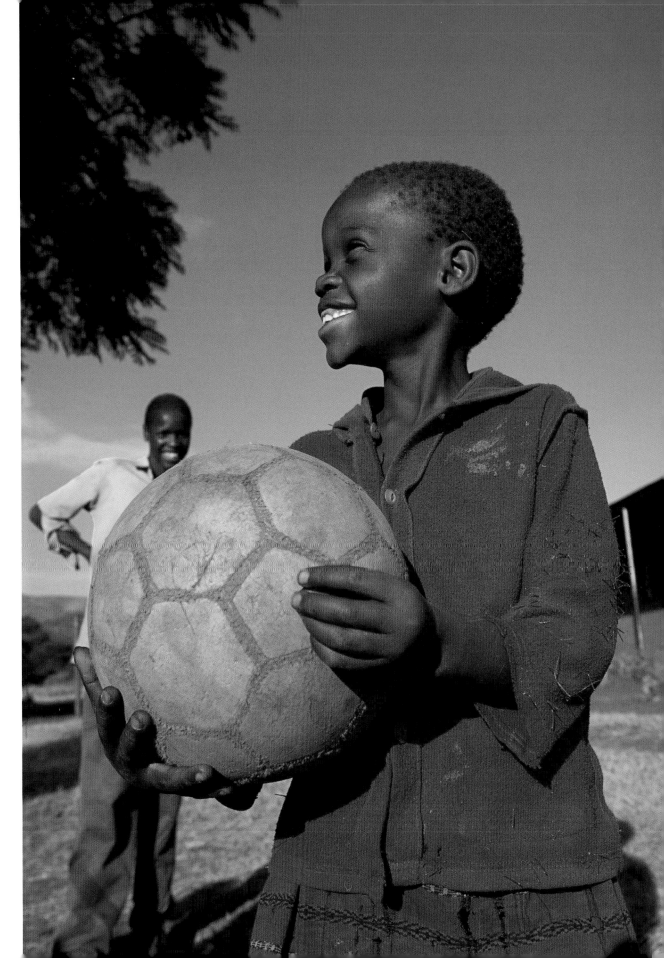

Children playing soccer. Northern Province, South Africa.

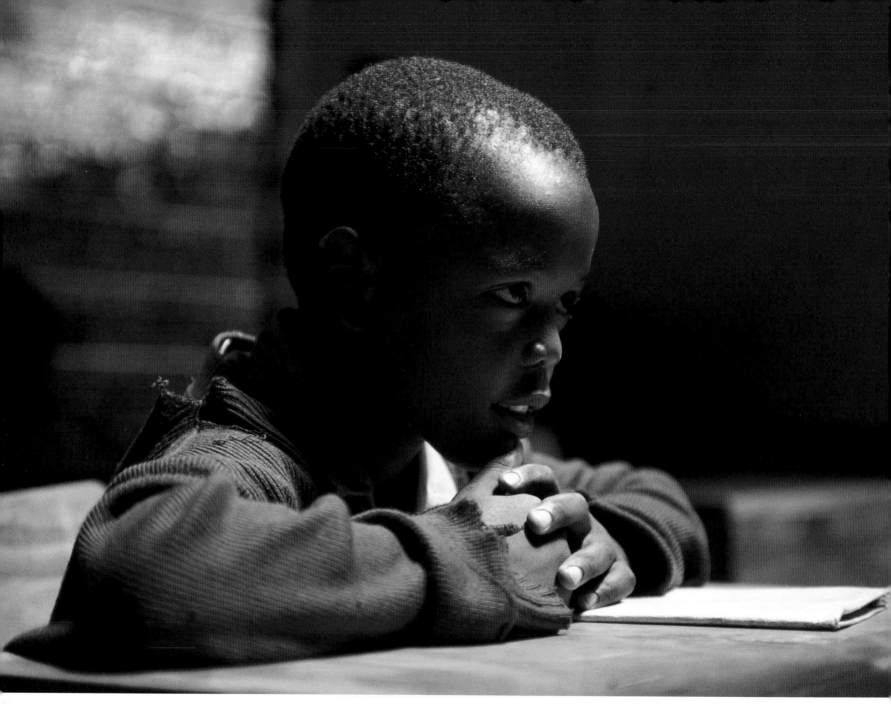

▲ Collins Ochieng. Nairobi, Kenya. Ten-year-old Collins Ochieng comes from a family of ten children. According to custom, his father inherited his brother's wife, along with their five children, when his brother died. Collins lives with both his parents, who are unemployed, although his father is a trained electrician. Their only source of income is the little his mother makes selling sukuma wiki, a staple food in Kenya similar to kale. Collins lives in a slum called Kawangware but walks two hours every day to attend this school run by Kids to Kids in Westlands, another Nairobi neighborhood. With more than 130,000 children living on the city's streets, Kids to Kids is one of many organizations working to give children like Collins an alternative.

Children's talent to endure stems from their ignorance of alternatives.

— MAYA ANGELOU

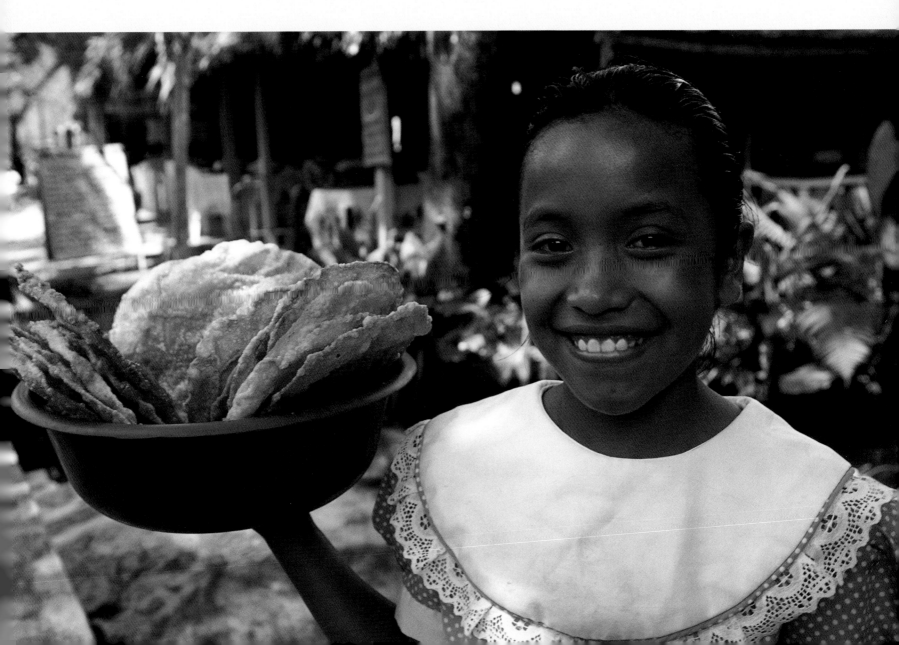

◀ Girl selling tortillas. Chiapas, Mexico.

▼ Children sleeping in the street. La Paz, Bolivia. Bolivia is the third poorest country in the western hemisphere, after Haiti and Guyana, with 97 percent of the population living below the poverty line. No wonder I had all my camera gear stolen within twenty-four hours of arriving. Bolivian children, especially girls, often drop out of school before the fifth grade to help tend the crops and animals. When farming fails, thousands end up in La Paz as street children, selling candy, shining shoes, working as prostitutes — anything to support their families. In most countries the rich live in prime real estate above the sprawl of the city. In La Paz it is the poor who live in higher neighborhoods with the strain of the altitude.

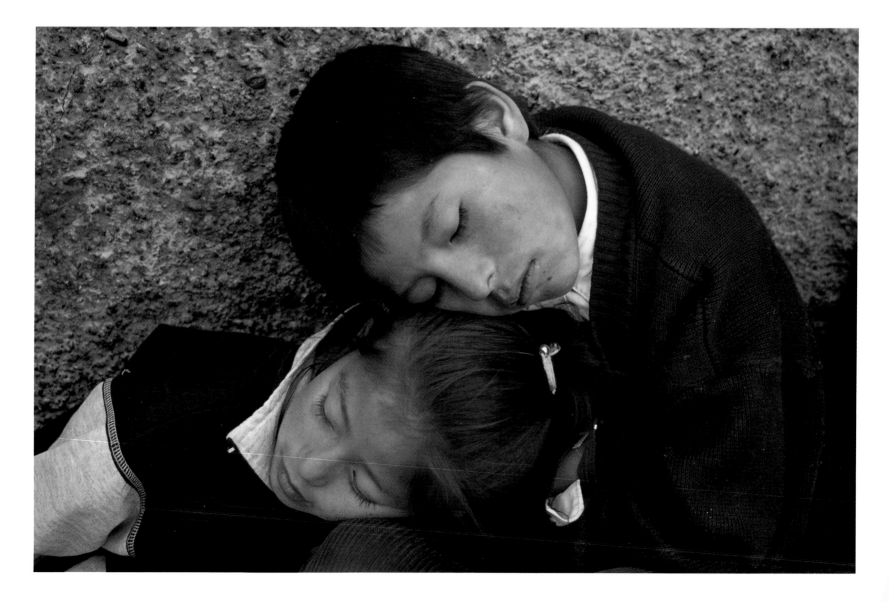

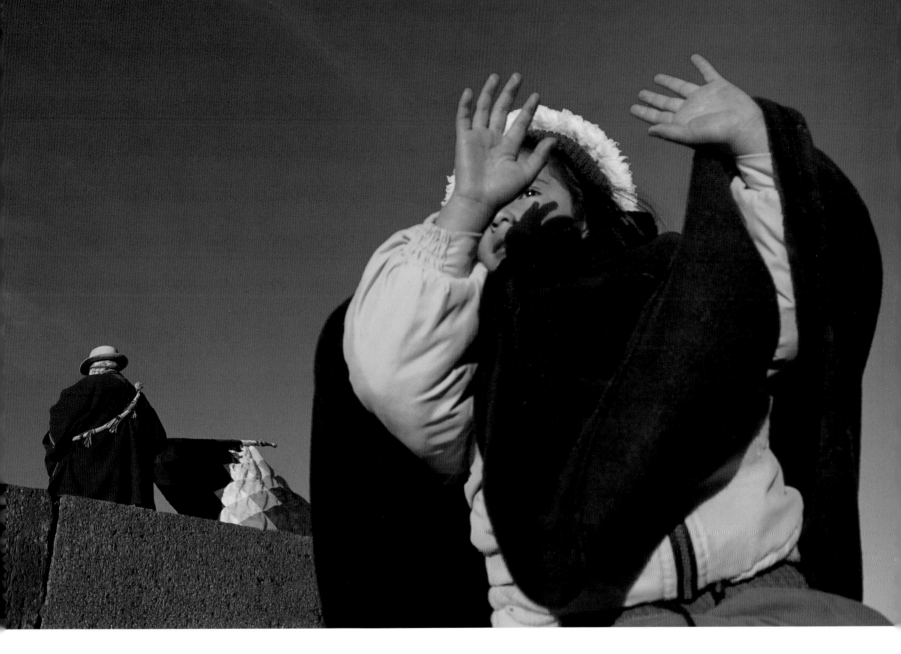

▲ Aymará Indian girl at Tiahuanaco ruins, Bolivia. On the Aymará New Year, an immense crowd of Indian worshippers — many in ceremonial dress, chewing coca leaves, and waving indigenous flags, like the man on the left — gather at these sacred ruins before dawn to celebrate the June 21 winter solstice. Shamans chant and blow cigarette smoke as they perform traditional Aymará rituals to the mountain gods and Pachamama, the earth goddess. Musicians dance and whirl to their wooden panpipes and drums. All stop to raise their hands, as this young girl does, to catch the first ray of sunlight of the Aymará New Year as it appears on the horizon and shines through the temple entrance.

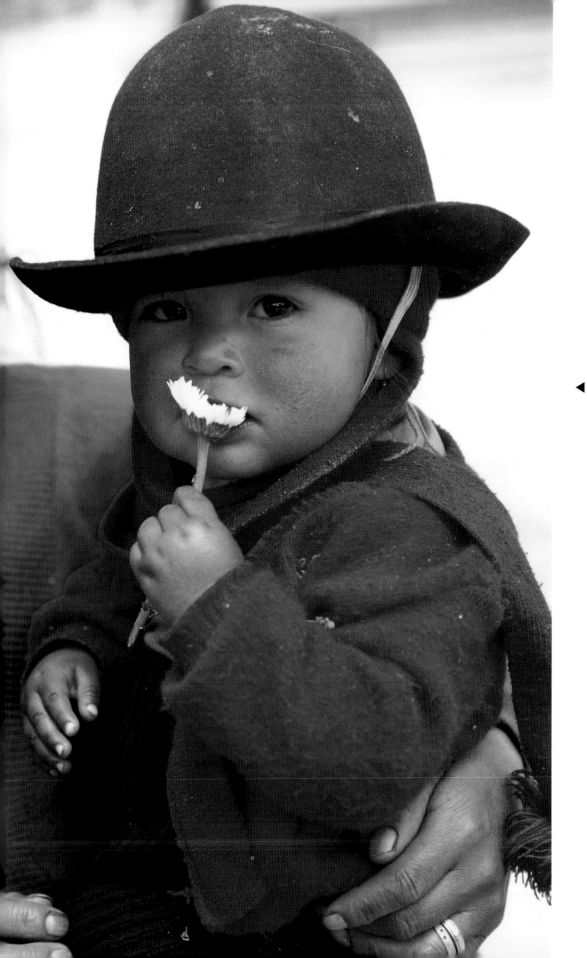

◄ Quichua girl holding flower in the highlands.
Ingapirca, Ecuador. Ecuador is the smallest country
in the rugged Andean highlands and Quichua
Indians constitute the bulk of the rural population. I
was up at dawn photographing the ancient
Ingapirca Inca ruins with not a soul in sight, except
for lumbering llamas grazing on the lush greens
surrounding the ruins. As I hiked the high grass-
lands, I saw two young boys pile into the back of a
pickup truck and head to school as their small
sister, held here in her mother's arms, waved
goodbye.

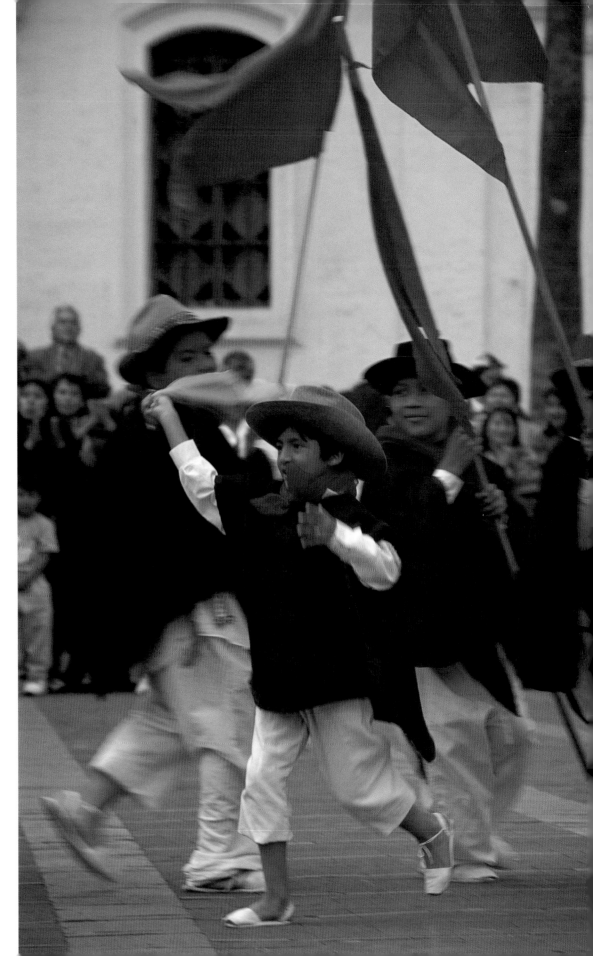

▶ Schoolchildren in a dance performance. Quito, Ecuador. As I walked through the old colonial quarter of Quito, the streets were packed with children celebrating a fiesta with dances and parades. These children are dancing in their native Otavalon costumes.

▶ Martha, a Matses woman at home with her child. Amazon jungle, Peru. Martha's baby was sick with a cold. As we walked near their village, she stopped periodically to pick medicinal plants to stuff into the little girl's shirt next to her chest — the rainforest's version of Vick's VapoRub.

Despite visible changes to their culture, many Amazon Indians continue to live much as they have for hundreds of years. Babies grow up playing in the jungle. Men hunt wild boar with poisoned arrows and blowguns, and take their dugout canoes and harpoons out onto the river to fish. They retain an intimacy with nature and an appreciation of shared community with their neighbors. As a result, they move through the world with a profound sense of place and purpose.

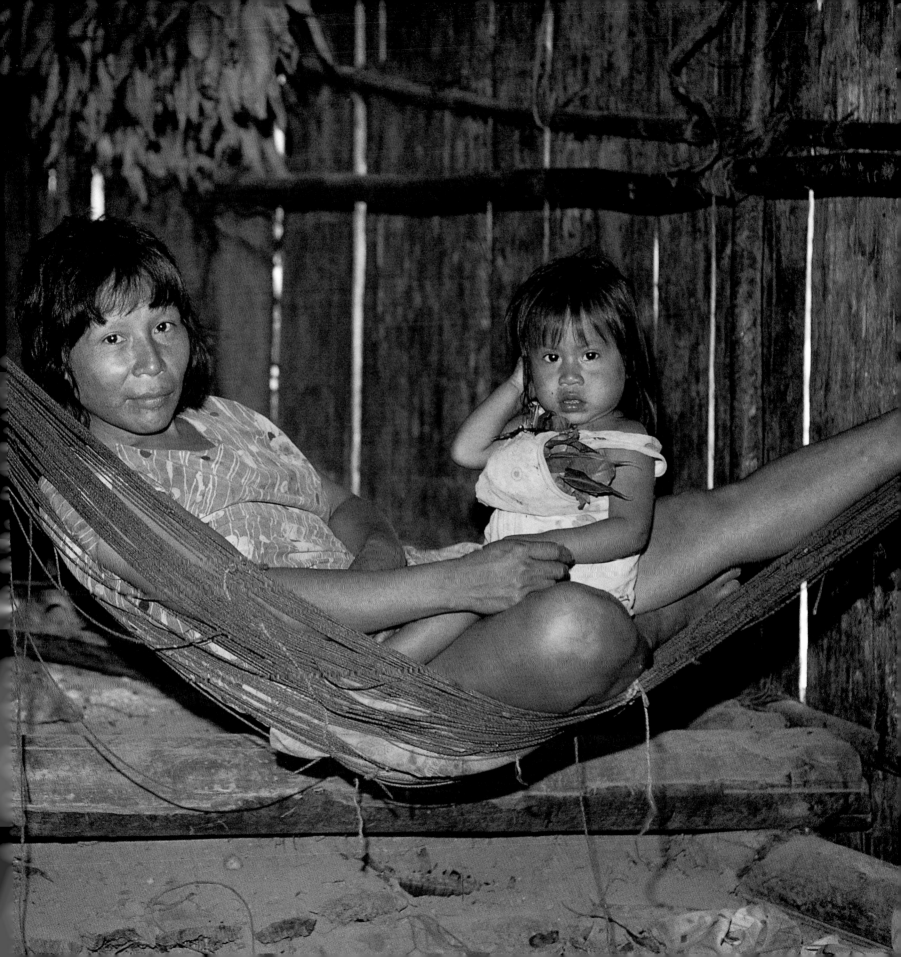

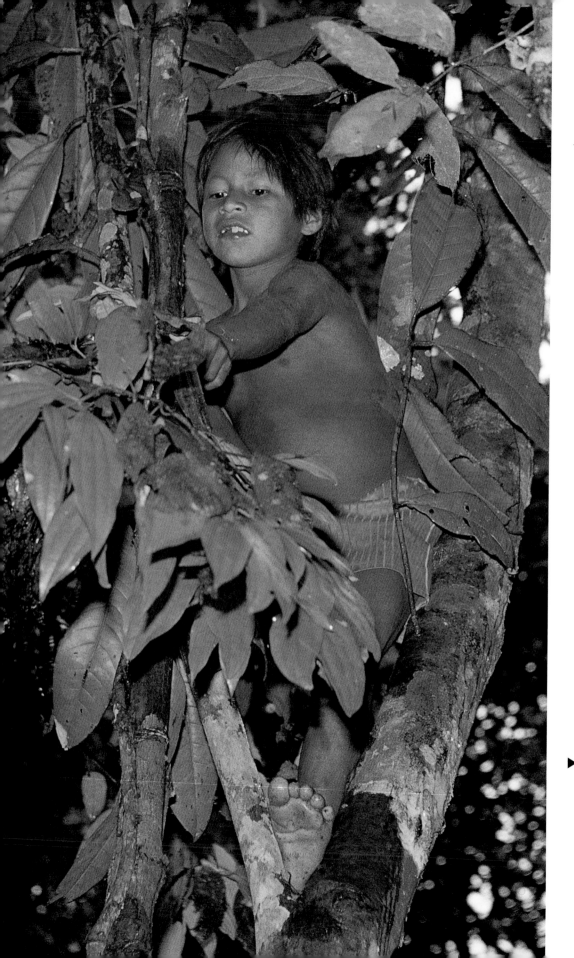

◄ Boy collecting medicinal plants. Amazon jungle, Peru. The Matses, or "Cat People," believe them-selves to be descendants of the jaguar. Jagged tooth-like tattoos outline their jaw-lines like railroad tracks to represent the hunting aspect of their nature. Small holes rim their noses where they once proudly wore their "cat whiskers" until Christian missionaries decided it was an inappropriate prac-tice. More recently, polyester gym shorts replaced penis sheaths. The shaman from one neighboring Yagua tribe we visited wore a ruffle-fronted tuxedo shirt as he shimmied up trees. Who on earth, I won-dered, was making fashion judgments for these native people?

▶ Boy with pet monkey on his head. Angamos, Amazon basin, Peru.

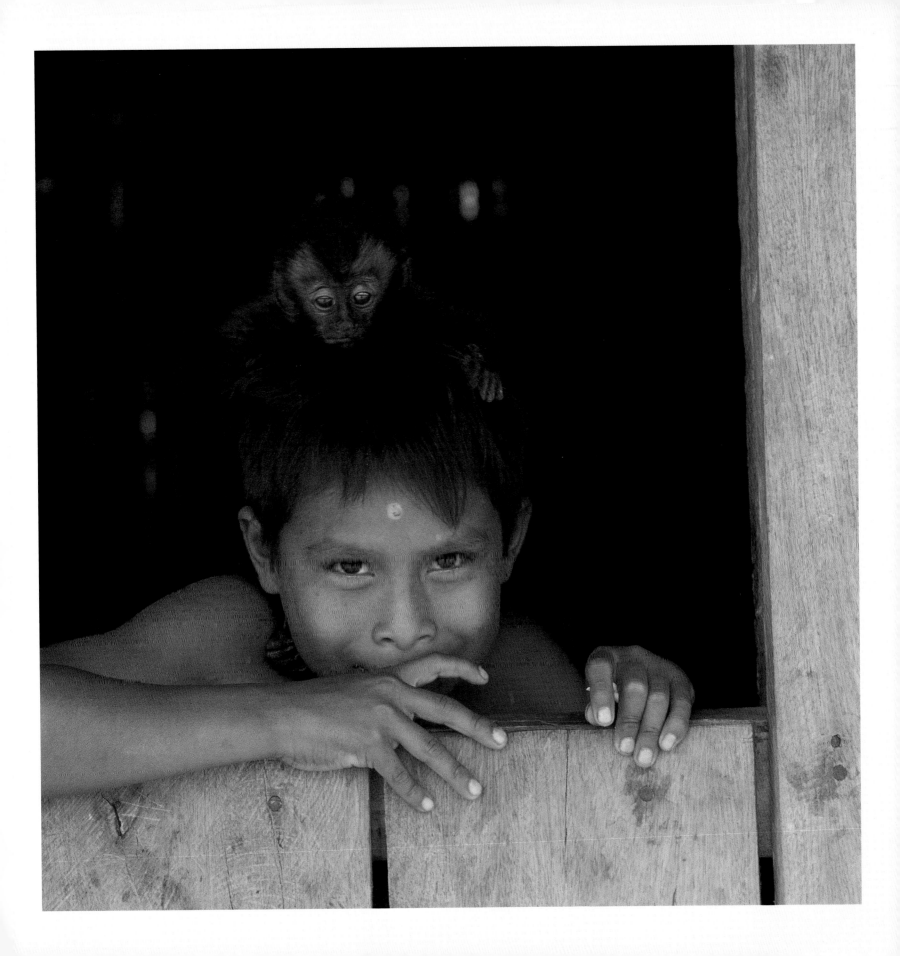

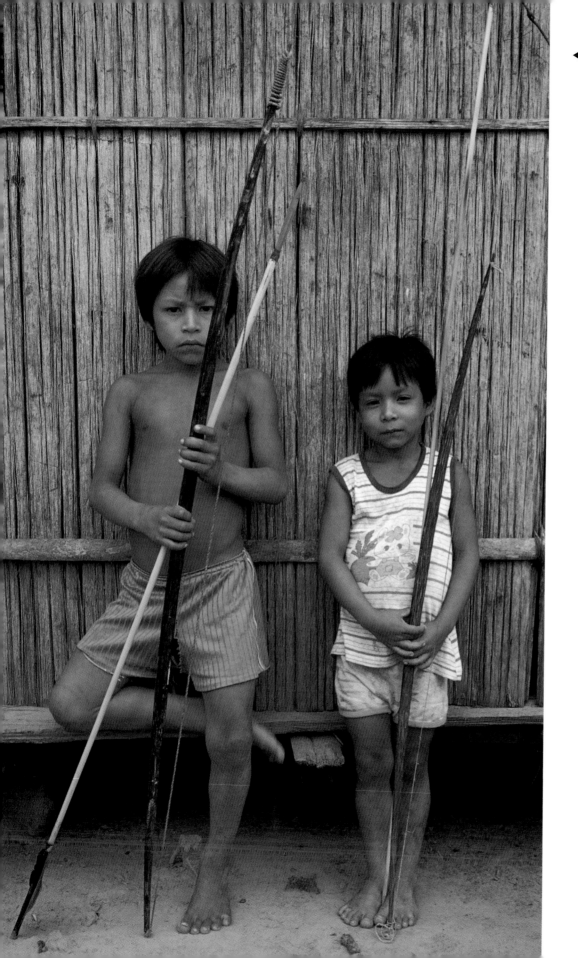

Matses tribe boys playing with their bows and arrows. Amazon jungle, Peru. With three wives, Pablo seemed to have fathered nearly every child in the village — forty at last count. I was traveling with an ethnobotanist and we were accompanied by a full entourage whenever we entered the jungle to collect plants.

Although Pablo was honored as the village shaman, I was impressed with the knowledge that most of the Indians seemed to have about medicinal plants. Even Pablo's young children were quick to loop vines around their skinny little ankles and shimmy up to the tops of trees for specific plants. Mimicking their father, the boys scurried through the forest with small bows and arrows in animated delight, shooting at small birds and rodents. The boys had been banned from hunting for a long time, explained Pablo, because of their tendency to shoot at village dogs and chickens. As we talked, the boys were sticking their legs deep into giant red ant hills, daring each other to stay immersed as long as possible.

"Very naughty boys," Pablo said without much conviction.

At the end of the day we returned to the river and carefully bathed from the edge of a small wooden raft where the women washed their clothes. The river held threats that kept us from full immersion — crocodiles and candiru, small parasitic creatures whose sole purpose on this planet is to swim up one's urethra and lodge there until surgically removed.

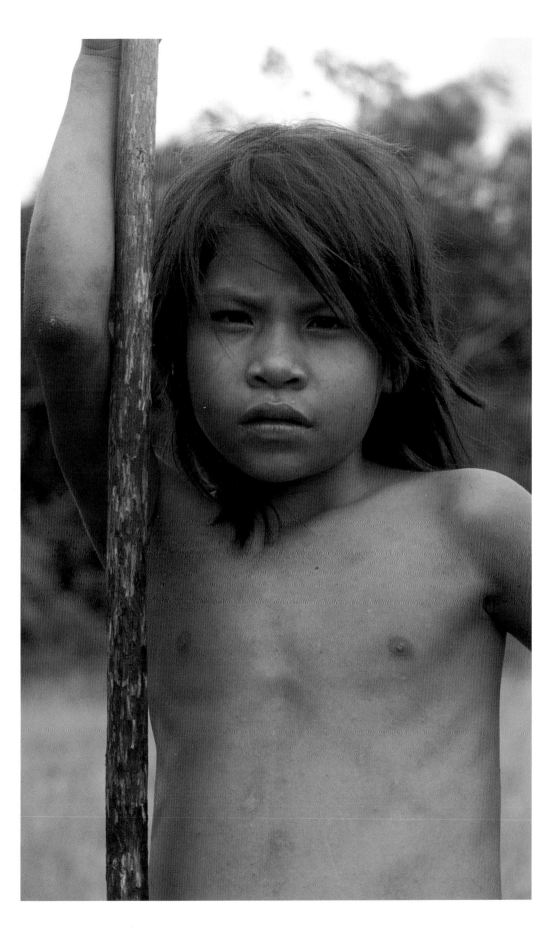

◄ Matses tribe girl out hunting with her brothers.
Amazon jungle, Peru.

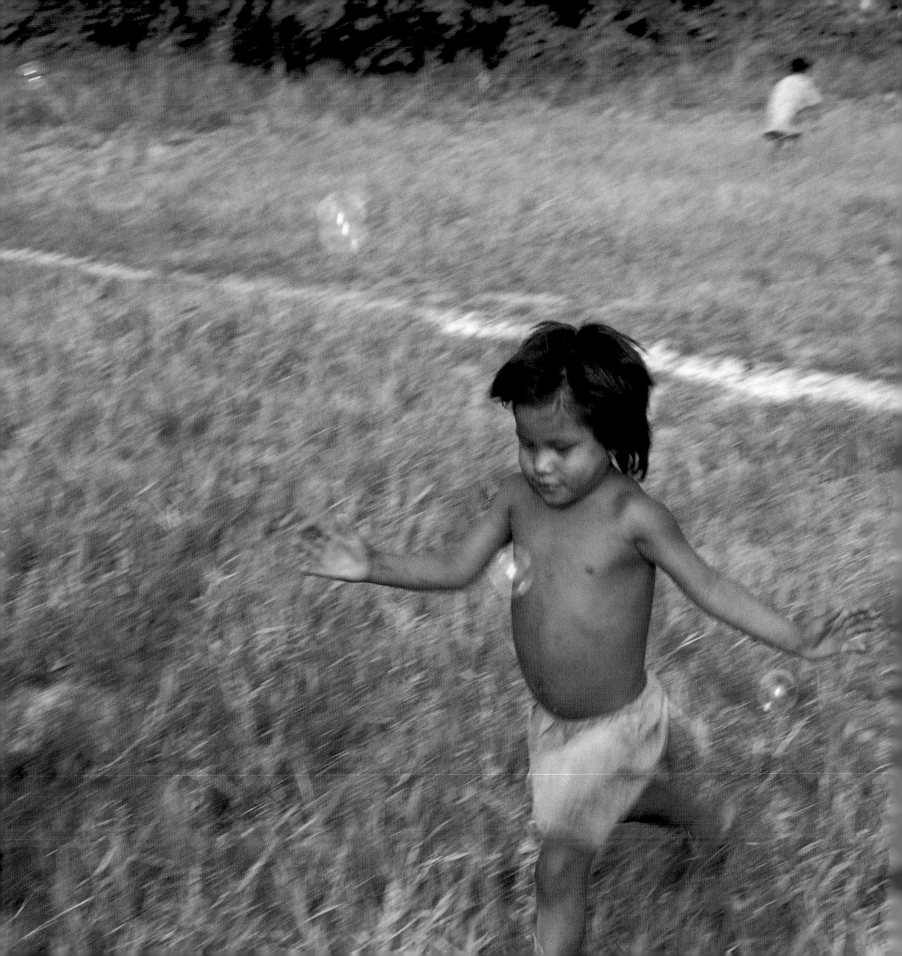

◀ Matses tribe children chasing soap bubbles near Angamos. Amazon jungle, Peru. I love seeing a child's joy in something so simple as chasing soap bubbles, and I've taken to carrying them wherever I go. Most of the youngsters I encounter have never seen them before. It's delightful to watch their fear turn to a wide-eyed, frenzied excitement as they realize they can actually pop them. Rather than blindly handing out candy and coins, I much prefer to interact with the children I encounter, to develop a relationship.

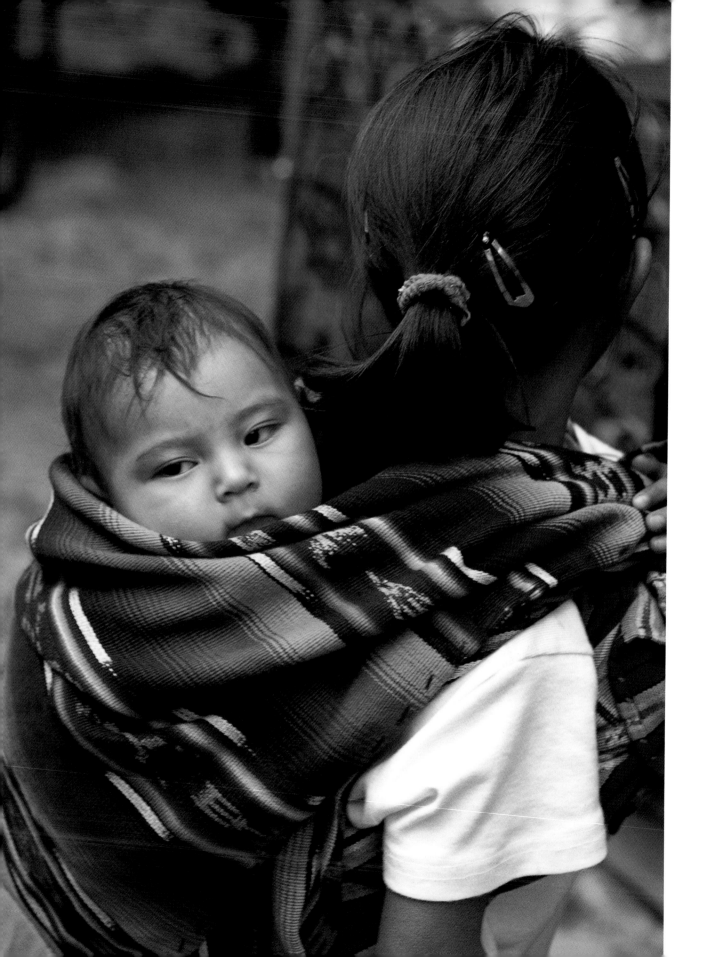

◄ Baby being carried by her sister in a colorful kaperraj shawl. The Chichicastenango market, Guatemala.

▼ Girl selling flowers with her mother. Chichicastenango market, Guatemala. Amid breathtaking mountain scenery, local vendors arrive by foot and bus the evening before to set up their wares for the Thursday and Sunday markets in Chichi. I watched as women with babies strapped to their backs set up bins of brightly colored flowers, fruit, vegetables, and bolts of colored cloth by the first light of dawn. In the early mist, villagers visit the surrounding churches, waving bowls of incense and lighting candles on the front steps.

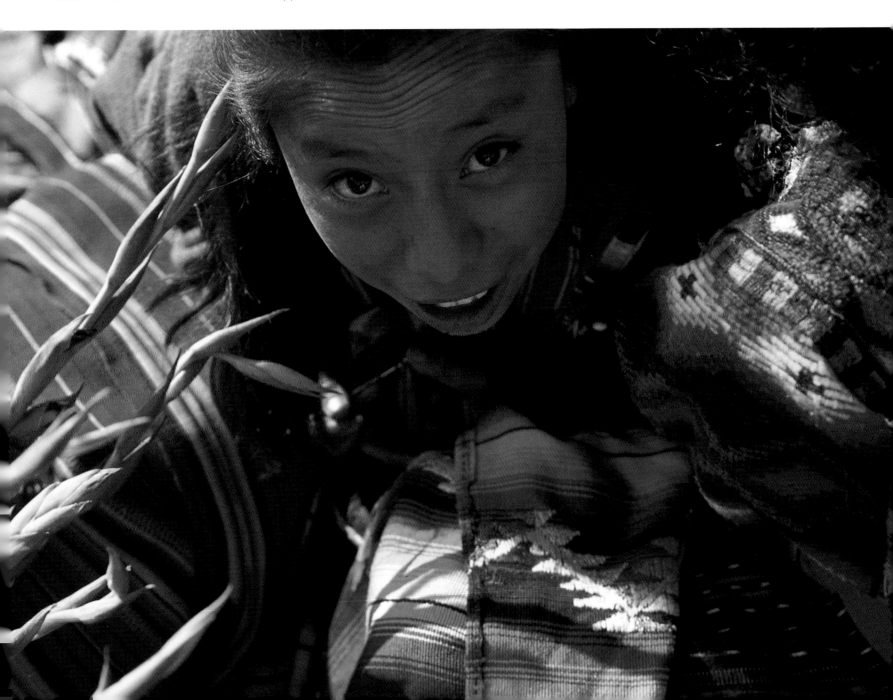

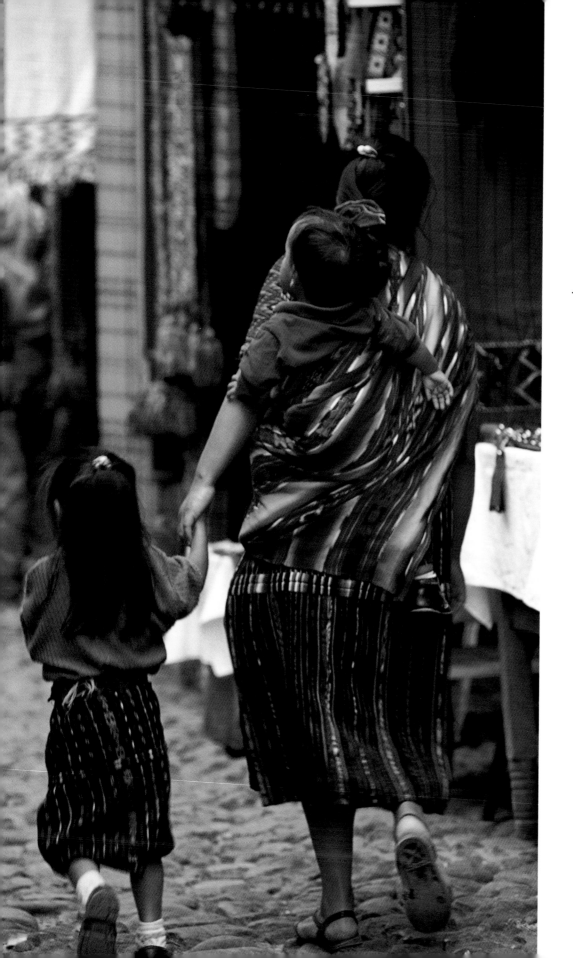

◄ Children with their mother at the market. Atitlán, Guatemala. Guatemala is still picking itself up after thirty years of brutal civil war. In 1996, the government signed a peace agreement formally ending the conflict, which had led to the death of more than 200,000 people and displaced more than one million from their homes, while thousands more went "missing." This same treaty called for equal rights for the country's indigenous people, including access to education and basic healthcare.

▼ Shoeshine boy. Chichicastenango, Guatemala. Decades of political violence and economic depression have left approximately 75 percent of Guatemala's families living in poverty. The strife has also caused at least 100,000 children — most of them indigenous Mayan Indians — to lose one or both parents. Most of these children have flocked to Guatemala City, the nation's capital, to work odd jobs such as shining shoes, selling food and newspapers, or directing traffic.

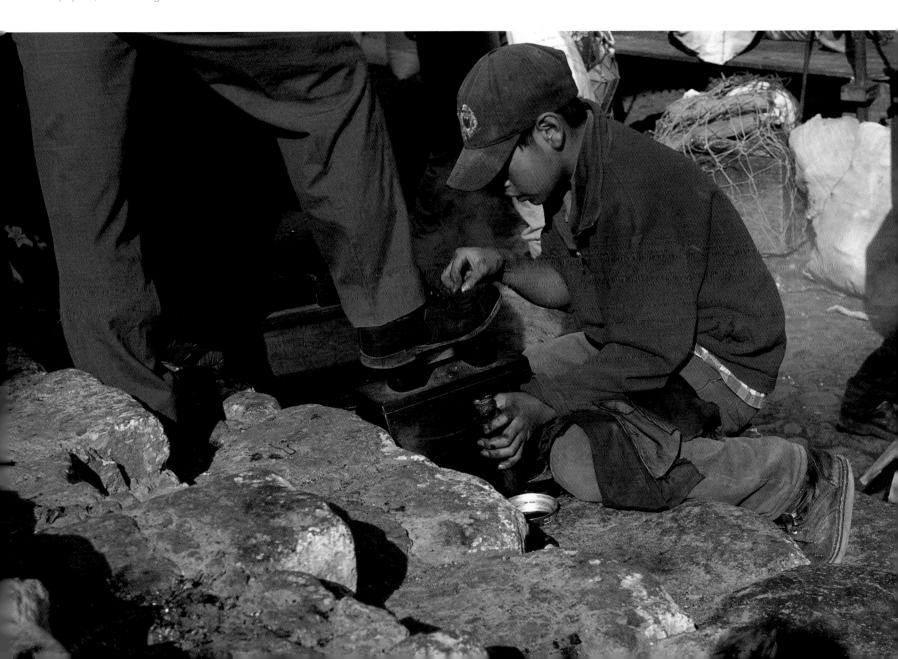

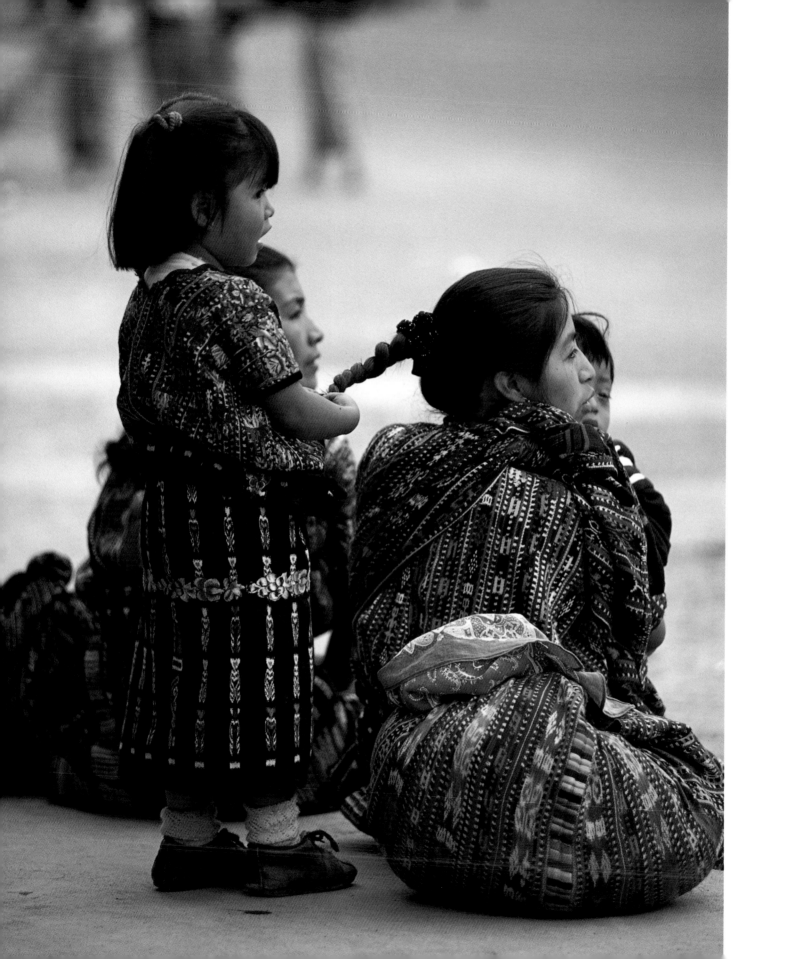

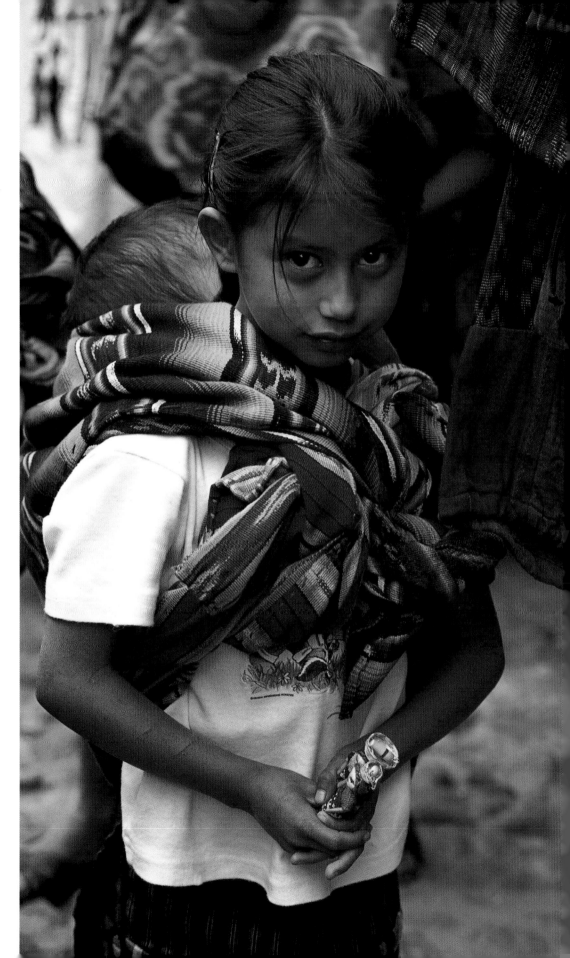

◀ Mayan children with their mothers. Lake Atitlán, Guatemala.

▶ Girl selling trinkets at the Chichicastenango market, Guatemala. Money from tourism is helping some Maya to improve their quality of life, education, and health, but it is also luring the younger generation away from their traditions and toward the tough and bustling cities.

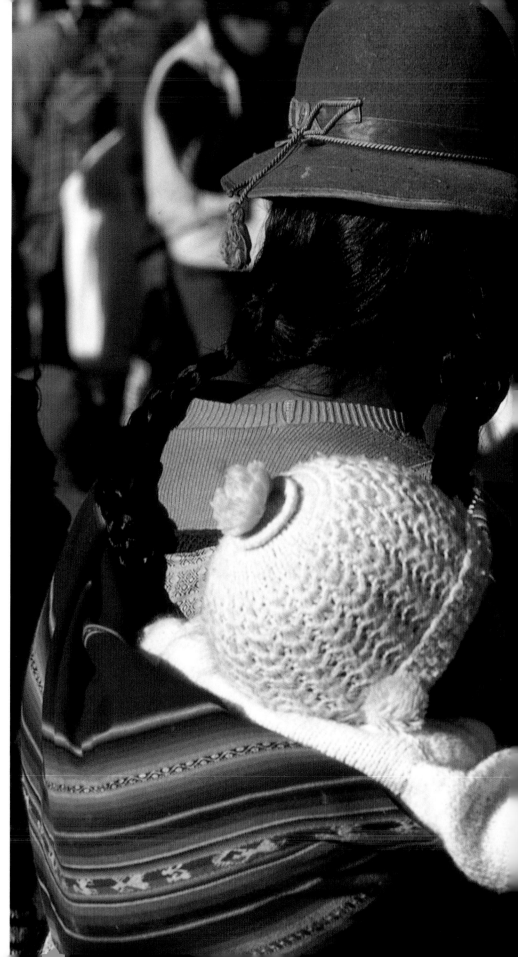

 Mothers with their babies in the El Alto Market. La Paz, Bolivia. Cholas, Indian women in their traditional dress of bowler hats and multiple petticoats, carry their babies through the thriving marketplace. I found everything for sale here from tables of rusty nuts and bolts, old radios, tractors, and bathtubs to an array of fruits and vegetables. They even offered bats, llama fetuses, and talismans for witchcraft use.

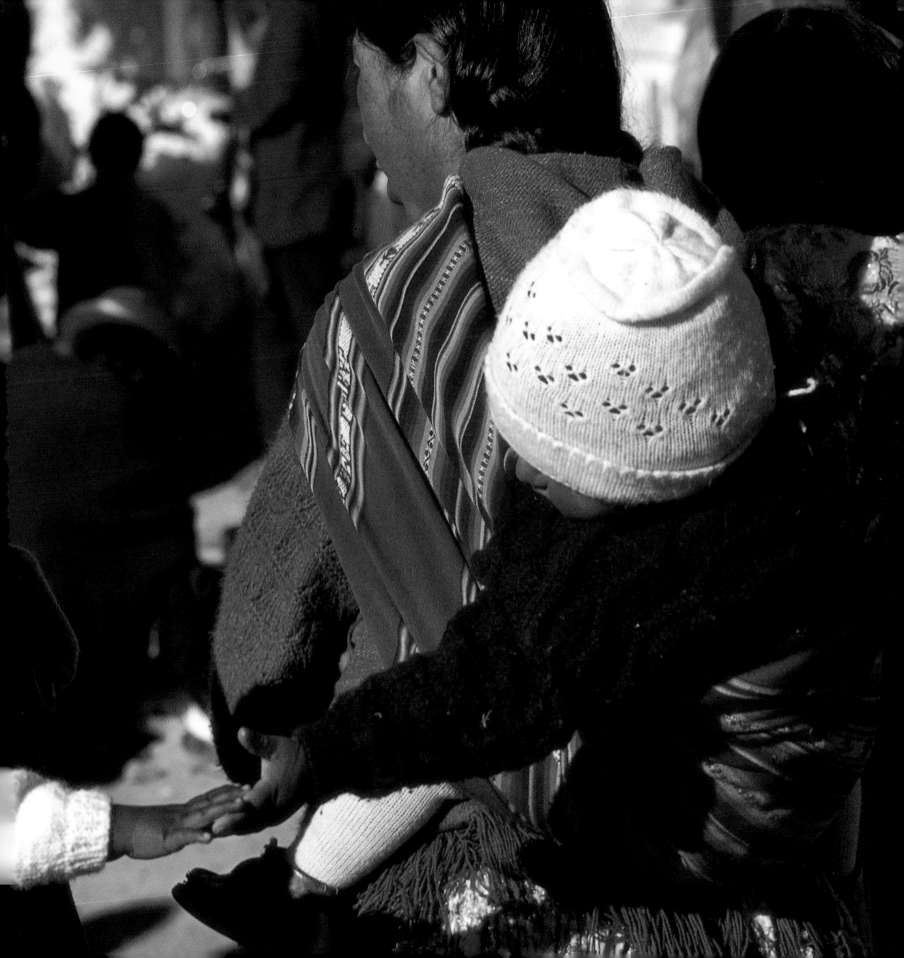

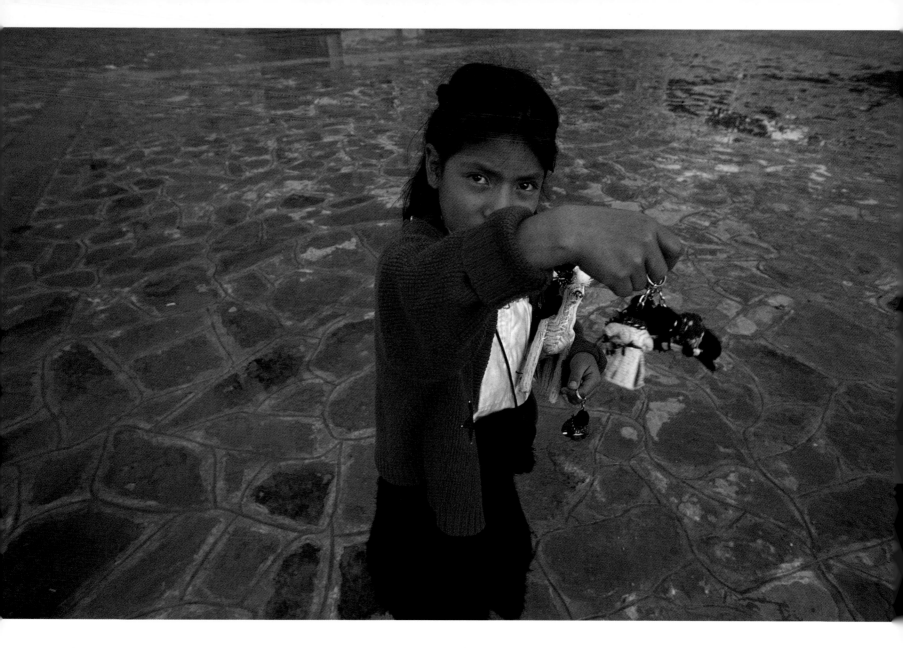

▲ Girl selling key-chains in the square. San Cristóbal de Las Casas, Chiapas, Mexico. As in many towns popular with tourists, in San Cristóbal I was constantly followed by tenacious children peddling whatever they could to make a few cents.

▶ Tzotzil girl in San Lorenzo Zincántan, Chiapas, Mexico. Each village in the Chiapas highlands has its own unique costume, and the predominant pink and purple colors of the Tzotzil costume are very distinctive. The women who were spinning wool when I arrived were excited to show off their beautiful shawls of brightly woven fabrics. They struck me as a fiercely proud people despite years of oppression by the Mexican government in response to their demands for cultural independence.

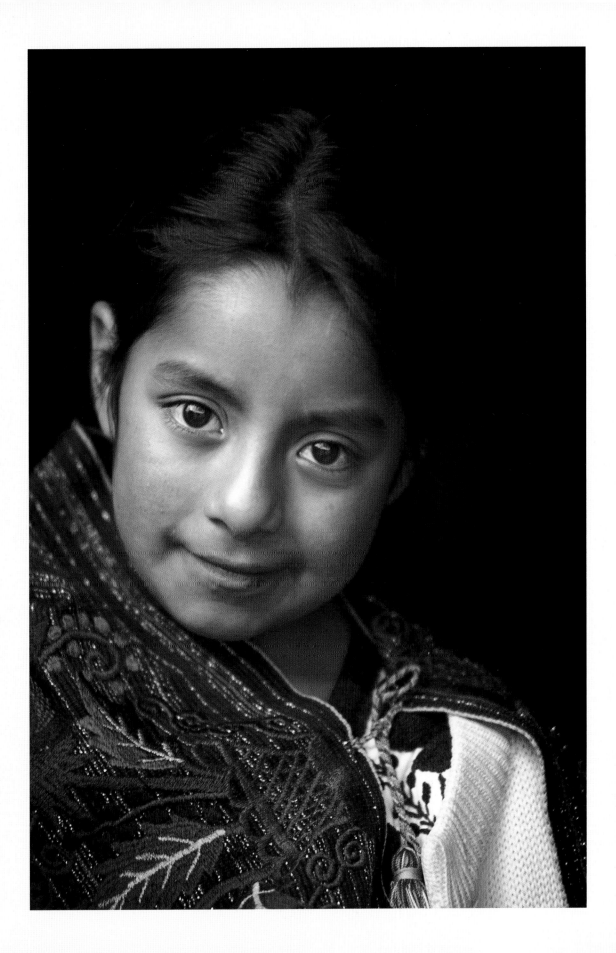

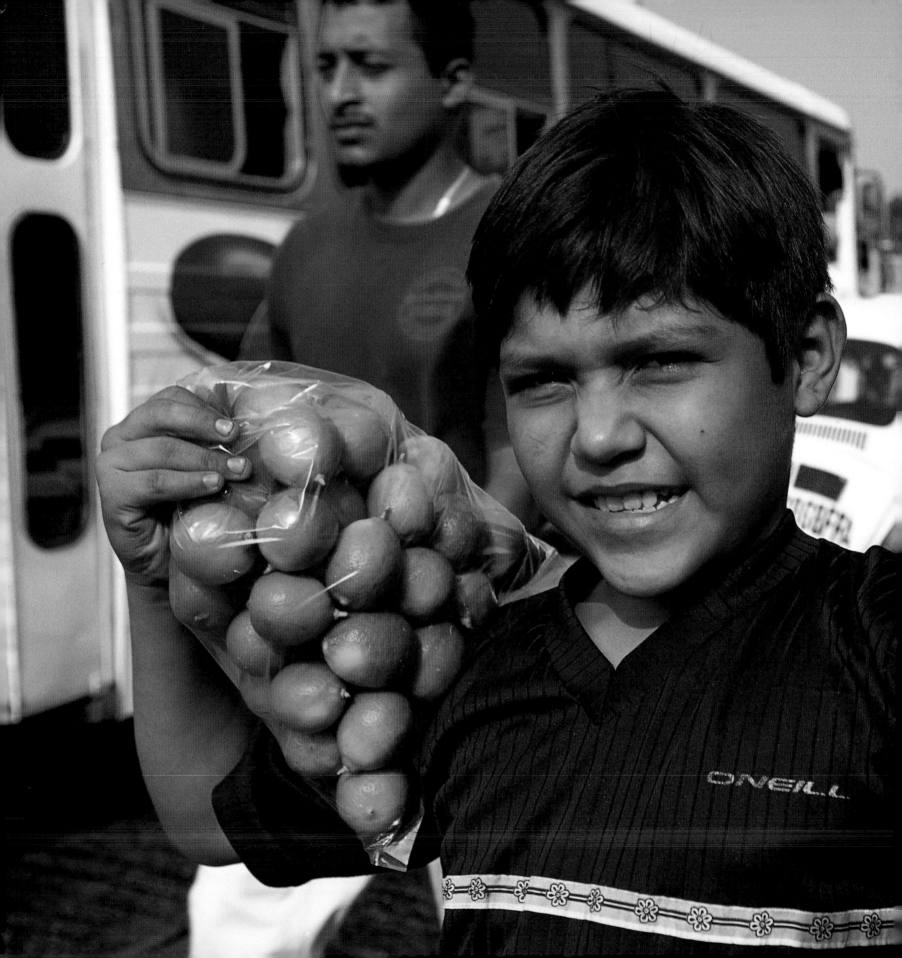

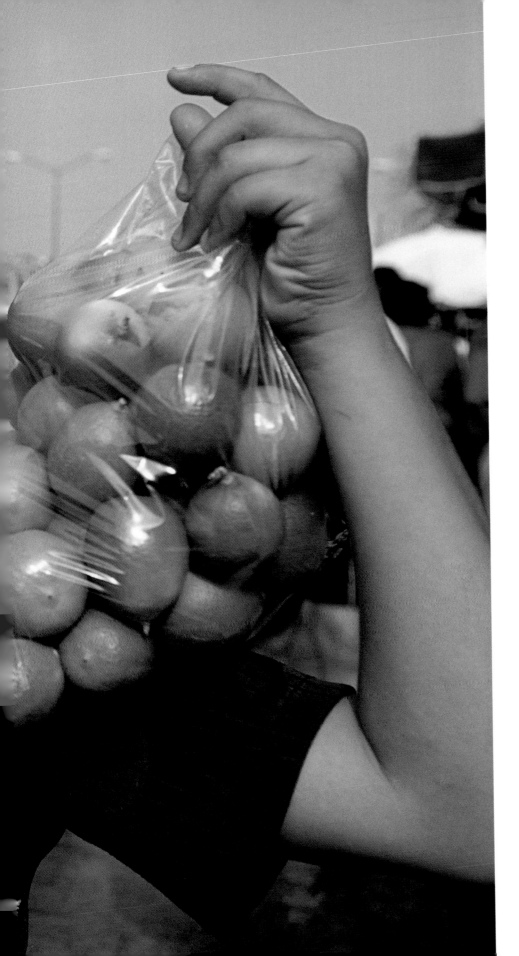

◀ Boy selling limes at the market. Old Acapulco, Mexico.

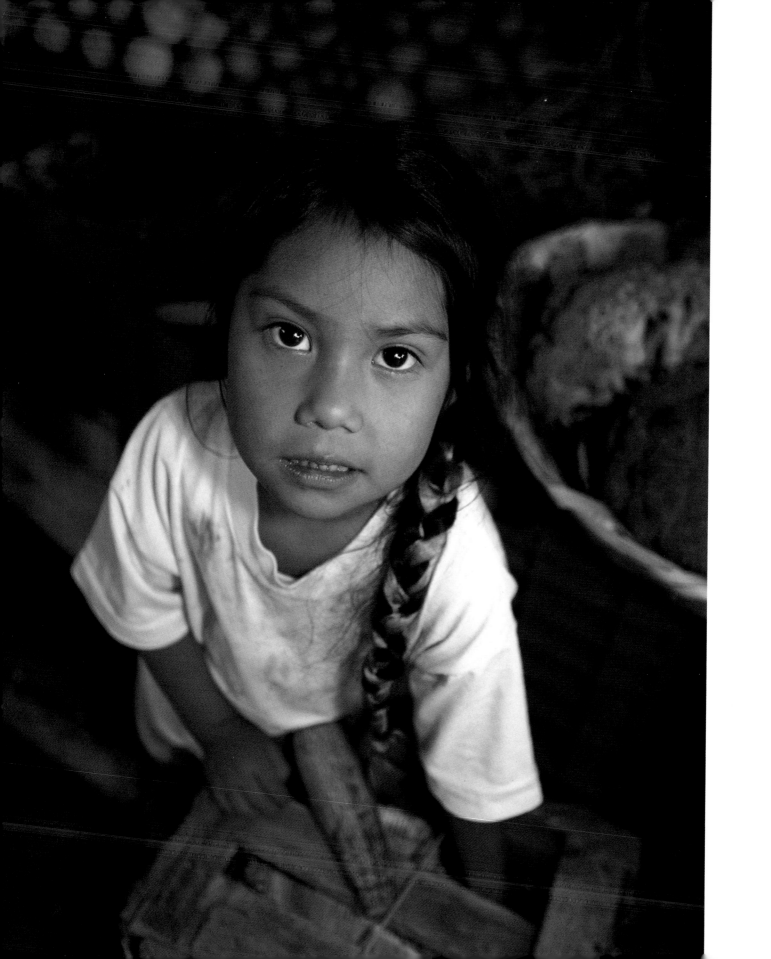

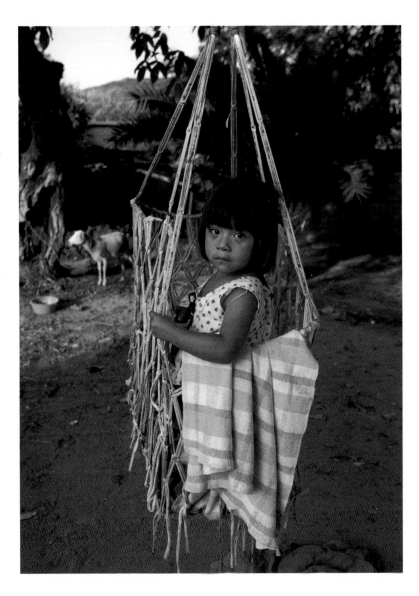

▲ Girl hanging in a basket behind her home in Oaxaca, Mexico. Roughly one-third of the 100 million people in Mexico are under eighteen.

◀ Young girl with her family selling vegetables at the local market. Oaxaca, Mexico. Many of the fifty or so indigenous cultures of Mexico have survived only because of their rural isolation. In the Oaxacan marketplaces the air is filled with the smell of chocolate, a key ingredient in their distinctive mole recipes, and vendors tout the merit of *mezcal*, supposedly the best in the world.

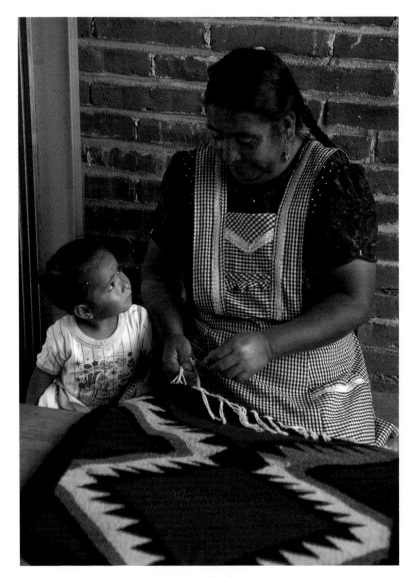

▲ Zapotec Indian woman weaving a carpet with her granddaughter. Teotitlán de Valle, Oaxaca, Mexico. Family ties are very strong in the Mexican culture, and children are always at their parents' sides. Oaxacan natives take great pride in their arts, from unique black pottery and carpet weaving to uniquely painted wooden sculptures. This family showed me the step-by-step process by which a carpet is made, from shearing the sheep, to growing the cochinea parasite on a cactus, whose blood makes their red dye. They pick indigo for blue coloring, various flowers for yellow. Most of these artisans work in their homes, where the craft is passed down from generation to generation.

63

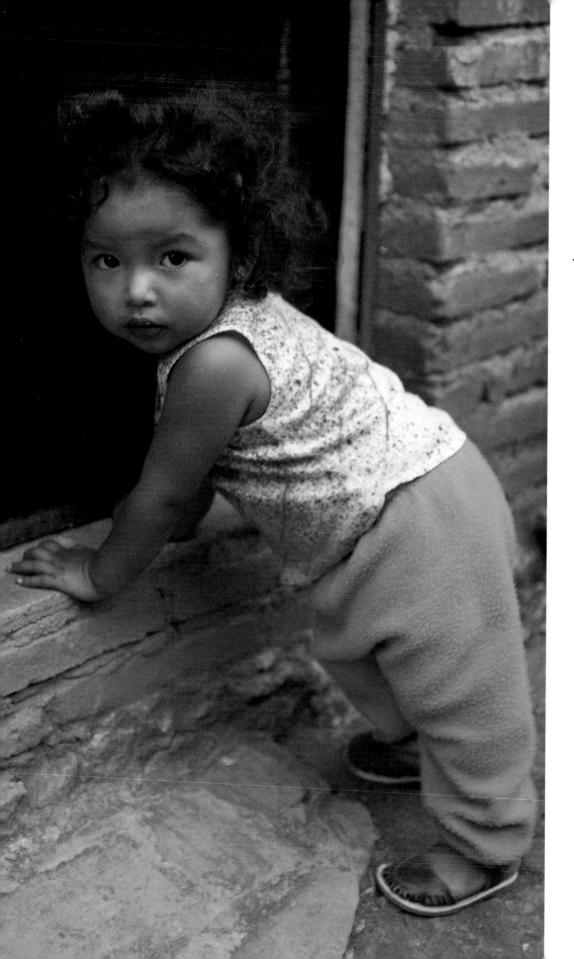

Girl playing at her home in Taxco, Guerrero, Mexico. This old silver-mining town's rambling cobblestone streets lead to bustling plazas lined with old colonial architecture. Silver jewelry shops struggle to survive as most of the town's mines are nearly depleted. Many Mexican towns I visited were facing similar economic challenges, forcing migration to the north.

Years ago, while working on a newspaper in San Diego, I photographed many border stories. Like a game of cat and mouse, the border patrol would chase the Mexicans who would cross the border to the United States and then suddenly dart back into Mexico to avoid being caught. At least 3 to 5 million undocumented Mexican nationals live in the United States, working mostly as agricultural laborers. Juan, whom I met in Guerrero, was one who considered making the crossing. "There are no jobs here, and with four children to feed, what choice do I have?" he asked. "There is more opportunity in the north. It is the only hope for my family."

Yesterday is gone. Tomorrow is yet to come. We have only today. If we can help our children to be what they should be today, they will have the necessary courage to face life with greater love. — MOTHER TERESA

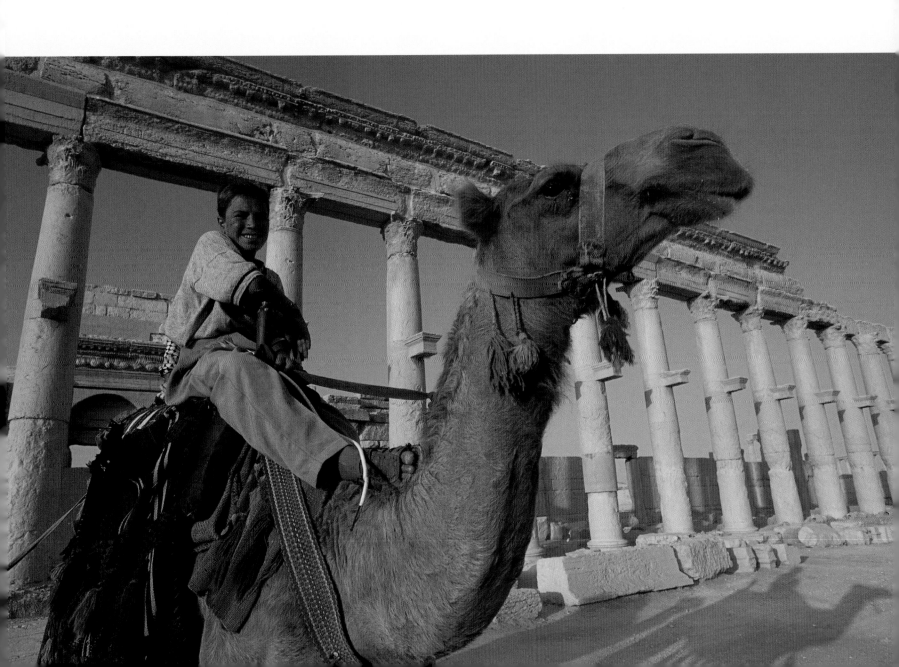

◄ Hallad, a fifteen-year-old camel driver. Palmyra, Syria. As I was talking with this Bedouin boy, his father appeared with a cartful of some of his ten brothers and five sisters. To help support his family Hallad offers camel rides to tourists at the ancient ruins of Palmyra, once an important link on the Silk Road from China and India to Europe.

► Twelve-year-old twins Abir and Fatima. Aleppo, Syria. Abir and Fatima's father wants them both to wear hijab, the traditional Islamic head covering, but Fatima refuses, preferring her jeans and T-shirt. Fatima seemed proud of her rebellion and both girls were very enthusiastic about being pho-tographed together.

Not all women wear the hijab in Syria. In fact I was surprised at some of their revealing outfits and contemporary lifestyles. Being a proud people, many expressed concern that my photographs would portray them to the rest of the world as being zealots or backwards.

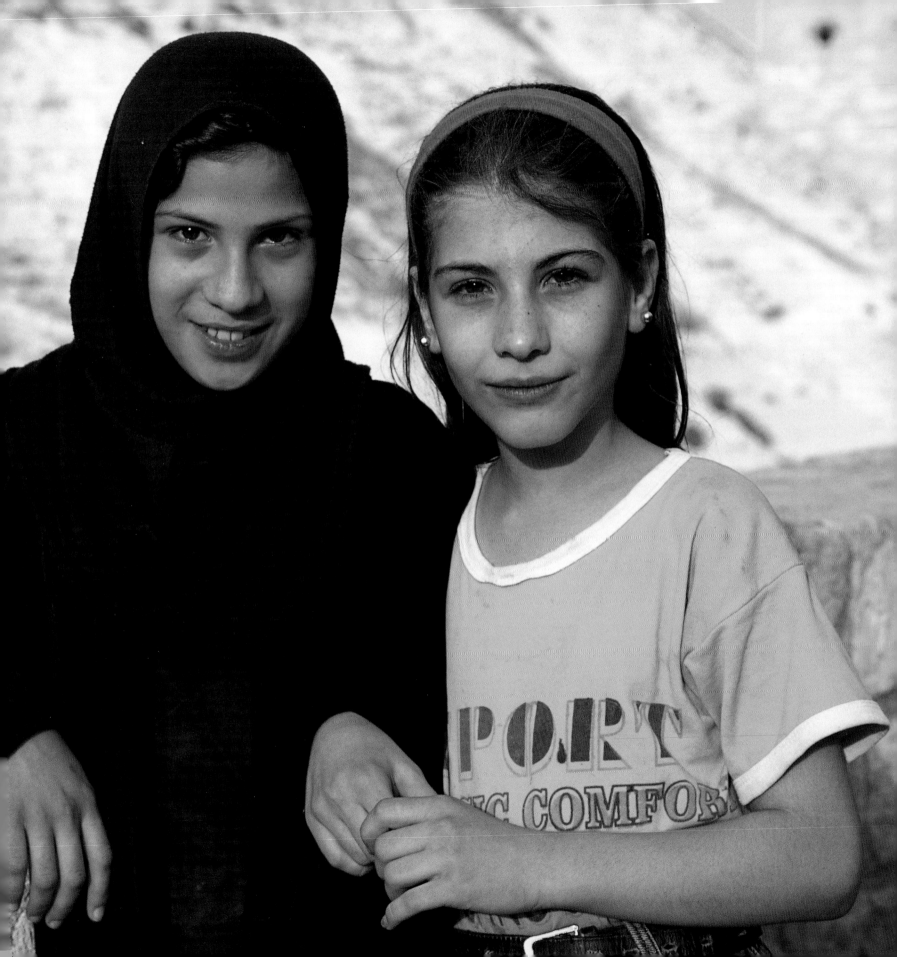

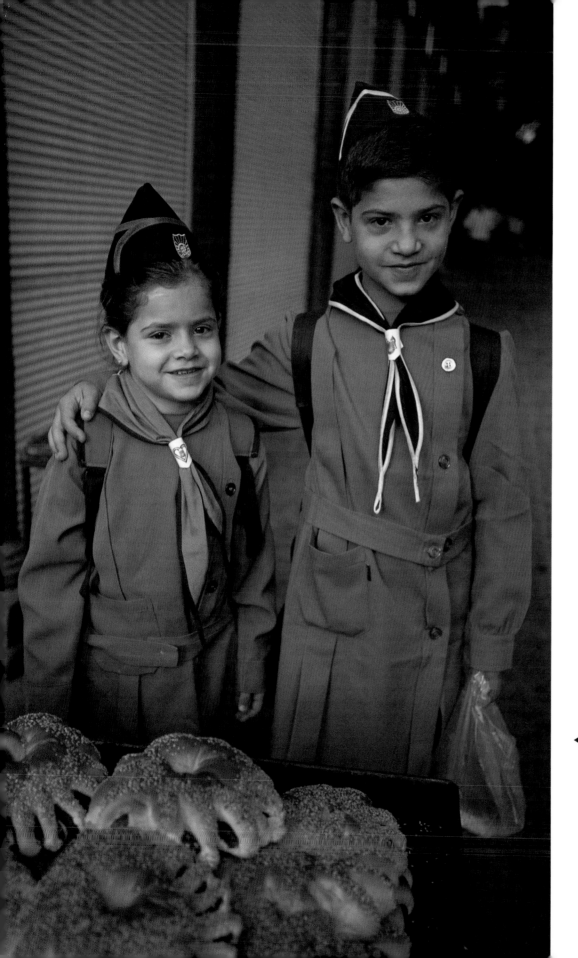

◀ Young schoolchildren in uniform. Damascus, Syria. I met this boy and his younger sister as they stopped to buy bread on their way to school. With free primary education, Syria has an estimated 70 percent literacy rate.

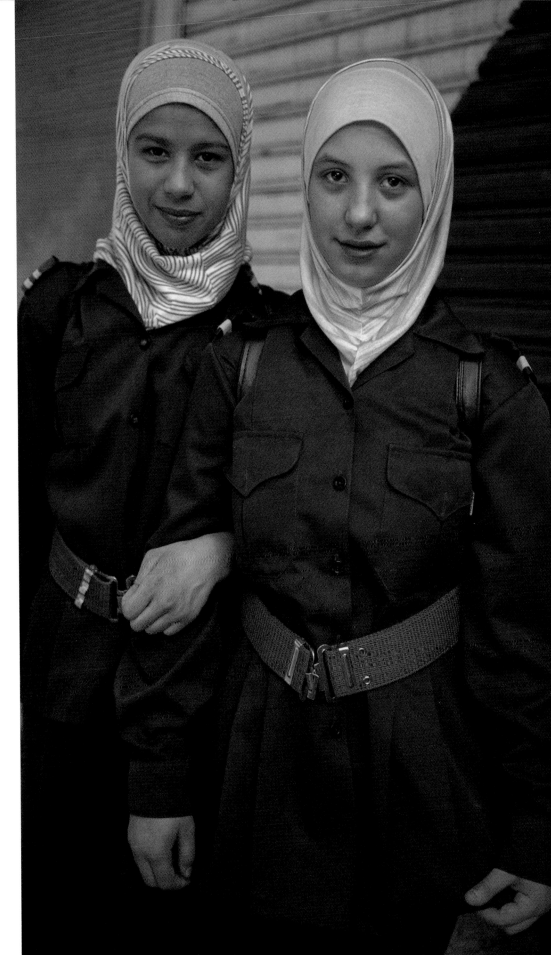

▶ Older girls in their school uniform. Damascus, Syria.
In the early morning, throngs of girls and boys in
their military-style school uniform flood the streets.
Like most young Syrians, these girls must enroll in
at least two and a half years of military service after
finishing school.

Boy selling bread in the Al-Jdeida quarter of Aleppo, Syria. Thousands of Armenians and other Christian minorities were driven out of Turkey in the twentieth century. As I entered the friendly cobble-stone streets of the Al Jdeida neighborhood, I was greeted by the traditional food and lifestyle they brought with them as they congregated in this historic quarter of Aleppo, a city in Syria's north.

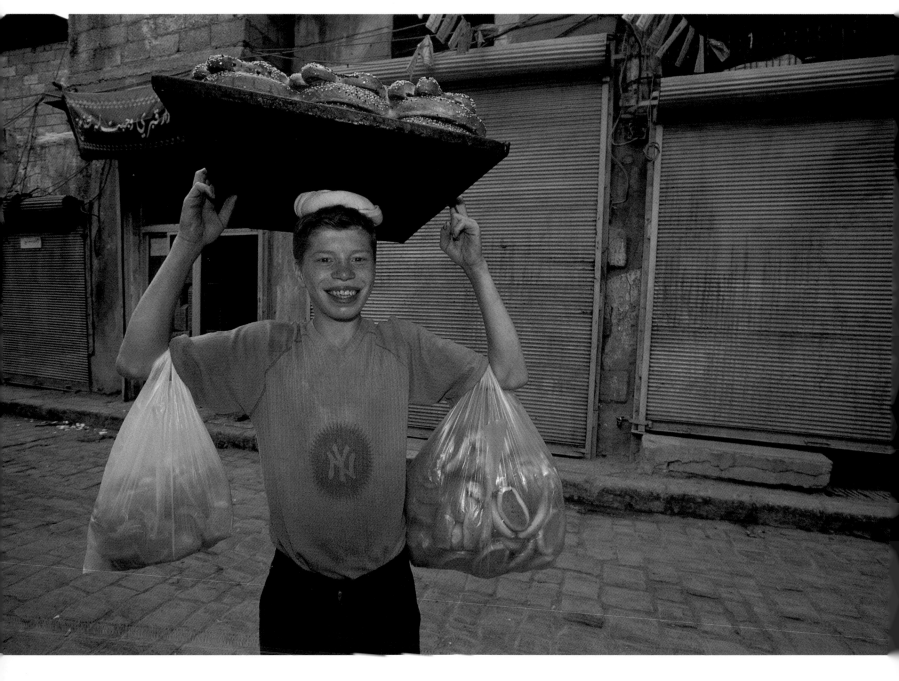

Sara, a fifteen-year-old from Iraq. The Sayyida Zeinab Iranian Mosque, Damascus, Syria. As I travel, especially in the Middle East, I appreciate that people are almost always able to separate me from government policies, just as I am able to do with them. On one of my recent trips I visited an old Iranian mosque in Syria. In order to enter I had to wear a hijab, a full-length robe and head shawl, which I had a difficult time keeping on. Laughing, an Iraqi woman stopped to help me with my struggle. She invited me to pray with her family and afterward I shared with them photos of mine. I was captivated by the beauty in her daughter Sara's eyes, a younger version of herself. When you look into the eyes of a child, politics can't help but become personal.

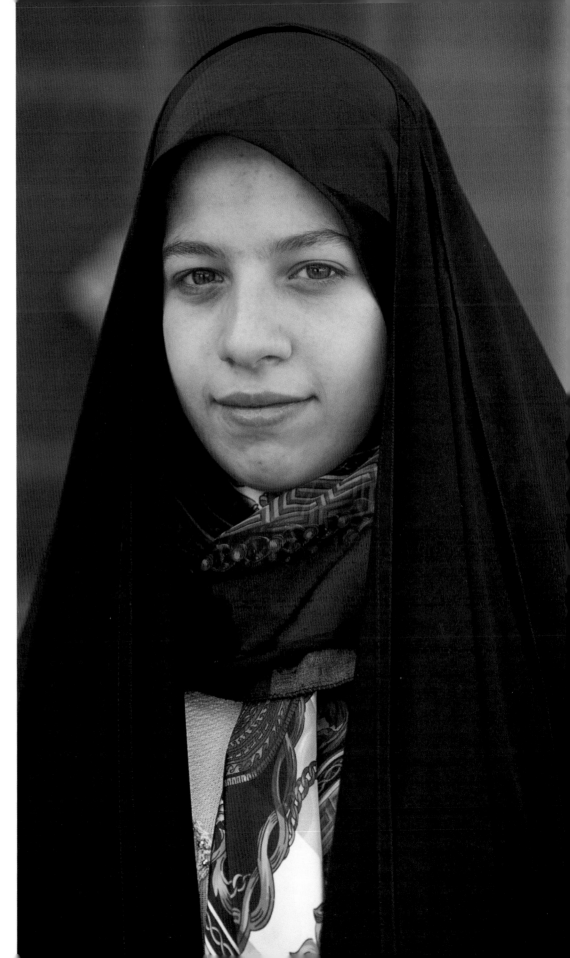

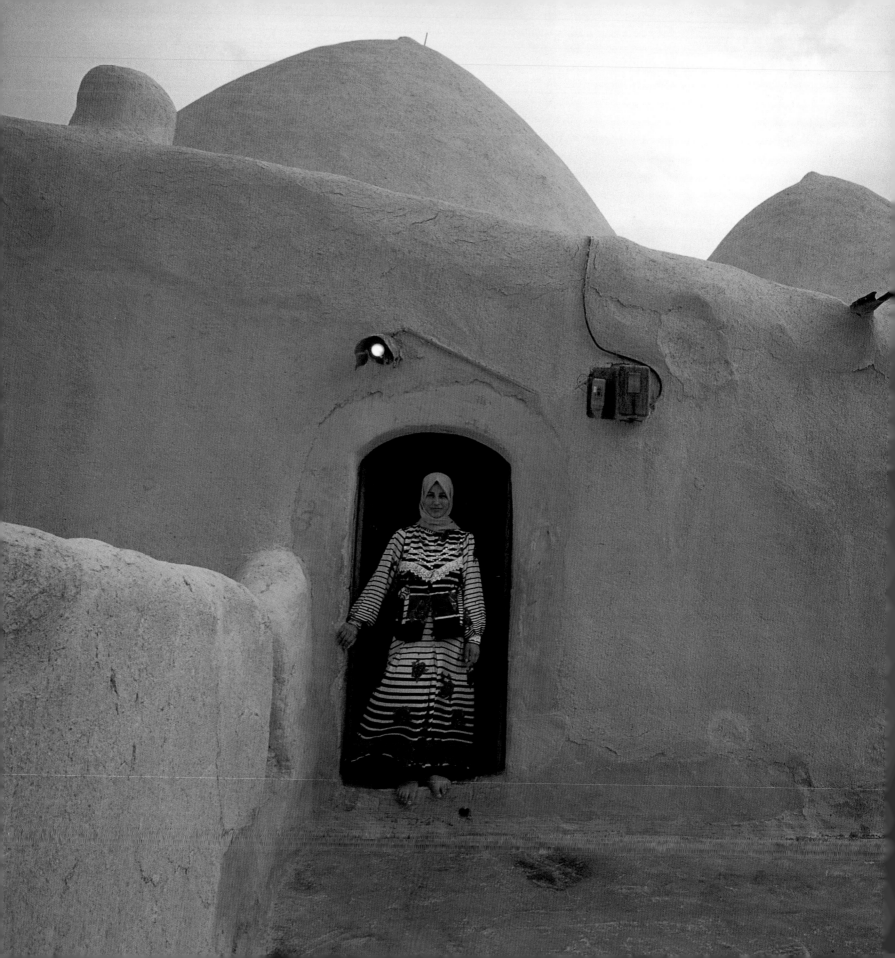

◀ Girl living with her family in a two-hundred year-old beehive house. Desert near Ebla, Syria. In this arid desert east of Hamma, inhabitants have adapted to the climate of hot days and cool nights with conical houses with thick walls and single entrances.

I left Aleppo and drove out to the desert with a driver in an old 1950s Studebaker as spacious as my San Francisco apartment. As we double passed cars around blind curves I gripped my seat, suggesting that this might lead to an accident. Mohammed shrugged and simply replied, "In sha 'allah." I decided then it might be a good idea to avoid driving on roads where "if God wills it" is the philosophy.

73

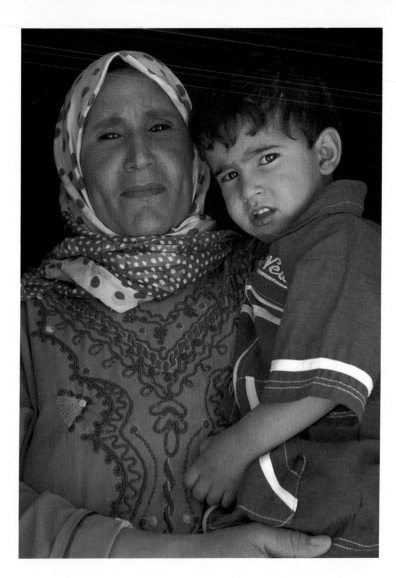

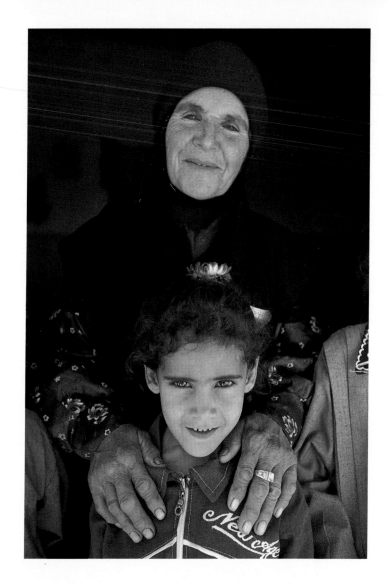

▲ A Bedouin mother and son near the Dead Sea, Jordan. Frayal works as a weaver at the Bani Hamida Women's Weaving project, supported by Her Majesty Queen Rania Al-Abdullah of Jordan. Her income has allowed Frayal to send all six children to school. "I don't want my children herding goats or living in a goat-hair tent," she tells me. "I want them to get a good education, to become doctors and engineers."

▲ Haya, a Bedouin grandmother and her granddaughter near the Dead Sea, Jordan. Six-year-old Shorok (meaning "sunset") has just returned home from school. Jordan is one of the better-educated Arab countries: about 87 percent of Jordanians are literate and about 97 percent attend primary school.

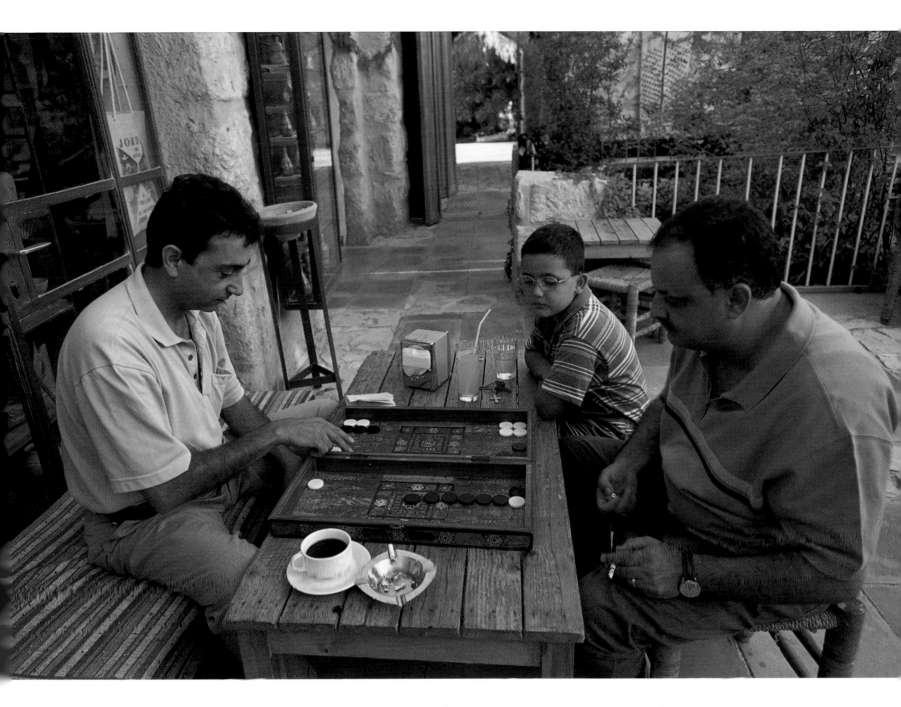

▲ Two men playing backgammon. Madaba, Syria. A
boy looks on intently as his father and a friend
spend a leisurely afternoon playing backgammon, a
popular game throughout the country.

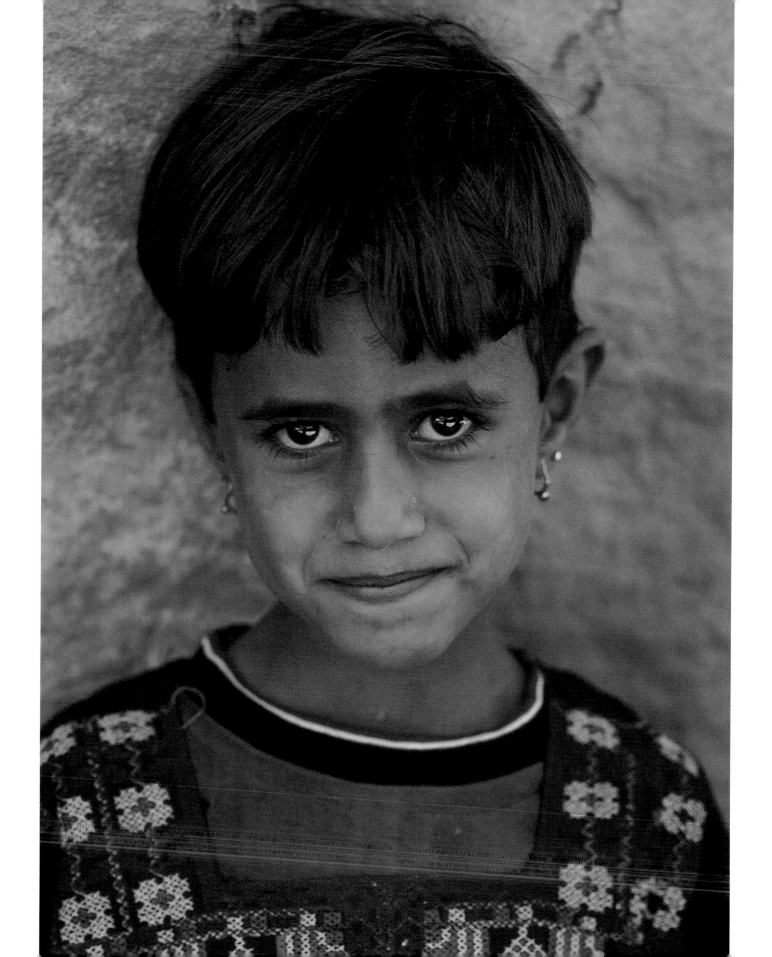

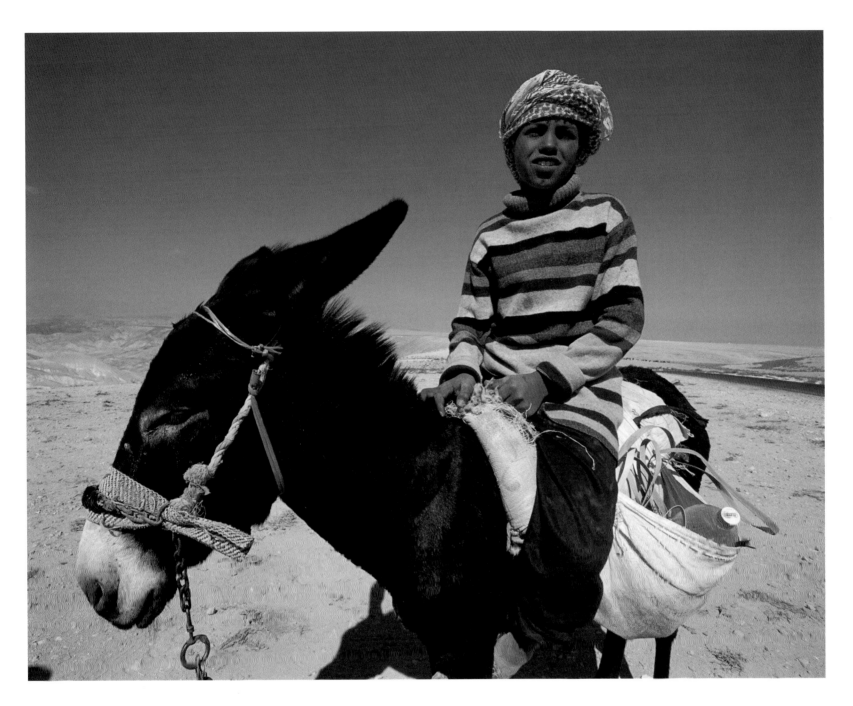

◀ Bedouin girl. Bedouin encampment in the desert of Wadi Rum, Jordan. While on a camel ride, I stopped to have tea with these nomadic desert dwellers. They lived in a black goat-hair tent — beit ash-sha'ar, literally a "house of hair" protecting them from the blazing sun. While the men saddled my camel, their wives spun wool and the children played on the nearby red rocks and sand dunes.

▲ Joseph, a Bedouin boy riding his donkey in the Wadi Rum desert, Jordan.

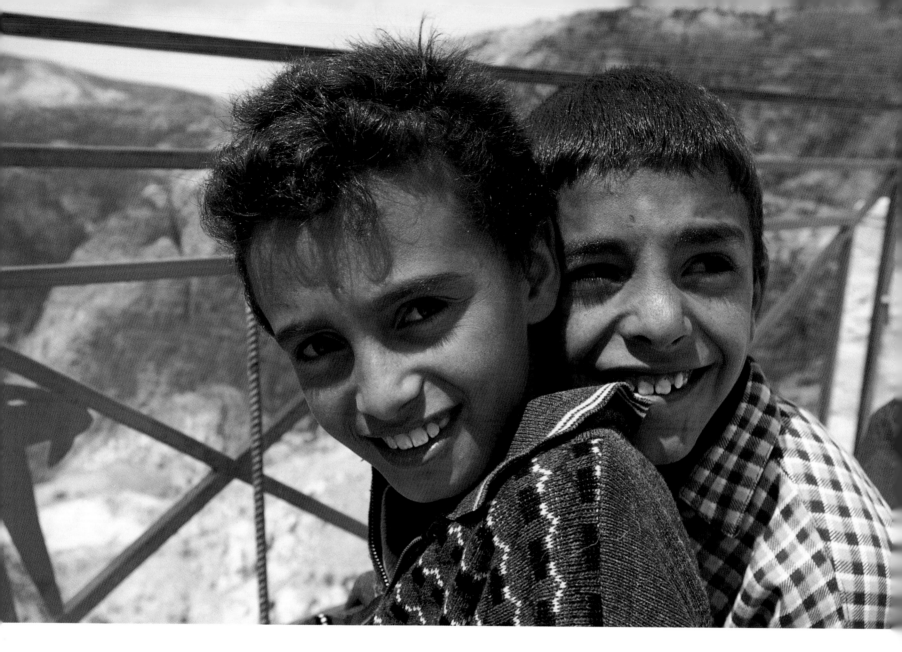

▲ Two schoolboys on a field trip in the Dana Nature
Reserve, Jordan. Accompanied by their teachers
and classmates these two friends were happy to
have a day out of school to explore the scenic
nature reserve and archeological sites. Excited
to meet an American, they peppered me with
questions: Did I support the idea of impending war
on Iraq? And being from California did I ever see
Arnold Schwarzenegger or Sylvester Stallone
walking down the street?

▼ Driving bumper cars in Amman, Jordan. Although the majority of the population is Muslim, Jordan is officially secular, with the right to freedom of religion guaranteed by their constitution. Compared to their neighbors in Muslim countries like Saudi Arabia, the women of Jordan enjoy more freedom and privileges. They have access to education, vote, work in business, and drive cars.

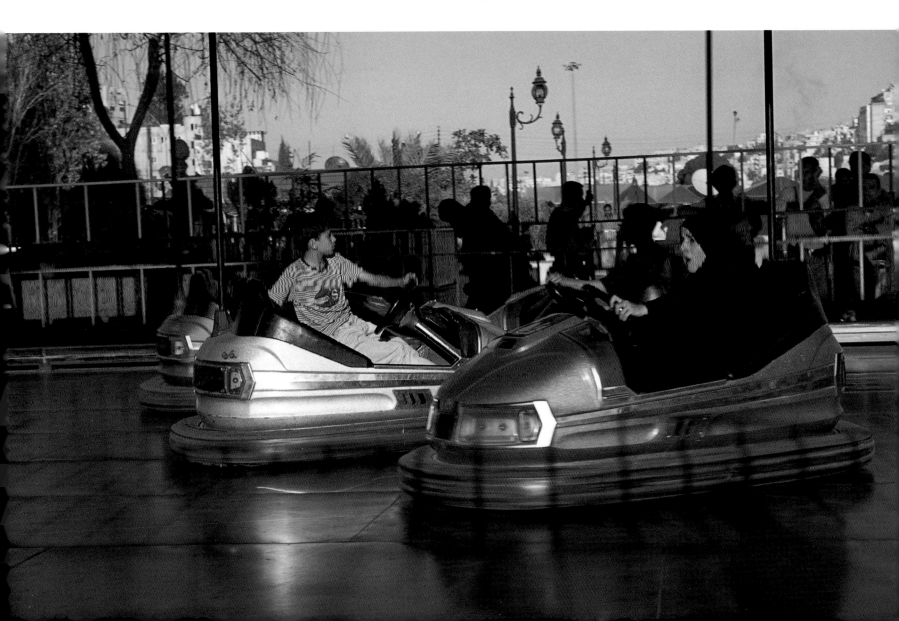

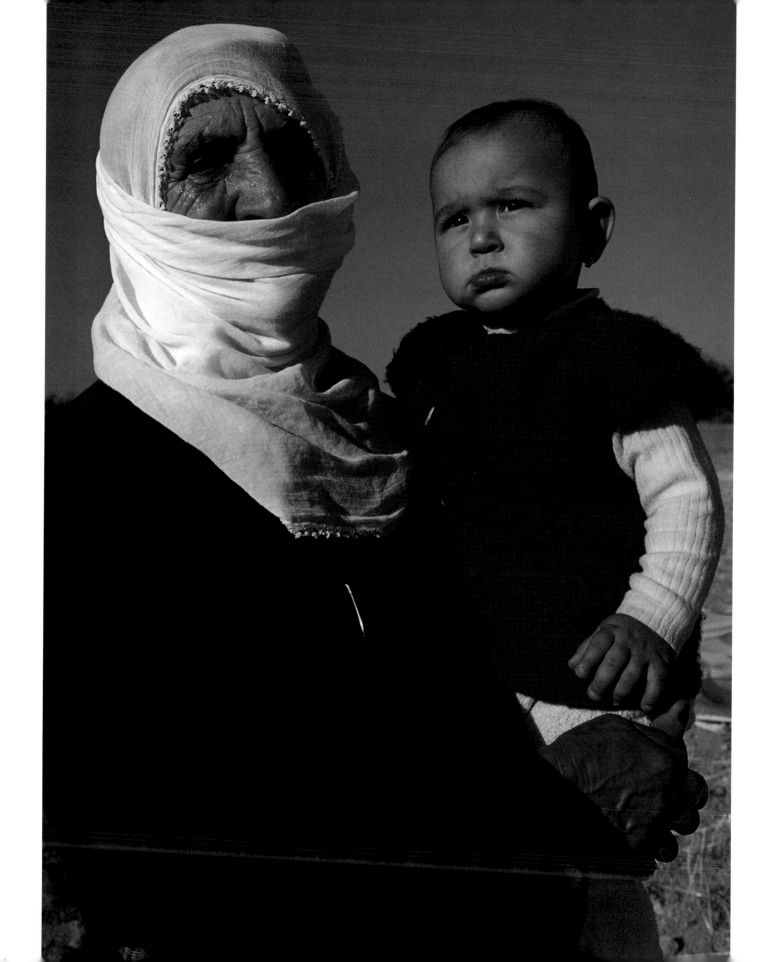

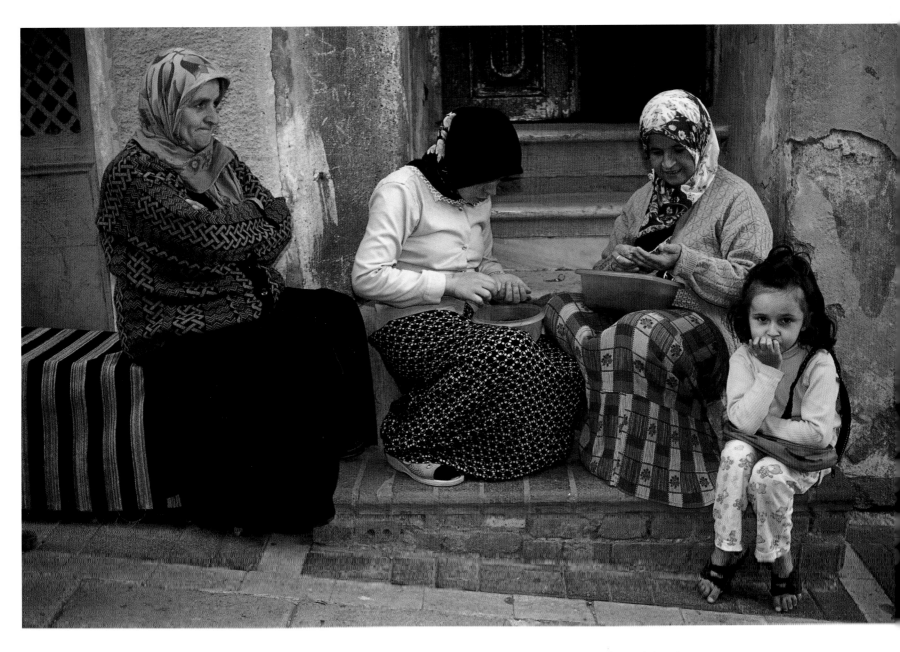

◄ Grandmother and her granddaughter. Cappadocia, Turkey. I spent the morning hot air ballooning over the prominent chimney rocks of Cappadocia. When we landed in a field this woman ran out with her granddaughter to show her the giant colorful balloon filled with odd-looking people.

▲ Girl sitting with her family in front of their home. Sultanbeyli, Istanbul, Turkey. The women of this old-world neighborhood are stringing prayer beads together. We could only communicate through smiles; they handed me a strand to keep as I sat with them.

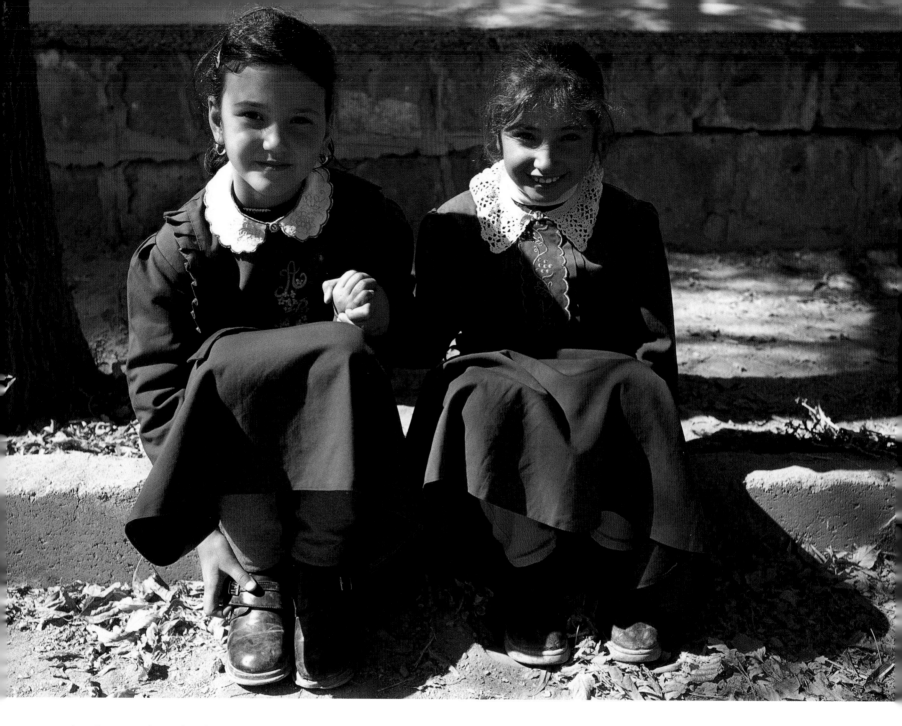

▲ Sisters Melva and Mehram Hurhan at Kaymaku School. Cappadocia, Turkey. Precariously balanced between East and West, two-thirds of Istanbul lies on the European side of the Bosphorus and about one-third on the Asian side, which often puts this country in a difficult worldwide military position. "When you start a fire with your neighbor, it usually spreads to your home," says one Turkish politician.

I went to Turkey just after September 11, 2001, with some initial reservations about visiting a Muslim country at that time. Sure enough, the country was devoid of tourists, although the Turkish people couldn't have been more welcoming. Many actually came up to me in the street to hug and kiss me, even giving me a pair of shoes in the market. One woman with tears in her eyes told me, "We all cried for you. Each person in his or her own way let me know how sorry they were about the horrible events that had befallen our country and our world.

Compassion can be put into practice if one recognizes the fact that every human being is a member of humanity and the human family regardless of differences in religion, culture, color and creed. Deep down there is no difference.

— THE DALAI LAMA

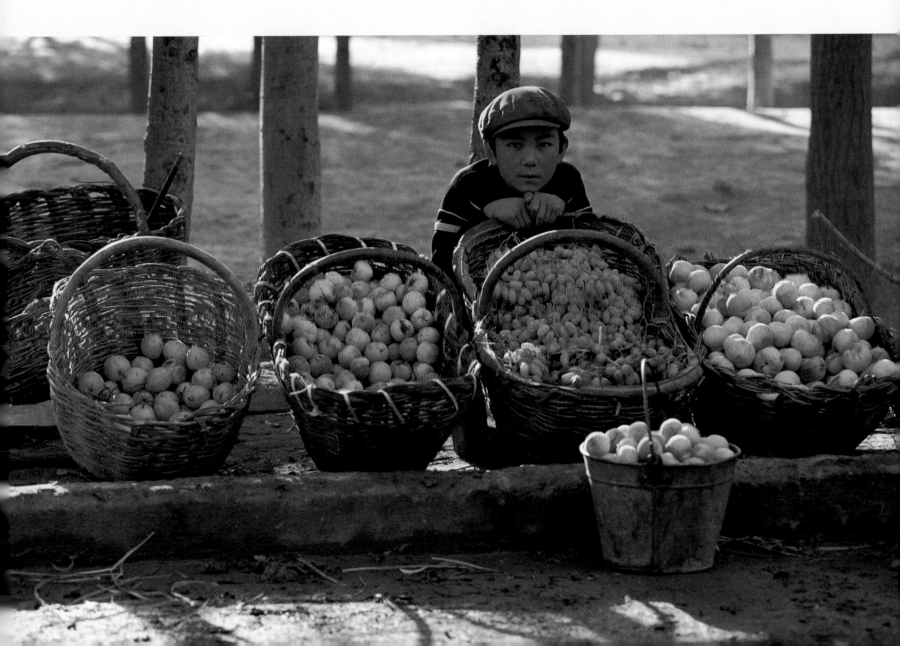

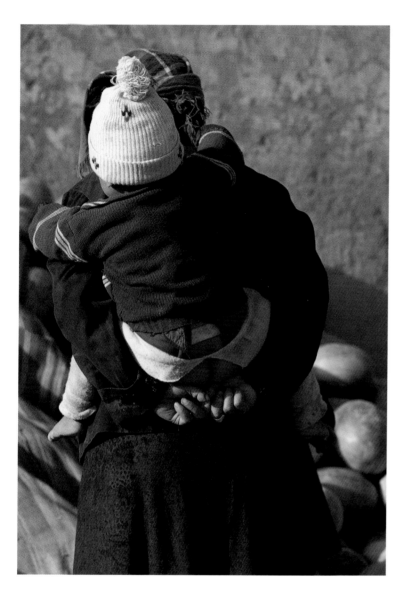

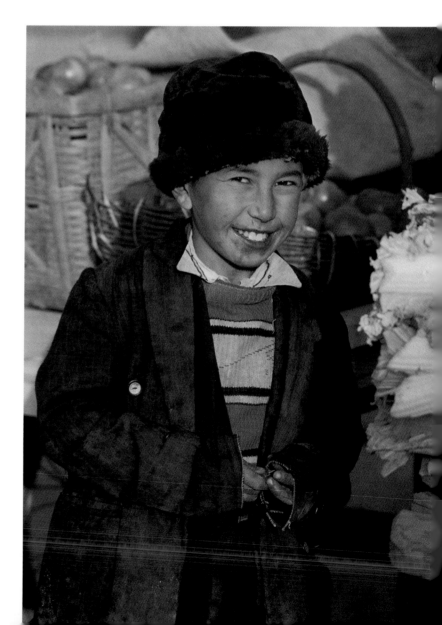

◀ Uygur Muslim mother and child. Lanzhou, China. Open slit pants are China's answer to diapers.

▼ Uygur boy selling vegetables in the Kashgar market. Xinjiang, China. In the slanting early morning sunlight, heavily laden wooden pony-drawn carts trundled down the dusty road toward the bustling open-air market in Kashgar. It was as if time hadn't passed in this medieval town for centuries and I felt glaringly out of place in my Gore-Tex jacket. Amid the variety of fresh produce and livestock for sale, goat-head soup simmered in steamy pots, medicine sellers displayed remedies varying from dried salamanders to monkey skins, and snowy fox-skin fur hats hung from racks.

◀ Uygur boy selling grapes by the side of the road. Turpan, Xinjiang Province, China. The largest minority group in Xinjiang are the Turkic-speaking Uygurs, one of fifty-six officially recognized ethnicities living in China. They have built their culture around the Silk Road, which initially brought Buddhism to China nearly two thousand years ago. A thousand years later, Islam came to Xinjiang by the same route, giving the Uygurs their current faith and alphabet, which they proudly defend. Turpan locals claim many of them live to be more than one hundred years old. They attribute their longevity to drinking milk, eating grapes, and enduring their dry climate.

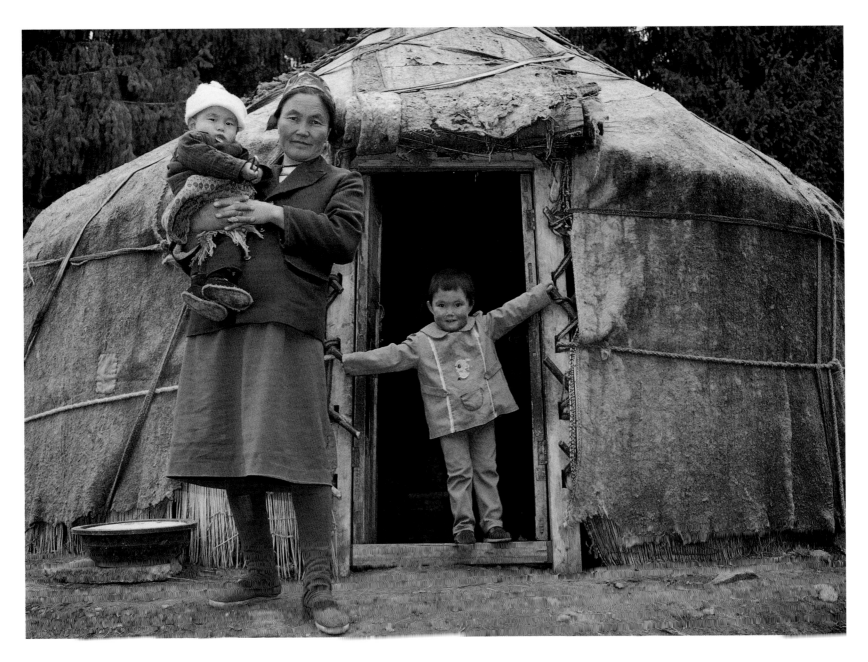

▲ Kazakh family in their yurt. Heaven Lake,
Xinjiang, China. After a three-hour journey
from the Muslim town of Urumqi, I stopped
to drink mare's milk with this Kazakh family.
They had set up their yurt and were grazing
their horses beside the azure waters of
Heaven Lake. As I played with the children,
some who had long noses and green or
blue eyes, I was once again struck by the
cultural diversity I was finding along the Silk
Road.

85

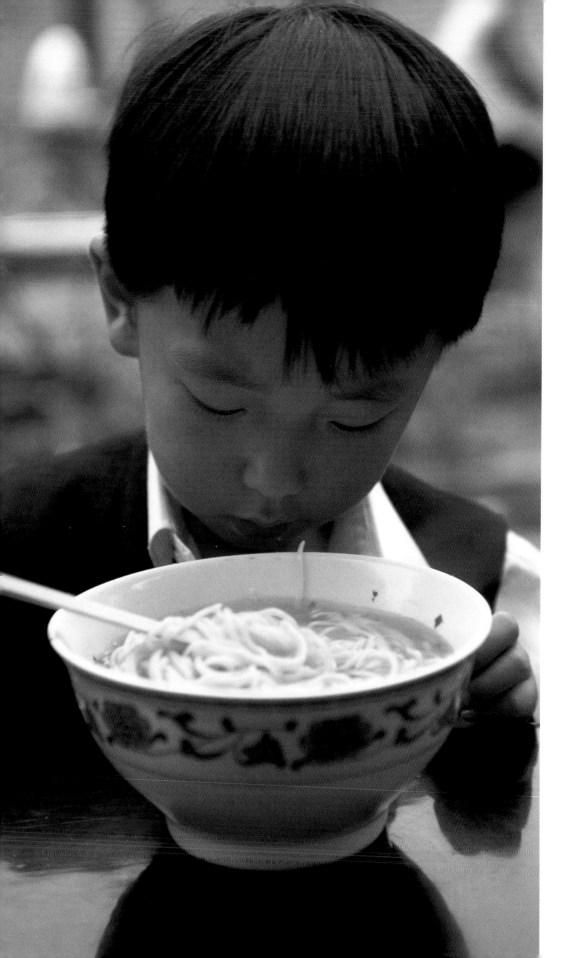

◄ Boy eating noodles in the local street market. Lanzhou, Gansu, China. This area is famous for its noodles, which are made from scratch in the local restaurants. I watched as the Uygur Muslim men pulled arm-length strips of taffy-like pasta for hours on end. This boy slowly worked through a bowl his grandmother bought him, wondering how he would ever get through it.

► Young boy and his grandfather. The Forbidden City, Beijing, China. China has the largest population in the world, with more than one billion people. Since 1980 a one-child-per-couple law has limited population growth, although urban couples who have seen economic prosperity in recent years have opted to have a second child and pay the fine. The desire for male children is still deeply ingrained, which often results in girls being abandoned or aborted.

▲ A young girl captivated by the merchandise at the
local bird market. Lanzhou, Gansu, China.

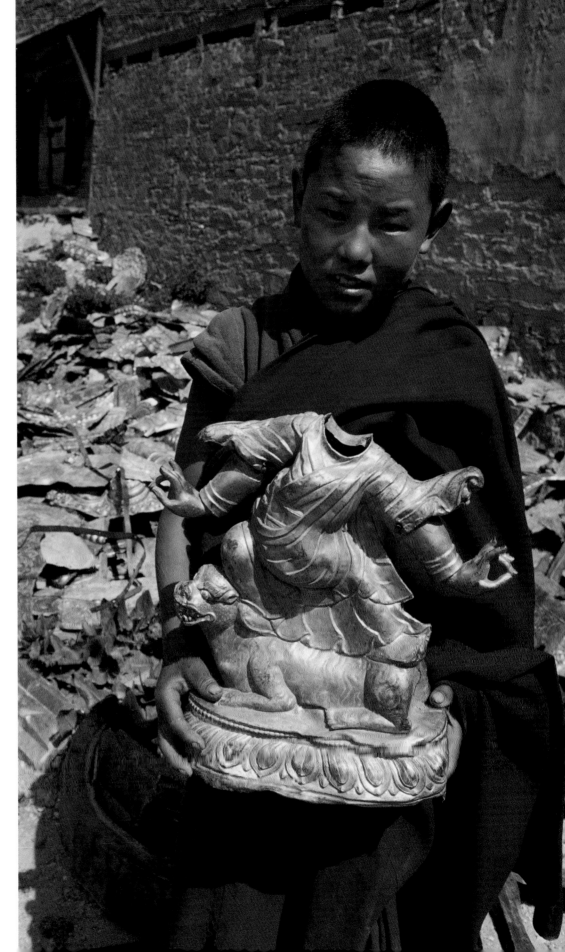

▶ Monk with Buddha statue, Gandon Monastery, Tibet. This young monk holds the remains of a Buddha statue sitting in a rubbish heap of religious artifacts. More than sixty five hundred monasteries have been destroyed by the Chinese, yet Buddhism remains the backbone of Tibetan culture. Gandon Monastery is in the process of being rebuilt, although religious practice throughout Tibet is still under scrutiny.

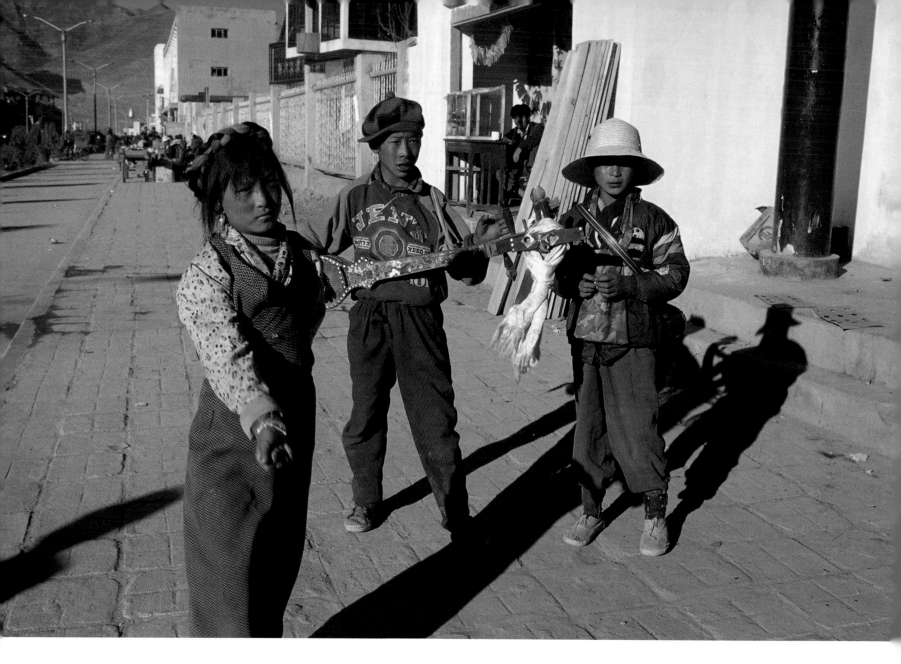

▲ Tibetan children playing music for money in the streets. Tsethang, Tibet. To most Tibetans, even more threatening than the destruction of monasteries are the Chinese who are swarming into Tibet at an alarming rate. Persuaded by economic benefits, Han Chinese now outnumber the Tibetans by a ratio of five to one in Lhasa. This influx of Chinese workers has caused massive unemployment among Tibetans, contributing to the demise of both the Tibetan land and its people. Young Tibetan children are being systematically denied an education; it is reported that 70 percent of Tibetans in Tibet are illiterate. Wildlife and forests are being obliterated as the land is raped for precious minerals. Roughly one-quarter of China's nuclear missiles are based in Tibet.

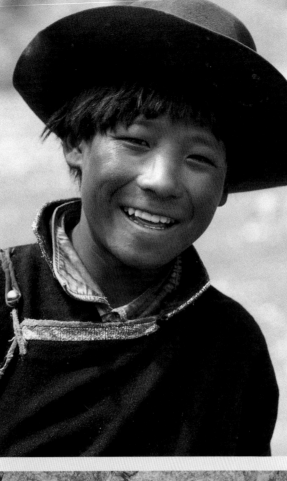

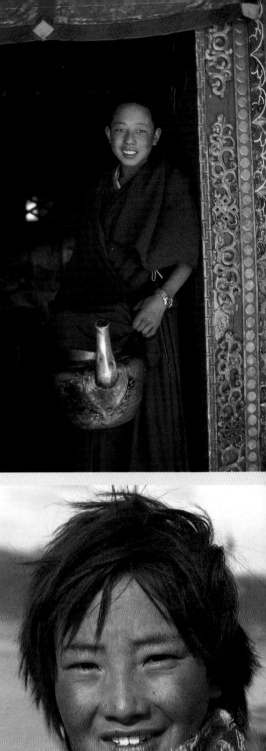

▶ Tibetan boy working in the fields. Gyantse, Tibet.

▶ Monk during tea break in the doorway of Ganden Monastery. Tibet.

▶ Tibetan student learning to write script. Lhasa, Tibet.

▶ Young Tibetan boat passenger bundled in his woolen *chuba* on the Tsangpo River. Central Tibet.

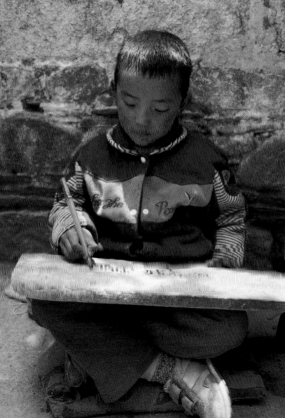

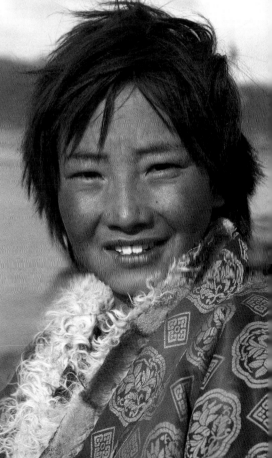

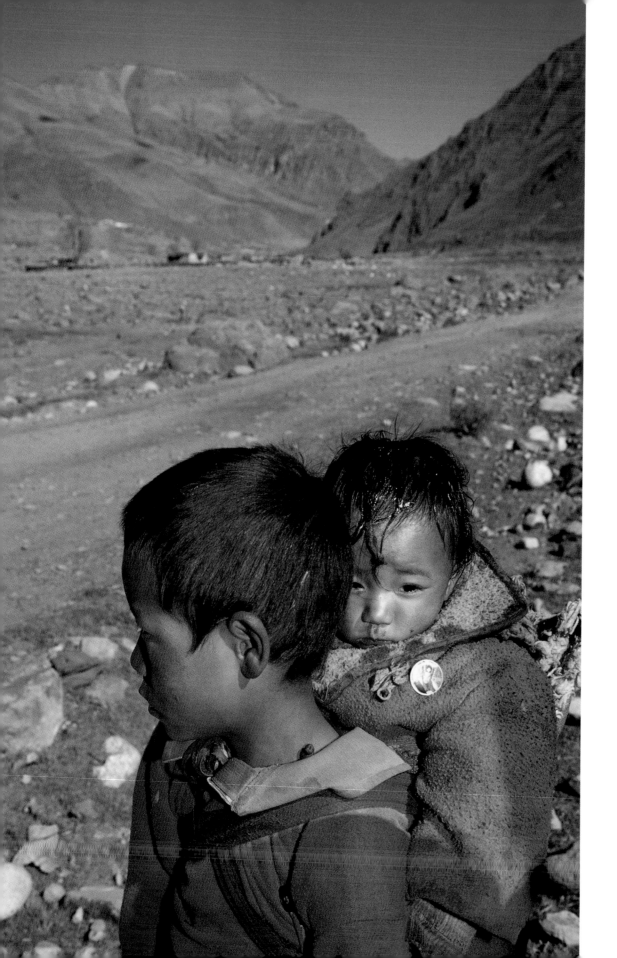

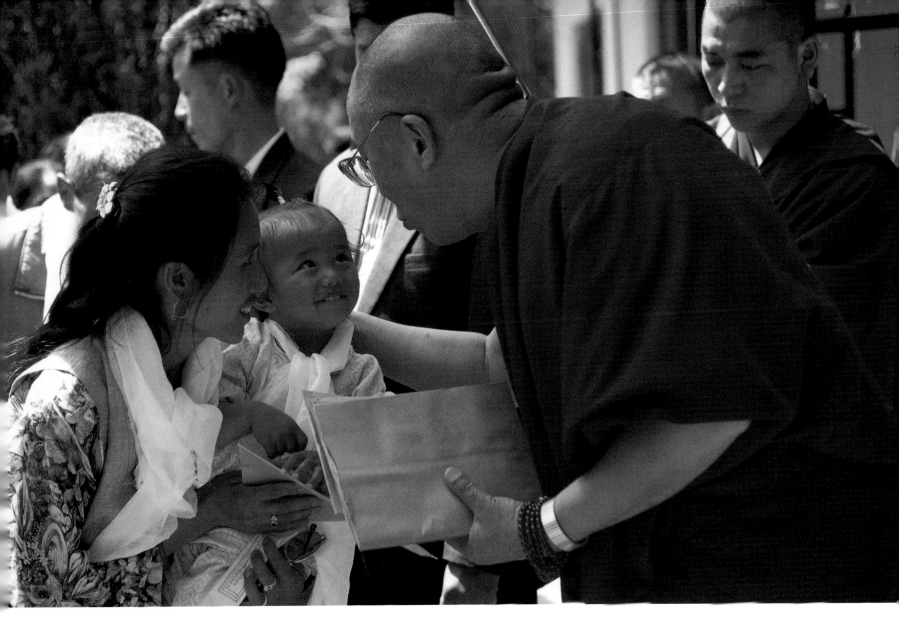

◄ Tibetan boy carrying his brother on his back. Central Tibet This baby's face and hair are greased with yak butter to protect him from the harsh high-altitude sun. He wears a pin of the Karmapa Lama, who has a monastery in this area. The new Karmapa, who is now reincarnated as a young boy, recently escaped to India, along with thousands of other Tibetans, to be closer to his spiritual leader, the Dalai Lama.

▲ The Dalai Lama blesses a young girl with her mother in Dharamsala, India. Hundreds of young children walk or are smuggled over the high mountain passes of Tibet every year in hope of receiving a Tibetan education in exile. His Holiness arranges an audience with every one of them. Since the 1959 exodus from Tibet led by the Dalai Lama more than 130,000 Tibetans in exile have fought to preserve their unique culture and identity while rebuilding their lives in the forty-seven Tibetan refugee settlements throughout India and Nepal. In this sense, Tibetan refugees have managed more than mere survival; they have created a Tibet in exile that is in some ways more truly Tibetan than their occupied homeland.

93

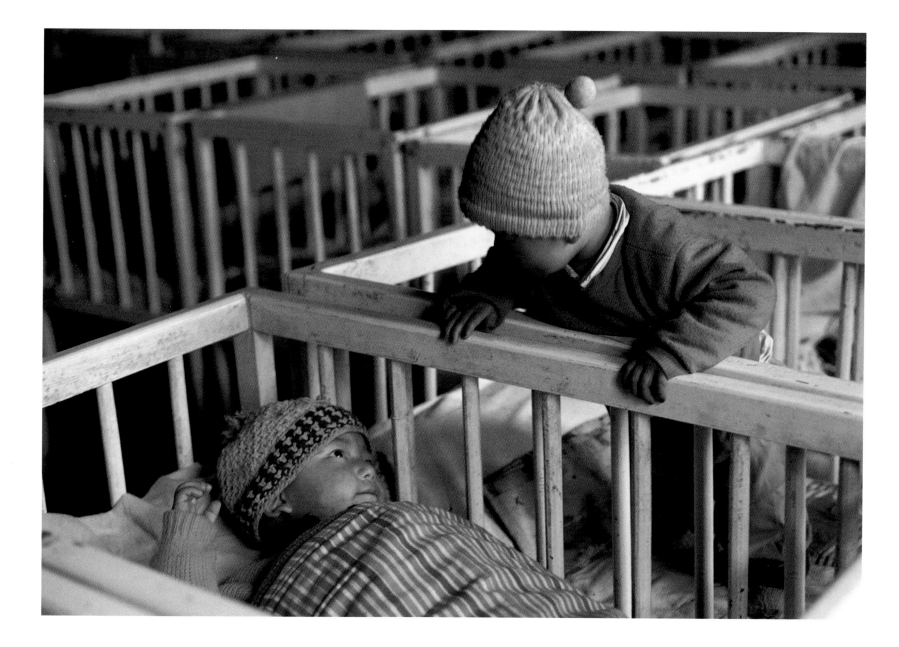

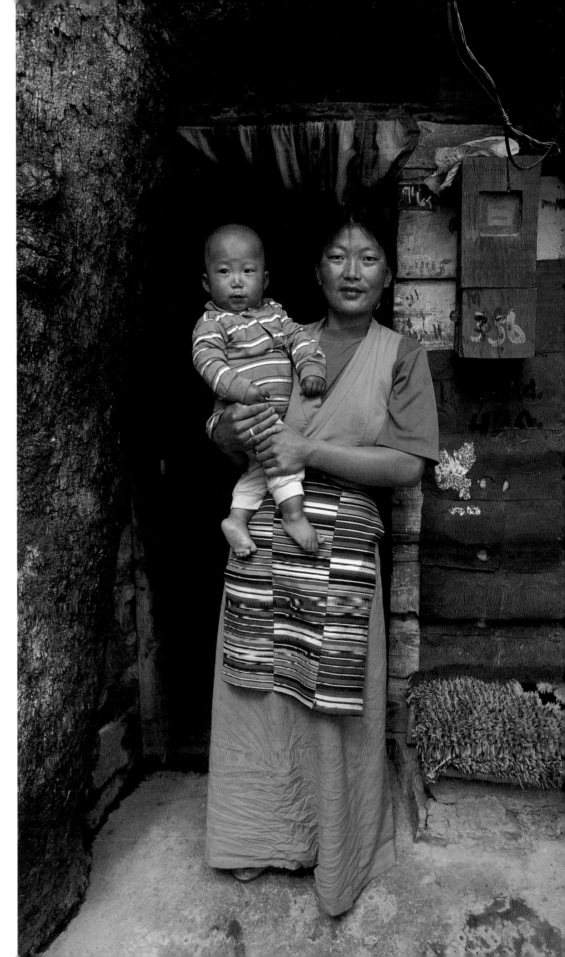

▶ Dolka, with her baby. Dharamsala, India. Dolka has recently arrived from eastern Tibet to raise her family in the exiled Tibetan culture in Dharamsala. As the older refugee generation passes on, the next finds themselves hoping for the freedom of a land they have never seen. Meanwhile, Tibetan refugees strive to assimilate into the modern twenty-first century while maintaining their Tibetan identity. While some Tibetans have opted to become citizens of other countries, most continue to live in limbo and keep their Tibetan nationality.

◀ Tibetan children playing in day care while their parents work nearby weaving carpets at the Self Help Settlement. Darjeeling, India. "I hope, as every parent does, that my child will have a good education, a happy life, a sense of identity," says Chodon, a schoolteacher in another Tibetan community, the Chairok Tibetan Settlement in Nepal.

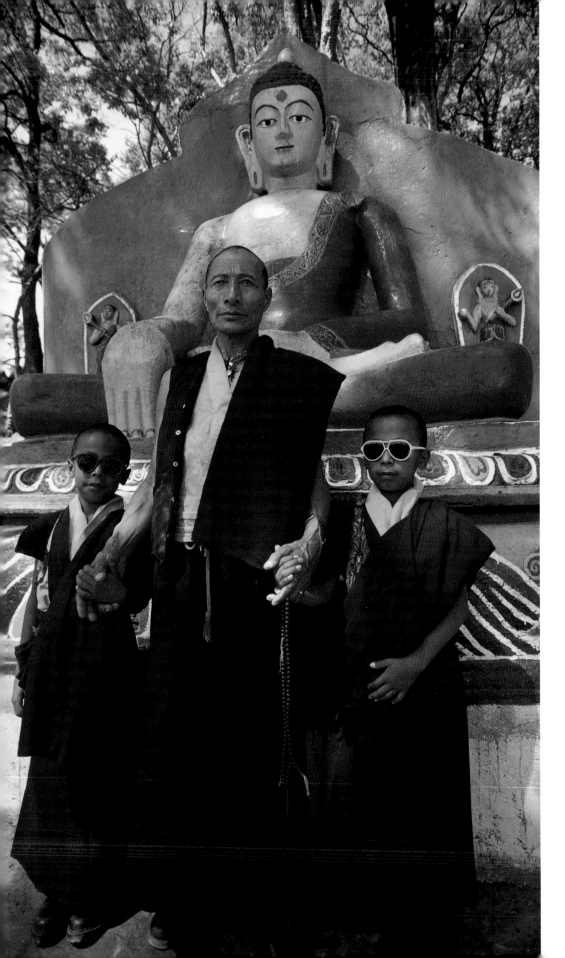

◀ Tibetan Lama and his twin grandsons. Swayambunath, Nepal. Lobsang Thenba, a Tibetan lama living in exile, stands proudly with his two young grandsons at Swayambunath stupa in Kathmandu, Nepal. These twins have been trained to be monks since birth, and one has been recognized as a high reincarnated lama or *rinpoche*.

▶ Domze, Tibetan girl, and her doll. Kathmandu, Nepal. I've known Domze and her family for years and I had the great privilege to help send her to school. I remember taking her to town on the back of my bicycle and her excitement as we bought her first school uniform and two new pairs of shoes, one for everyday use, the other for special occasions, such as the Dalai Lama's birthday. When my family came to visit I had them bring my old dolls from the attic at home. When we came back to the house, all the dolls were reverently lined up on the altar. Thupten, her father, was worried the children would ruin them.

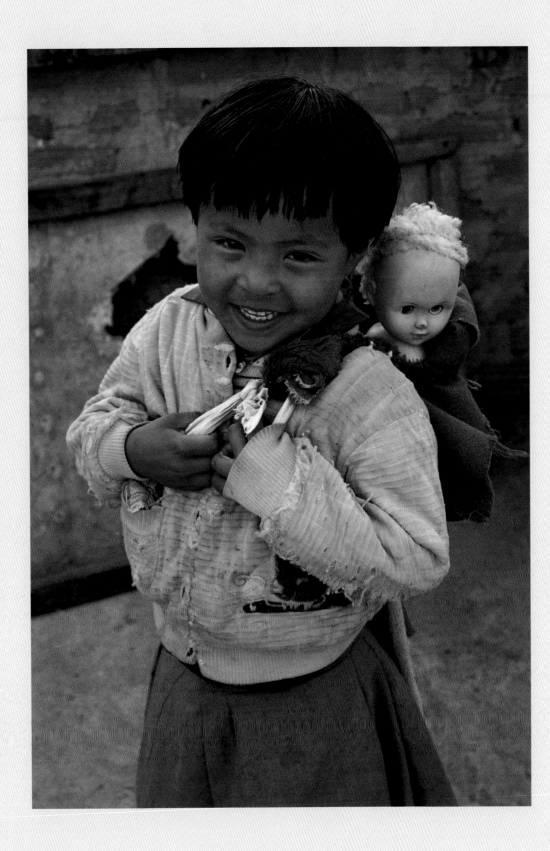

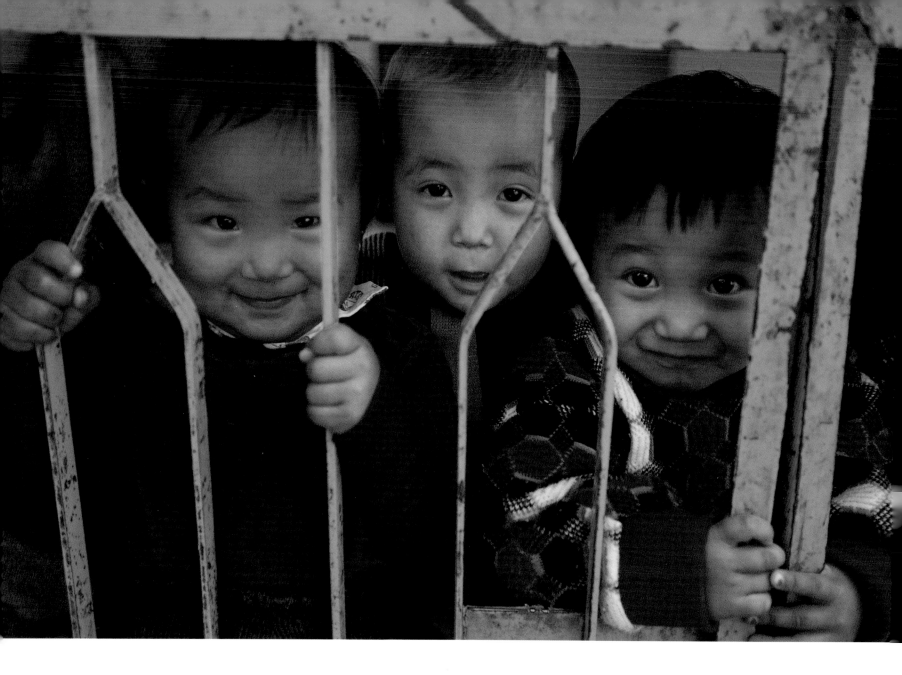

► Children at the Tibetan Children's Village School. Dharamsala, India. Soon after 1959, the onslaught of so many Tibetans emigrating to India raised immediate concern for the welfare of the young children, especially those recently orphaned. With notable foresight, the Dalai Lama quickly created the Tibetan Children's Village (TCV) in 1960, headed by his sisters Mrs. Tsering Dolma Takla and, currently, Mrs. Jetsun Pema. The main school and orphanage in Dharamsala houses more than fifteen hundred students, although branch schools with dormitories for thousands more are established throughout many of the settlements in Nepal and India. Caring supporters from literally all over the world sponsor these children.

◄ Tibetan children playing in day care. Dharamsala, India.

▼ Tibetan children enjoying a warm summer day. Jampaling Tibetan Settlement, Pokhara, Nepal.

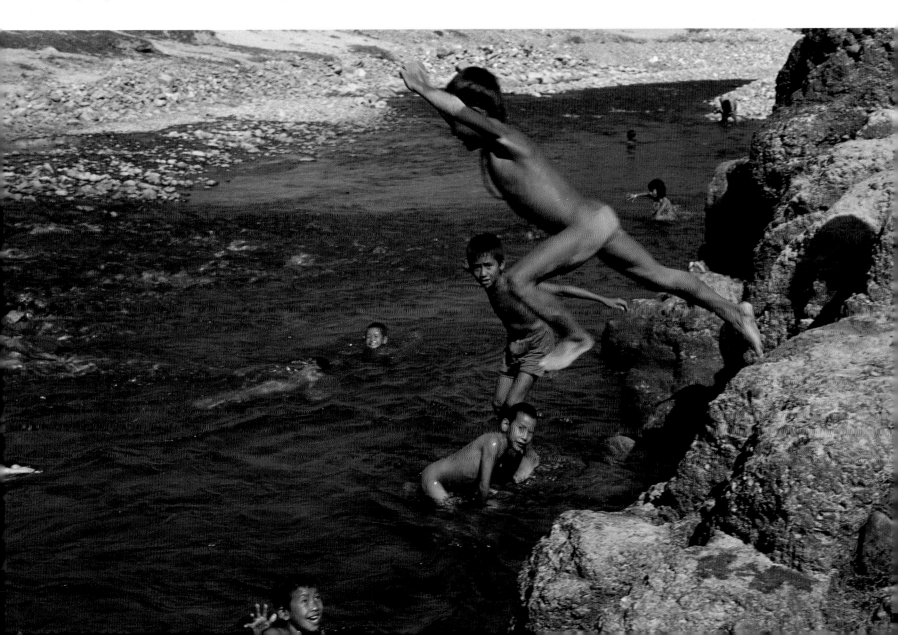

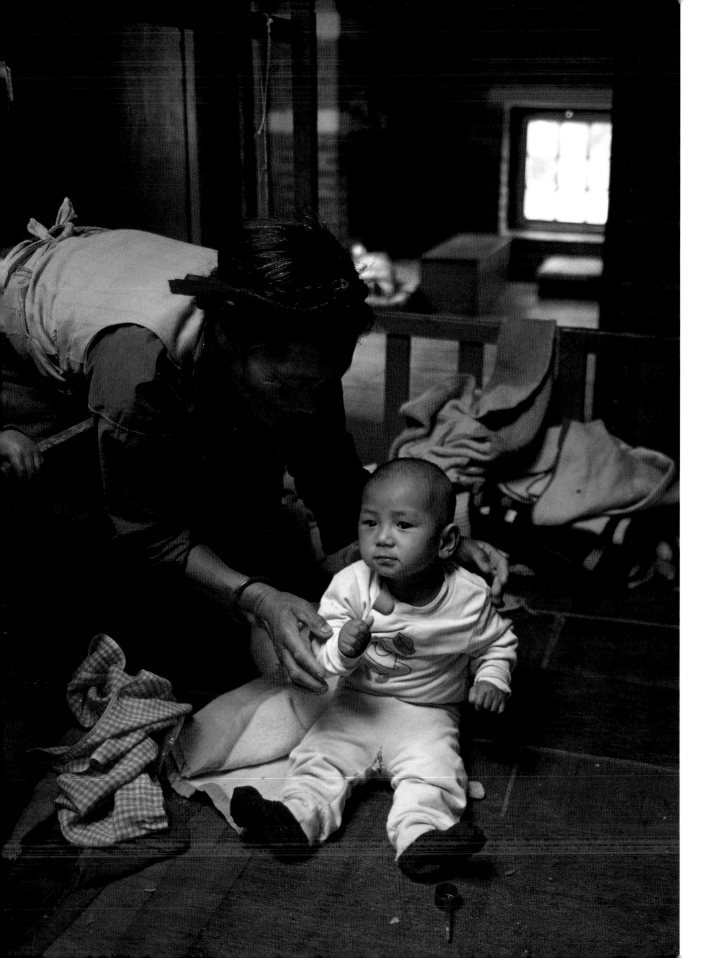

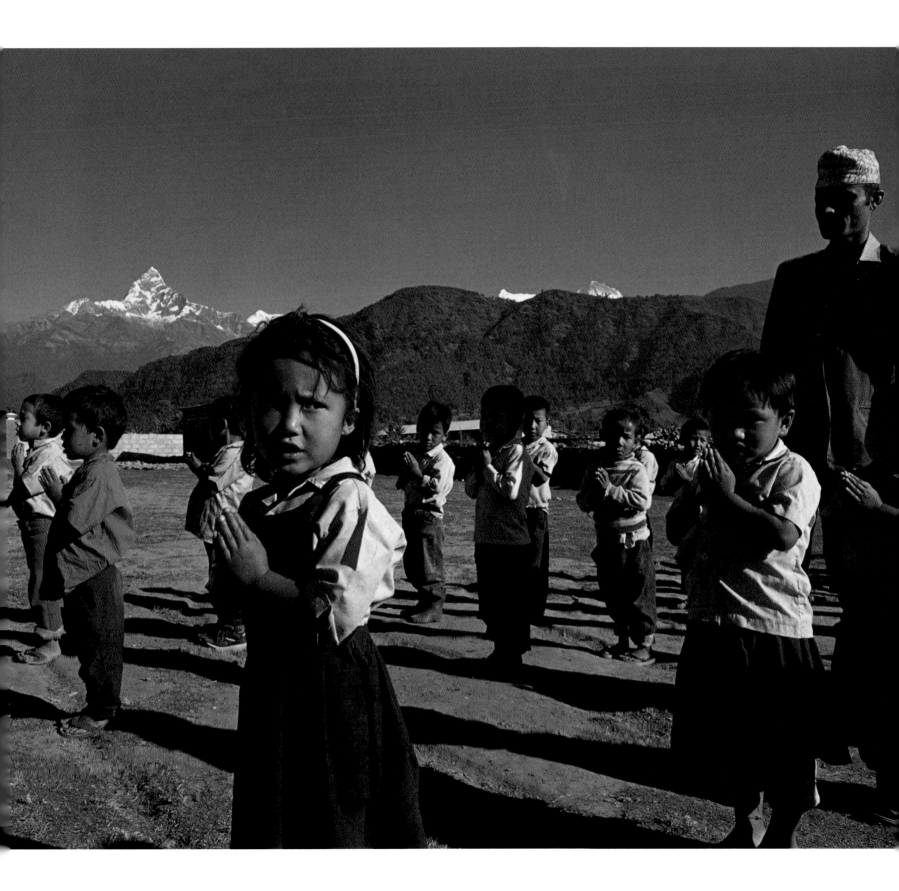

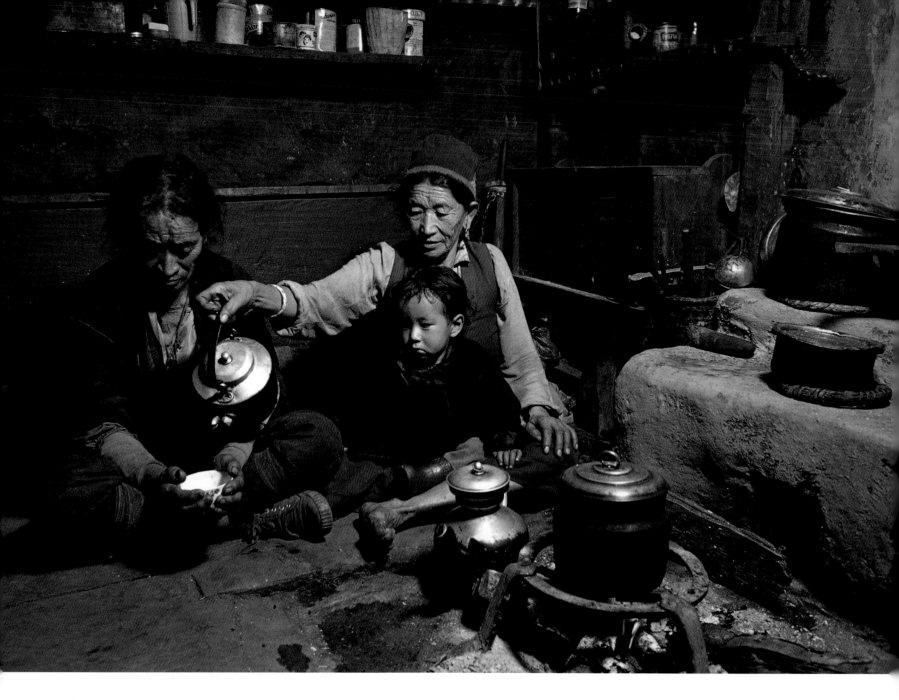

◀ Tibetan schoolchildren. Tashiparkhel Tibetan Settlement, Pokhara, Nepal. "Our aim is to educate our children as best we can to integrate with the rest of the modern world, as well as maintain their traditional background," says Tsering Dhondup of the S.O.S. Children's School. "We feel it's important to raise them in a Tibetan environment and for them to grow up with a sense of identity in relation to their own culture."

▲ Nyima, her grandson, and one of her six husbands. Kanchung, Nepal. Nyima was sixteen when she married her six husbands. She still cooks and cares for the surviving three. Here she pours tea with her grandson while sitting in their kitchen in Kanchung, on the Tibetan border in northern Nepal. In one of the few cultures that practices polyandry, Tibetan women often marry all a family's brothers as a way of keeping land and wealth in the family.

▼ Reincarnated Lama Kalu Rinpoche in Dharamsala, India. I visited Kalu Rinpoche in his last incarnation when he was a very old man, living in Darjeeling, India. It was cold and raining as I waited outside his monastery home with a Tibetan friend. After some time, his caretaker eventually came out. "I'm sorry, he said, "but Kalu Rinpoche is too ill to see you." I left feeling sad that I wouldn't have the chance to meet this great lama. Sure enough, he died within a few months.

Years later, his reincarnation came to visit Dharamsala during the Dalai Lama's teachings. I went to visit him at the Norbulingka Monastery. His mother led me into the room, telling him who I was and that I wanted to photograph him. He looked up distractedly from the Game Boy he was intently playing. "I remember you," he said. "You came to visit me in Darjeeling. It was raining. My caretaker was making momos. I was too ill to see you then, but I'll visit with you now."

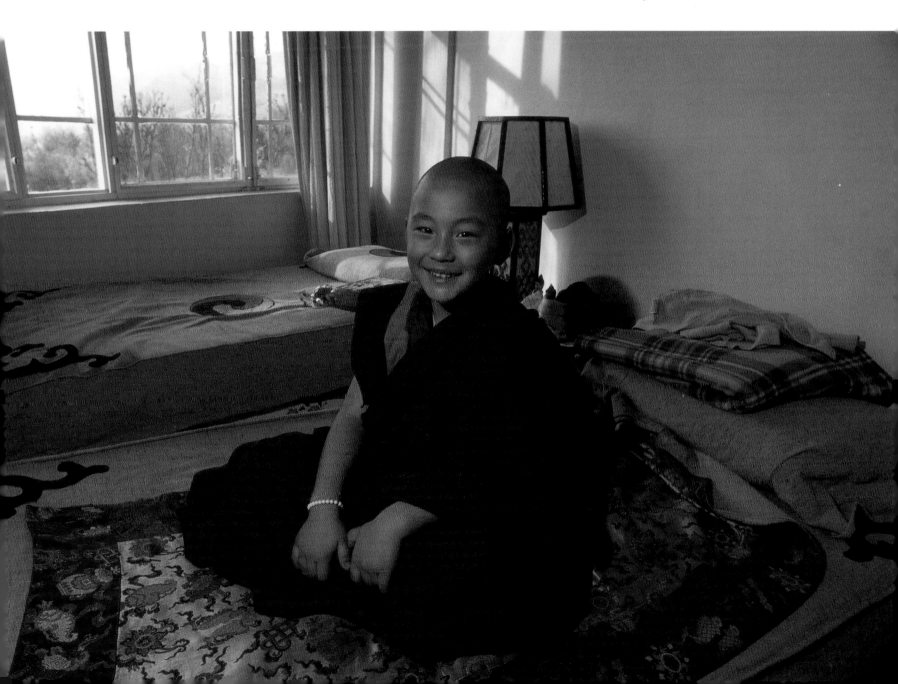

Tibetan nun. Gaden Choeling Monastery, Dharamsala, India. Lobsang Dolma showed me old photos of herself as a giggly young schoolgirl in Darjeeling. She knew at an early age she wanted to be a nun. Now she studies Buddhist scriptures at Gaden Choeling Monastery. New nunneries are being rebuilt in India to house hundreds of nuns, many who were tortured or imprisoned in Tibet.

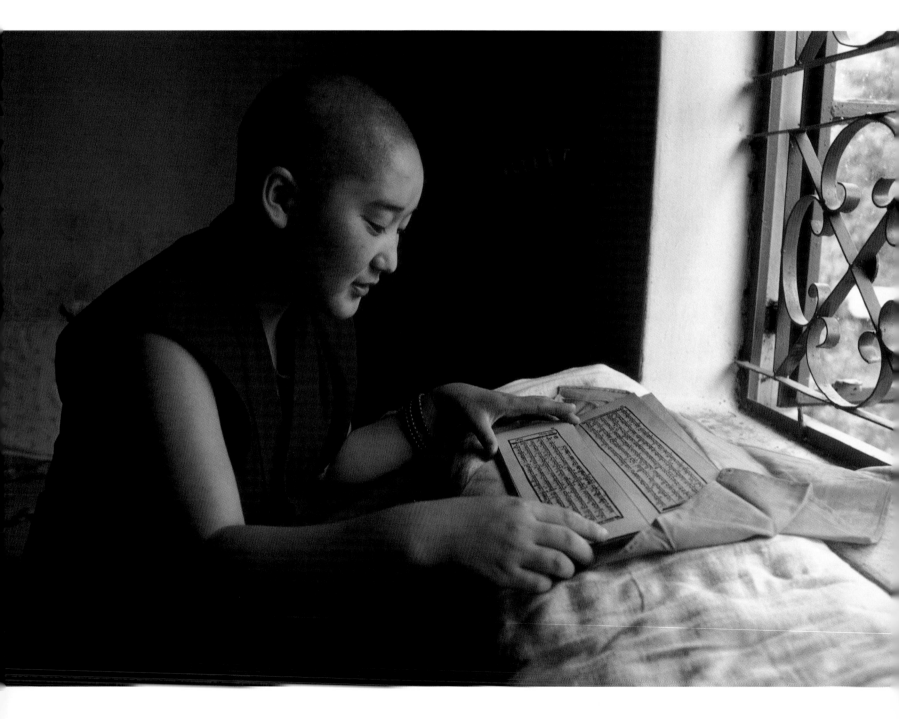

▼ Two generations of Tibetan monks at Dip-Tse-Chok-Ling Monastery. Dharamsala, India. For years, Tibetan families by tradition entered at least one son in the monastery. This practice ended when the Tibetan population became threatened by the Chinese invasion and thousands of monasteries were destroyed. As monasteries are being rebuilt in exile, the practice continues with some boys beginning their religious training as young as two.

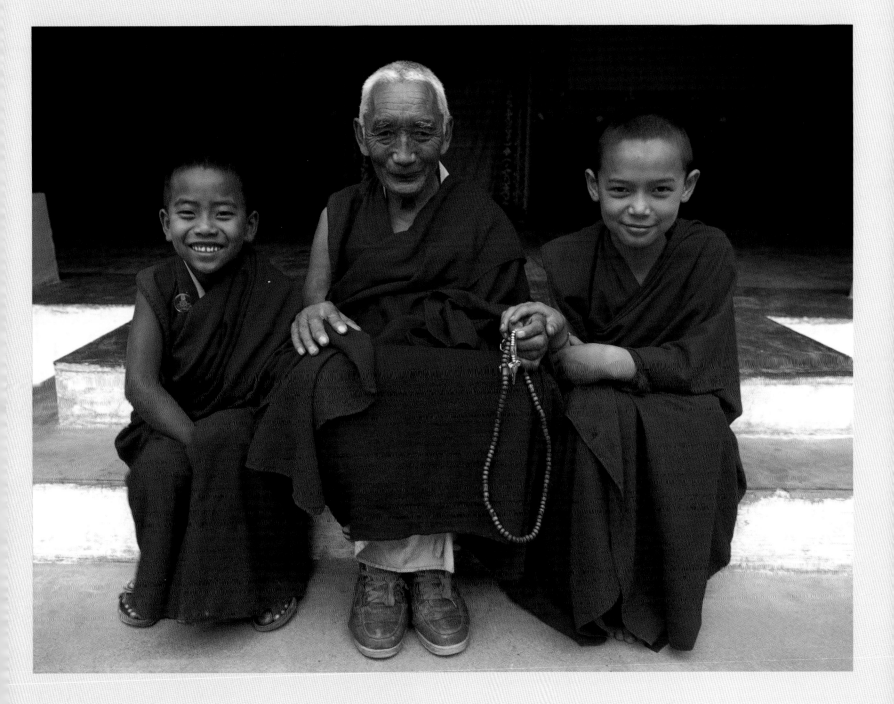

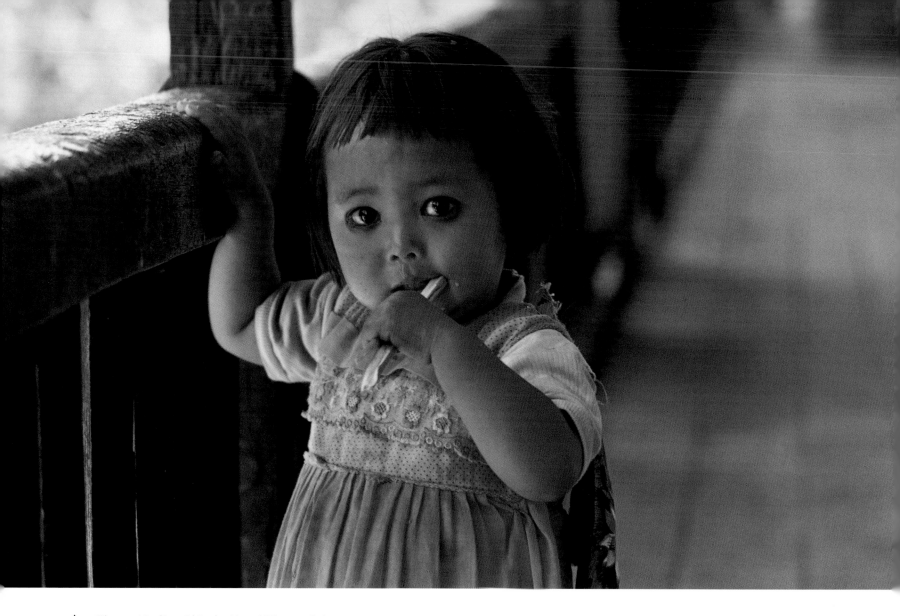

▲ Tibetan Muslim girl in the Hawal Tibetan Colony.
Kashmir, India. Although Tibetans are predominate-
ly Buddhist, a small percentage have intermarried
with Islamic traders who have worked their way
across Tibet over the decades. The Muslim
Tibetans continue to respect the Dalai Lama as
their political leader but don't follow him spiritually.
Fearing religious persecution when the Chinese
invaded their country, they were forced to flee with
other Tibetans; most have resettled in Muslim-
based Kashmir.

▼ Tibetan mother and child at their Buddhist altar. Bridim, Nepal. Every Tibetan home has an altar, and Karma and Tsamchoe tend theirs every morning. It took me weeks to hike to their distant village on the border of Tibet. I was moved by the fact that no matter how remote or isolated families are, their Buddhist faith and devotion to the Dalai Lama are undeterred.

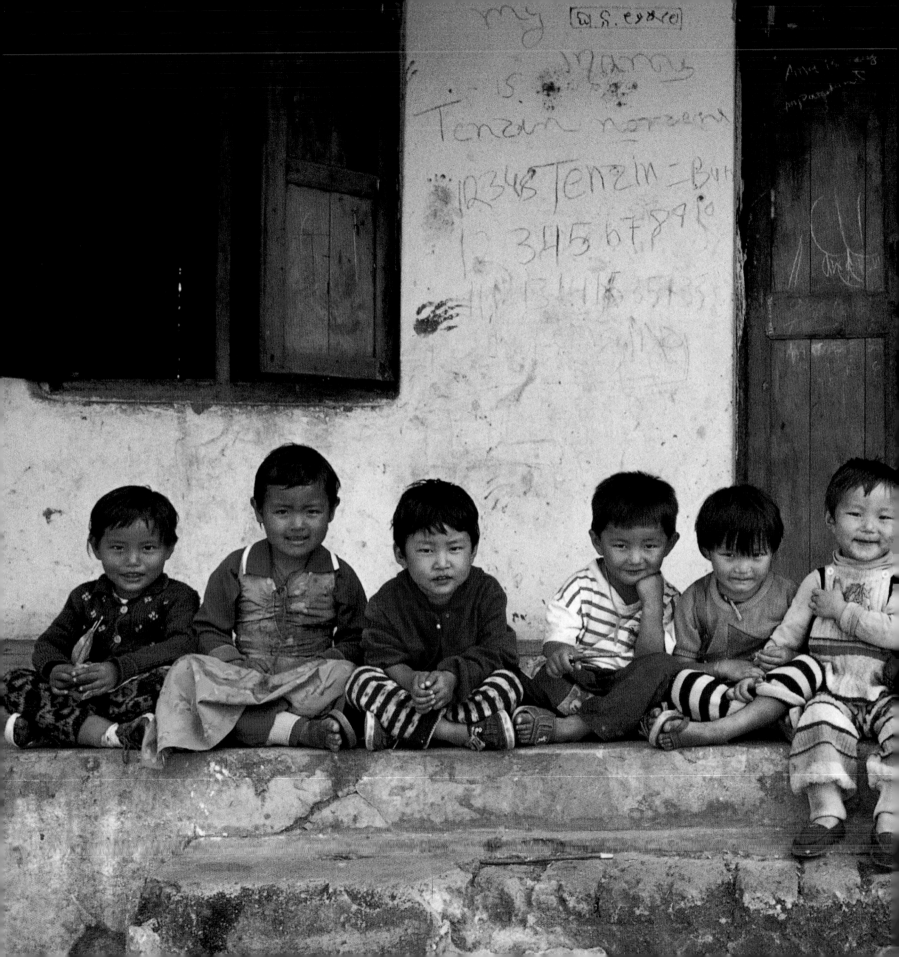

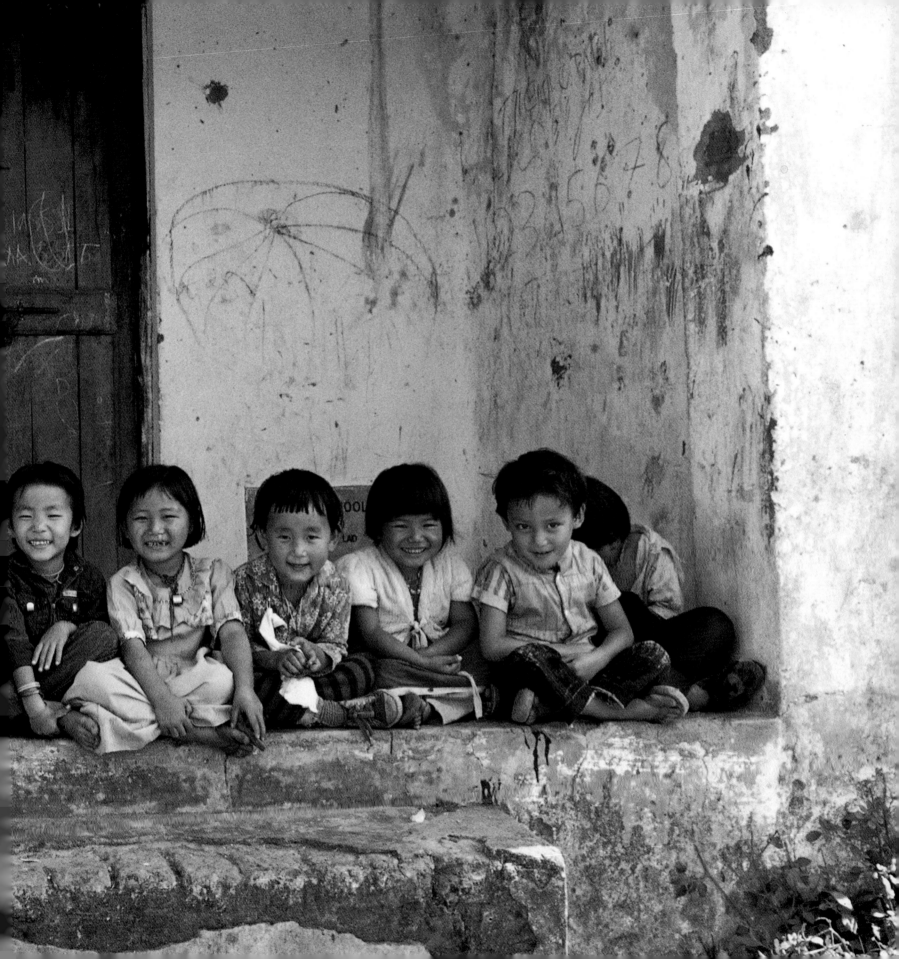

◄ Row of Tibetan schoolchildren at the Chandragiri Tibetan refugee settlement. Orissa, India. The Tibetan government in exile stresses the importance of education and all children attend school. Most of their parents had never seen maps of the world before leaving Tibet.

► Recent refugee at the Newcomers Reception Center. Dharamsala, India. With no one to carry her, six-year-old Karma Lhadon walked from Tibet with a group of chaperoned children through the snow-covered Himalayas for weeks before reaching India.

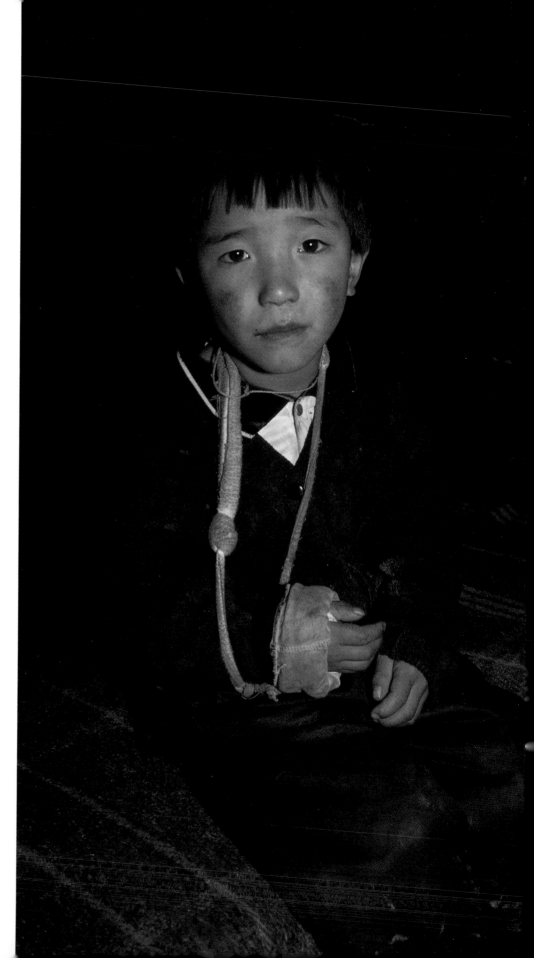

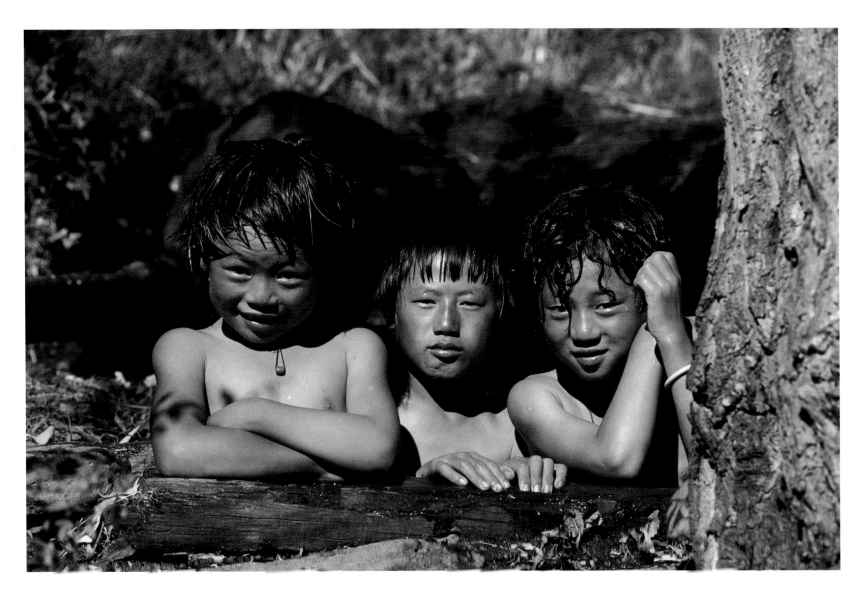

▲ Three girls bathing in a warm thermal pool, Paro, Bhutan. In its self-imposed isolation, this pristine country known as Druk Yul, "land of the Thunder Dragon," is influenced very little by the outside world. Distractions such as television have only recently been introduced. As I hiked through the forest, I met these three girls enjoying the simple pleasure of playing in hot springs.

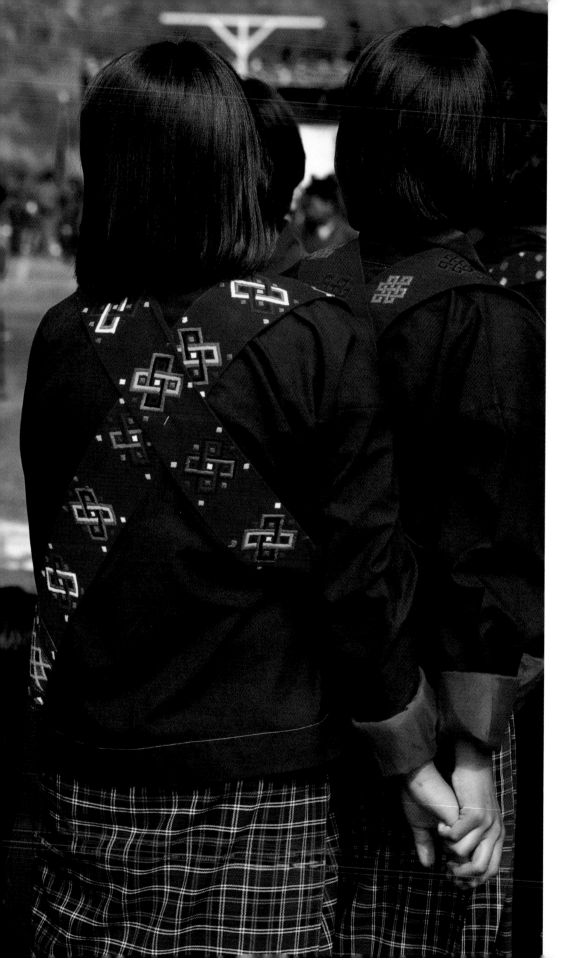

▶ Bhutanese boy. Paro, Bhutan. I met this boy while we were watching an archery contest, a very common event in Bhutan. Archery is the national sport, and a Bhutanese boy's first toy is often a bow and arrow.

◀ Girls in traditional dresses. Thimphu, Bhutan. I attended this dance performance of excited local schoolchildren celebrating the king's birthday in the nation's capital. In an attempt to preserve Bhutan's culture, everyone in this Buddhist Himalayan kingdom wears traditional clothing. These schoolgirls are dressed in colorful Bhutanese kiras, while the boys wear a gho, a plaid robe usually complemented with argyle socks. One challenge facing Bhutan is integrating a mosaic of tribal cultures while at the same time retaining the ethnic diversity that is such an important facet of the country.

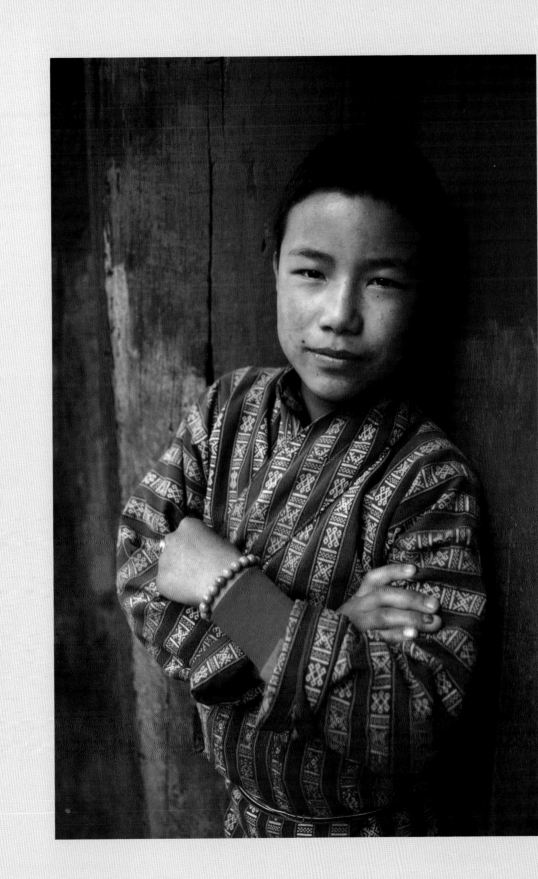

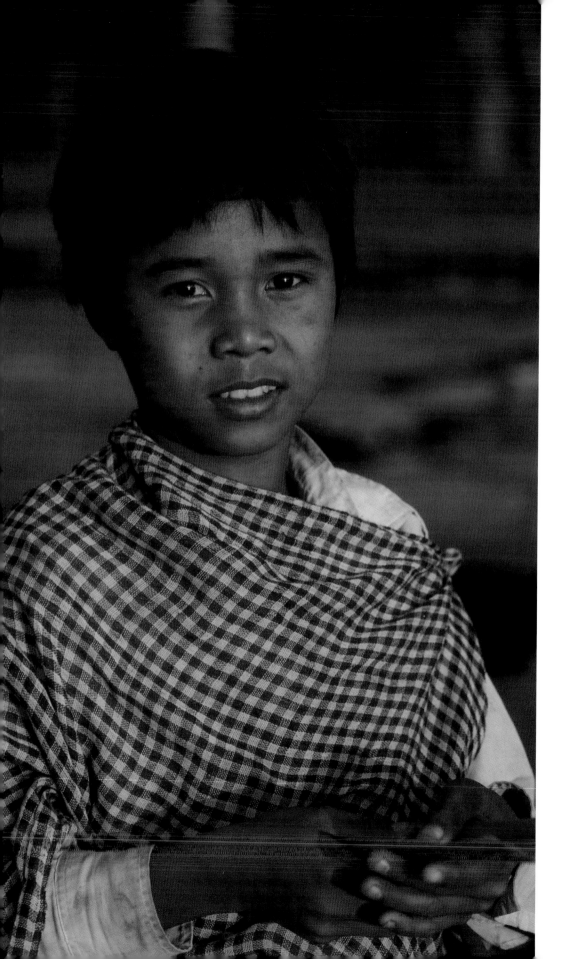

◄ Boy at play. Phnom Penh, Cambodia.

▼ Young soldier at Angkor Wat, Cambodia. As we walked deeper into the lush jungle in search of a hidden temple, I suddenly wondered, should I really be alone, following a fifteen-year-old with a machine gun? Although conditions have improved since the end of its civil war, Cambodia has made limited progress in meeting basic international human rights standards, which results in sporadic outbreaks of violence.

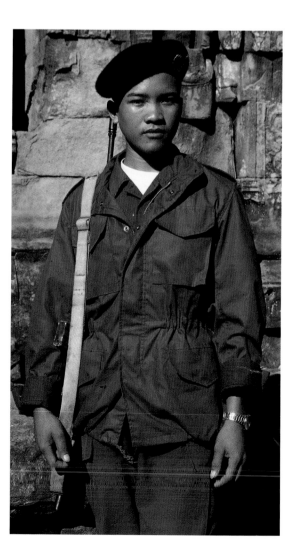

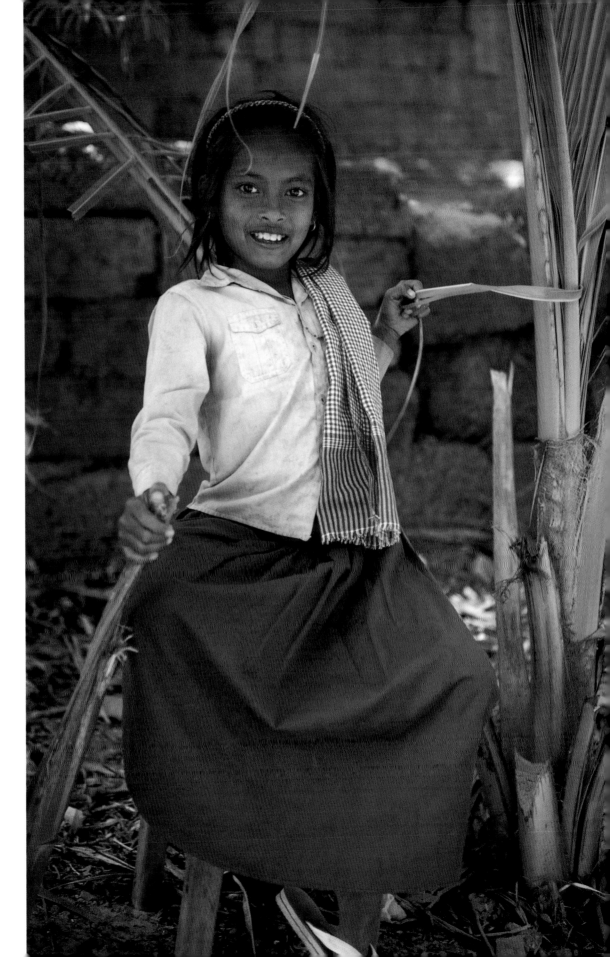

► Girl playing at Angkor Wat, Cambodia. I found this girl among a group of children clambering over the awe-inspiring ruins of Angkor Wat. As much as I was impressed by the beauty of Cambodia and its people, I was also disturbed by the number of amputees I encountered. Millions of land mines have given Cambodia the greatest proportion of amputees in the world. These unexploded ordnances impose a heavy economic and social burden on this country, already one of the poorest nations in the world. With an estimated cost of clearing a single mine at $300 to $1,000, more than five thousand mines have been collected and destroyed since Cambodia signed the Mine Ban Treaty in 1997.

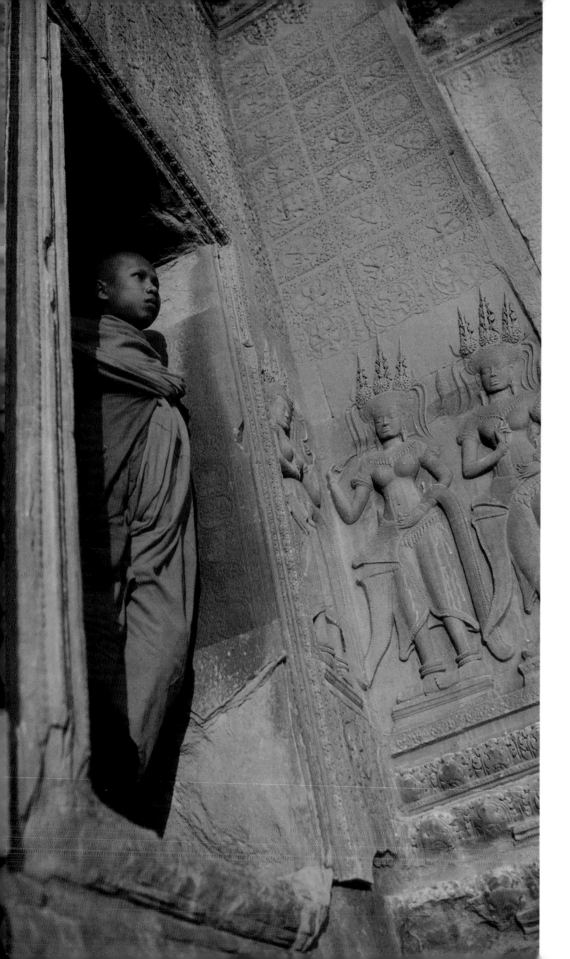

◀ Monk overlooking Angkor Wat at sunset, Cambodia. In contrast to the beauty of Angkor Wat's enduring Buddhist temples, reminders of the Khmer Rouge's brutal regime are virtually everywhere in Cambodia. The Khmer Rouge killed more than 1.5 million monks, doctors, artists, judges, teachers, musicians — anyone with an education. In 1991, after twenty-five years of genocide and civil war, an international peace treaty finally made Cambodia a free democratic nation.

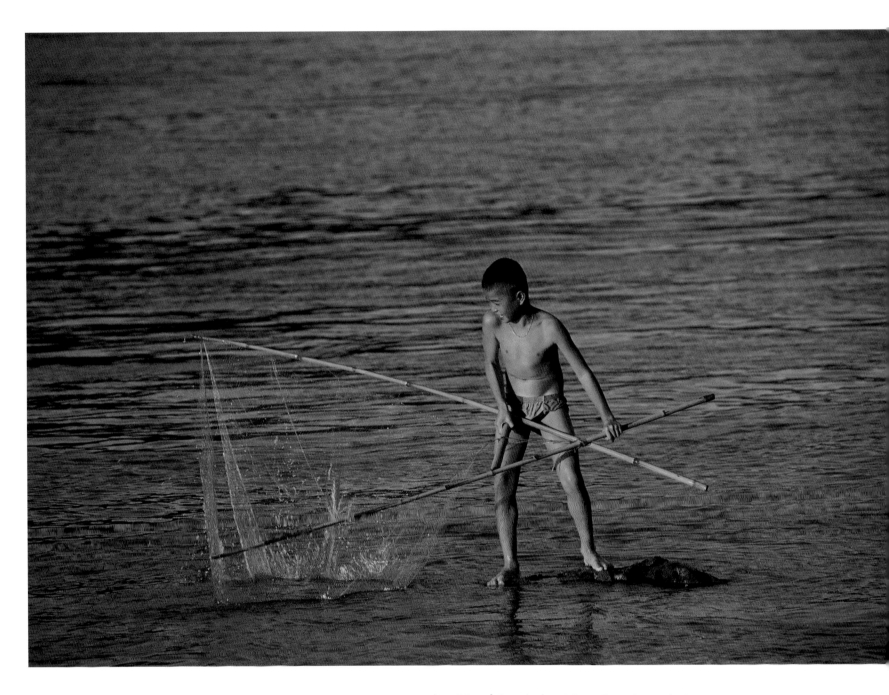

▲ A boy fishing in the Mekong River. Luang Prabang,
Laos. This landlocked communist country of six mil-
lion people has only been open to foreigners since
1989, making it one of the most pristine countries
in Indochina.

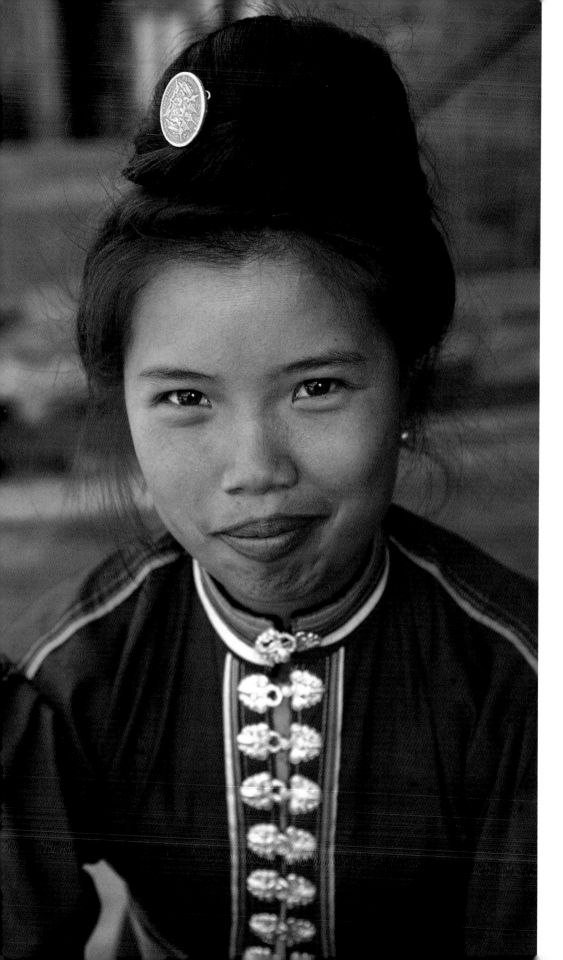

◄ Girl from Lao Thai tribe. Muang Sing, Laos. Laos is
a patchwork of hill tribes, with sixty-eight different
ethnic groups embracing the animistic beliefs and
subsistence farming of their ancestors. Laos is also
the world's third largest opium producer after
Afghanistan and Burma, with production tripling
from the 1980s to the 1990s to become one of the
country's main means of support. Recently the
country opened its doors to tourism, bringing a
slew of backpackers to Muang Sing seeking to get
high with the hill tribes. Here children approached
me not only to beg a few coins but also to
peddle drugs. Teenagers are being lured by the big
money of drug production, and Laos now has more
than sixty-three thousand opium addicts. The Akha
tribe especially are heavy opium smokers and resist
the intrusions of tourism. One chance encounter
with a group of very territorial silver-headressed
Akha women in the forest near their village left
me fleeing for my life as they pummeled me
mercilessly with their fists.

▼ Girl holding baby. Muang Kha, Laos. Flying over the Plain of Jars, I looked down at what I thought was a golf course. What looked like sand traps were in fact bomb craters. From 1964 to 1973, U.S. warplanes dropped roughly two million tons of bombs in the jungles of eastern Laos — an average of one planeload of bombs every eight minutes around the clock for nine years. Up to 30 percent of them didn't explode. These potentially lethal cluster bomblets or "bombis" continue to endanger the Laotian people, mostly fieldworkers and children who mistake them for colorful toys. This has deeply affected the Laotian economy by rendering much of the land useless. Although there is currently no U.S. organization removing bombs from Laotian soil, the British group UXO Lao is taking steps to visit villages, warn people of the dangers, and organize bomb-clearing groups.

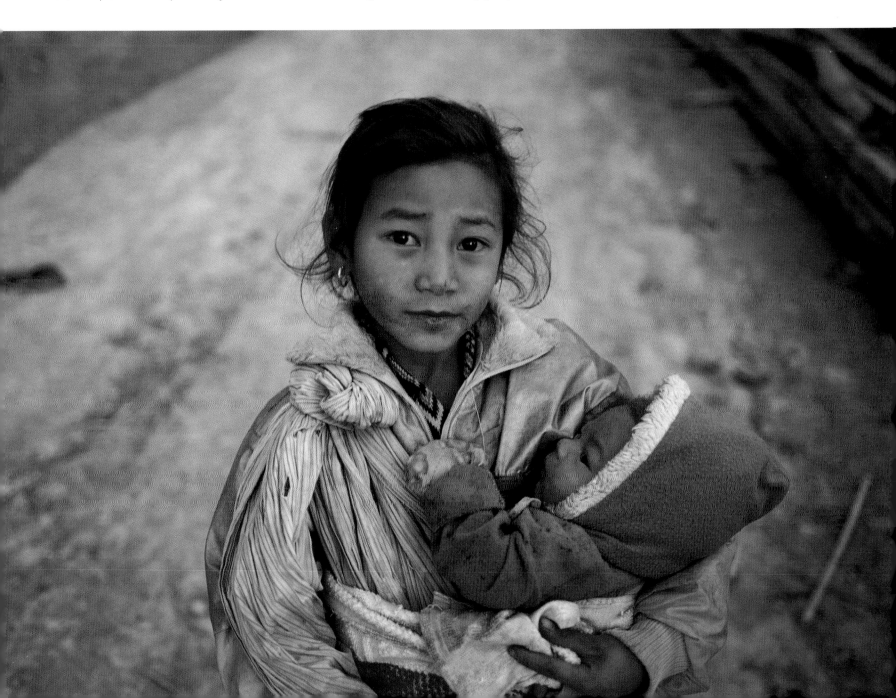

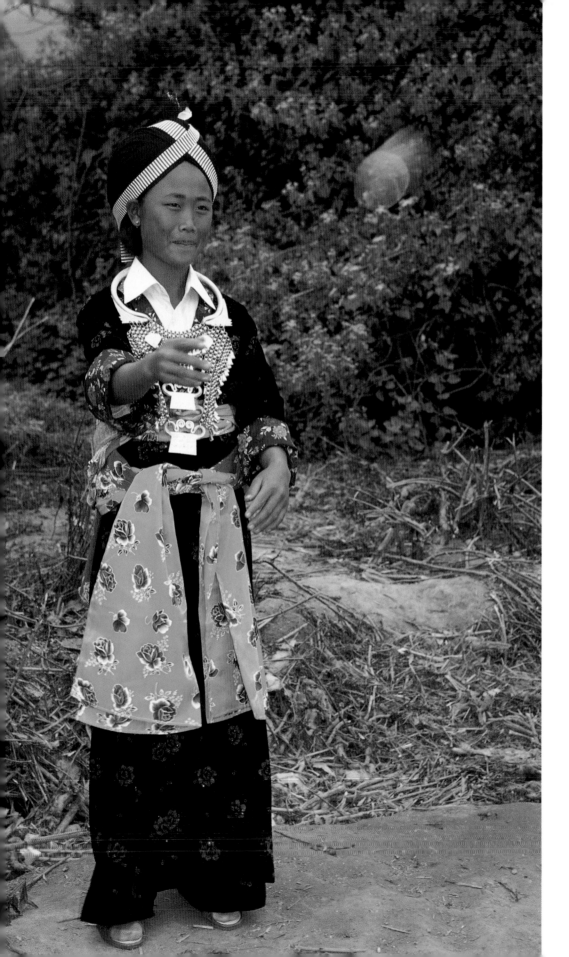

◀ Hmong girl. Muang Sing, Laos. Clothing is their banking system, and these Hmong girls are dressed in their best, usually with money sent from their relatives in the United States. Here they are playing courtship ball during the Hmong New Year. In a day-long celebration the girls throw balls back and forth to groups of boys. Girls single out their favorite and let him know they like him by throwing the ball to him most.

During the Vietnam War the American government was reluctant to send more of its own troops into Laos and encouraged the Laotian people to fight the communist Vietnamese on their own land. Because of their Buddhist beliefs, many Laotians refused to take up the guns given to them. As a result, the U.S. Central Intelligence Agency recruited tough Hmong tribesmen to fight the Pathet Lao and north Vietnamese. More than thirty thousand — a tenth of the tribe — were killed. Many of the Hmong have now relocated to the United States, a situation that is creating its own set of struggles.

▶ Monks collecting their daily alms. Luang Prabang, Laos. Laos is a predominately Buddhist culture and good merit is obtained by giving monks their daily food. Nearly everyone in town is up before dawn to line the streets and offer their donations, including this mother and daughter.

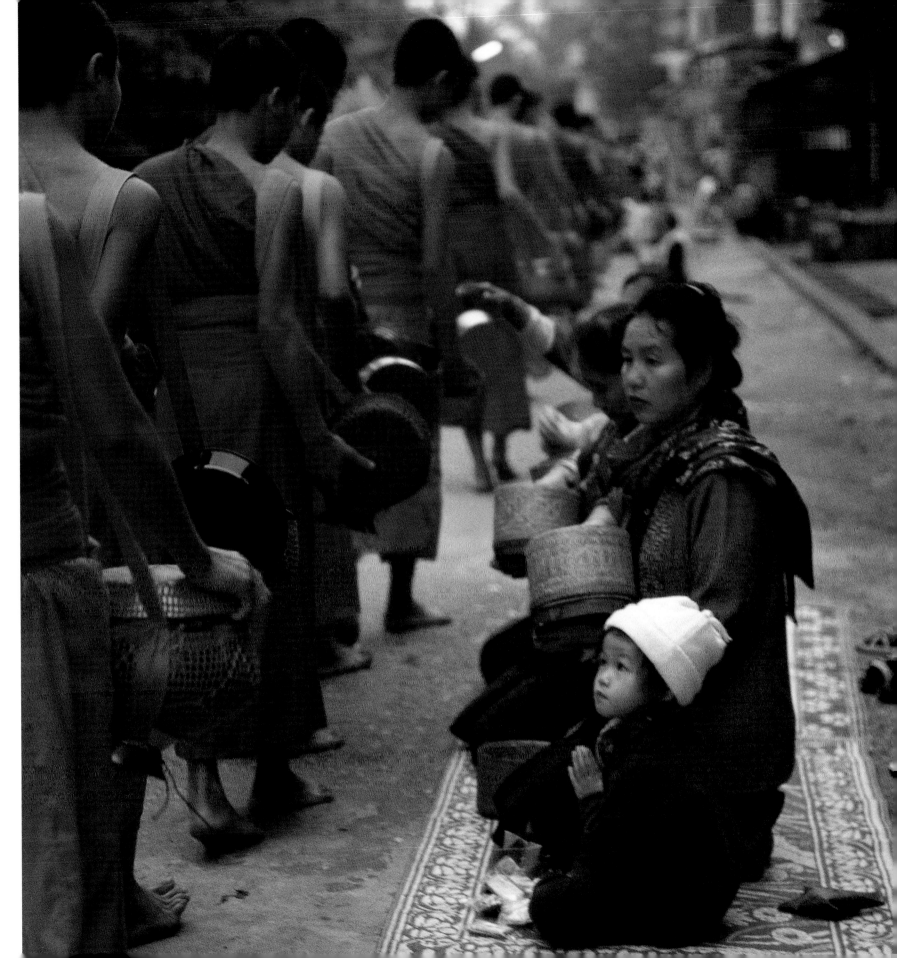

Boy bathing. Koh Mok Island, Southern Thailand. With no running water in their homes, everyone in this small fishing village bathes outside from the open wells. This boy's mother invited me to have tea with her family. They lived in the simplest of houses, an almost empty thatched hut on stilts over the water. As it came time to leave, she handed me some exquisite shells she had found on the beach and a small stem of bananas. So often during my travels I was touched by the fact that it is the people who have so little who are most eager to share what they have.

Children bathing in the early morning before school. Lipe Island, Tarutao, Southern Thailand. The once nomadic Chao-Le sea gypsies live in this small two-hundred year-old fishing village of Ban Ko Lipe. Suddenly put on the map when the television show Survivor was filmed in the area, these previously isolated boat builders and fishermen are having to contend with a sudden influx of tourism.

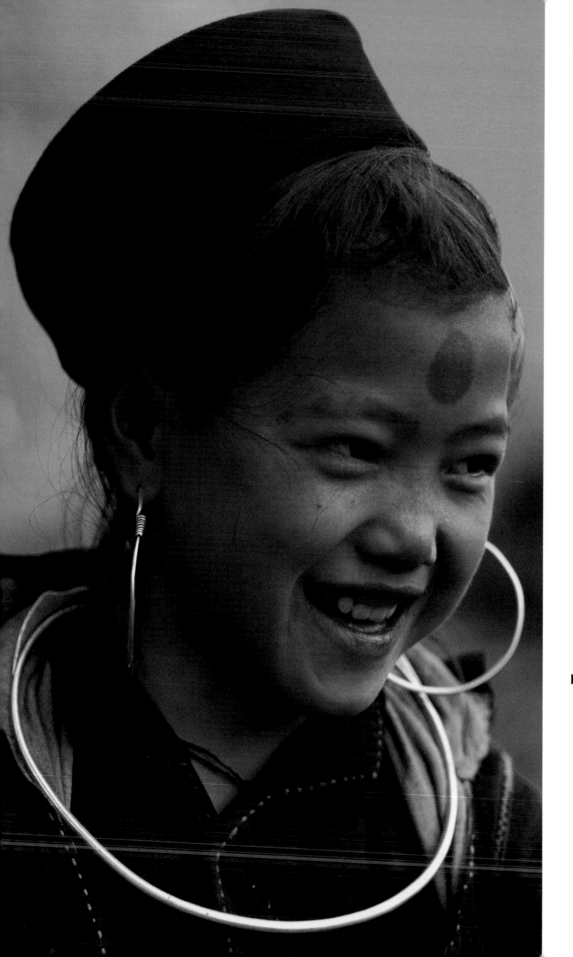

◄ Black Thai hill tribe girl at her village near Sapa, Northern Vietnam. A mecca for vacationing Vietnamese escaping the sweltering summer heat, the popular northern town of Sapa is feeling the strong influences of tourism. An old hill station close to the border with China, Sapa, with its relatively accessible roads and proximity to exotic hill tribes, has become a popular destination on the Western tourist route. Recognizing an opportunity, the Black Thai persistently corner tourists to sell souvenirs and locally embroidered and dyed clothing, which I soon found turns your skin blue after the first wearing.

I was hiking along the river outside of town when I saw dozens of people dressed in black on the other side. Propelled by curiosity, I crossed the raging river while balancing my camera bag on my head. Much to the surprise of this tribal village of Black Thais I showed up bedraggled and wet, a stranger stumbling into what looked like a scene from *Lord of the Flies*. Hearts and lungs were draped on straw mats, internal organs and entrails pinned to the ground with sticks. Drunken men playing the *khene* pipe and beating drums dragged me, nervous and still drenched, into the middle of their circle. With relief I discovered they were celebrating their water buffalo festival, and they welcomed me raucously into their festivities.

▶ White Thai Lu hill tribe girls in traditional dress. Northern Vietnam. How rare it is in today's world of rapid westernization and commercialization to find such untouched human beauty — not just in costume, but in spirit. These shy girls giggled, baring their black enameled teeth, as I playfully held up my silver bangle bracelets to mimic their large hoop earrings. Pierced ears and jewelry — a common female bond. Wide-eyed children squawked with delight as they chased after the elusive bubbles I blew from my magic bottle of soap; fathers stepped outside just to laugh.

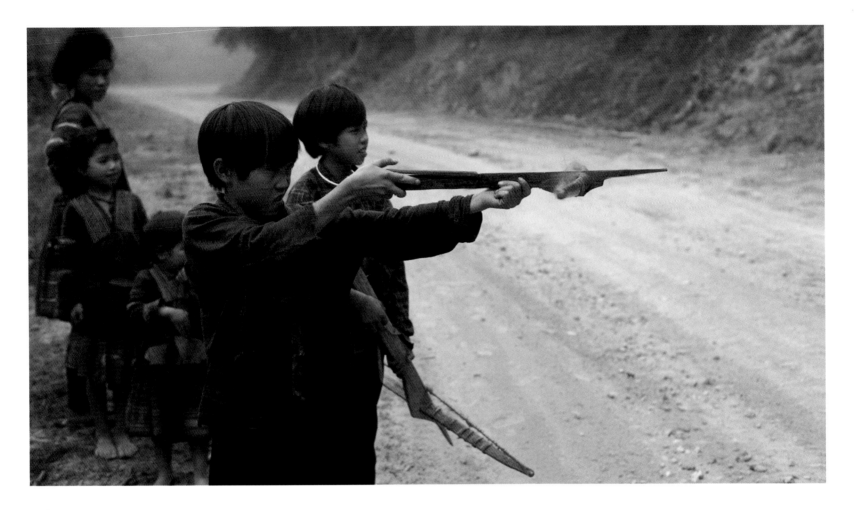

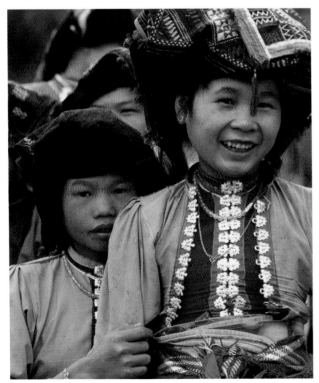

▲ Hmong tribe boys playing with a small crossbow. Lai Chau Province, Northern Vietnam. These boys taught me how to shoot their makeshift wooden bows, aiming the sharp-tipped arrows at small birds dancing in the dust.

▶ Hmong hill tribe girls with impressive coiffures. Lai Chau Province, Northern Vietnam. I made the arduous journey to the northern stretch of Vietnam in an old Russian army jeep. As we crossed the undulating hills it seemed that around every corner we encountered yet another ethnic group, distinguished by the variation of their colorful clothing. This group of women from a particular Hmong tribe sported magnificent, precariously balanced coiffures that bobbed up and down as they excitedly showed us their handmade embroidery.

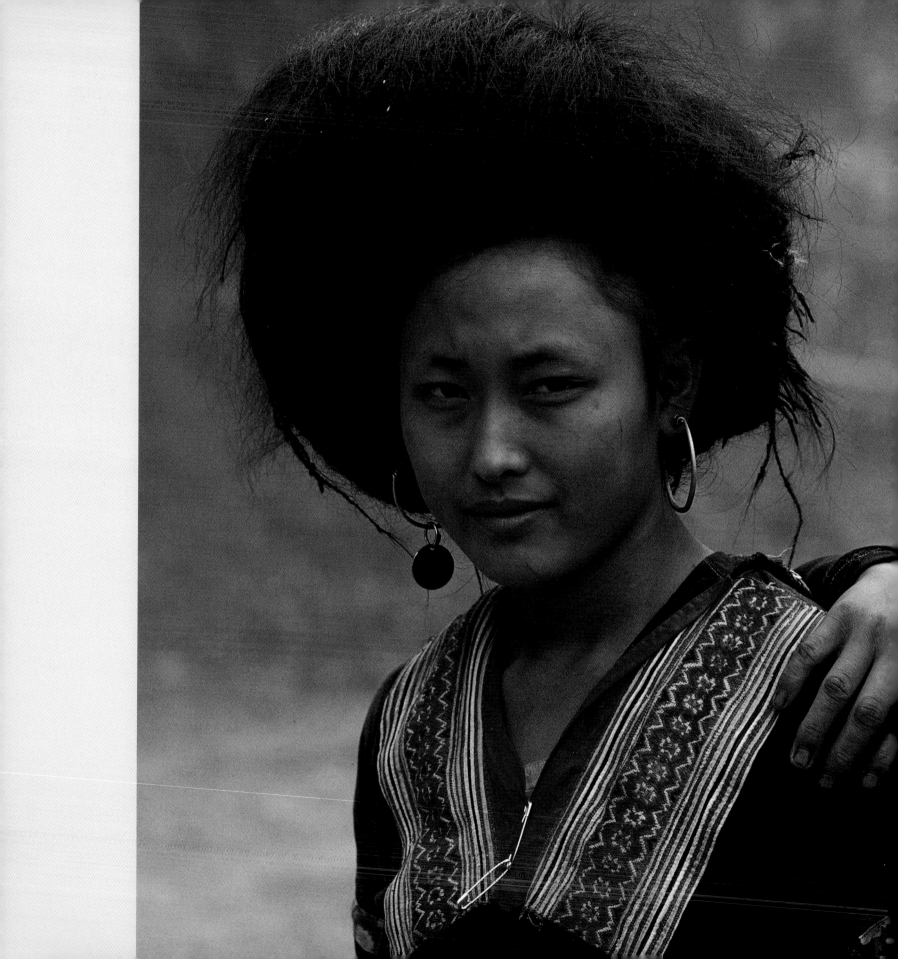

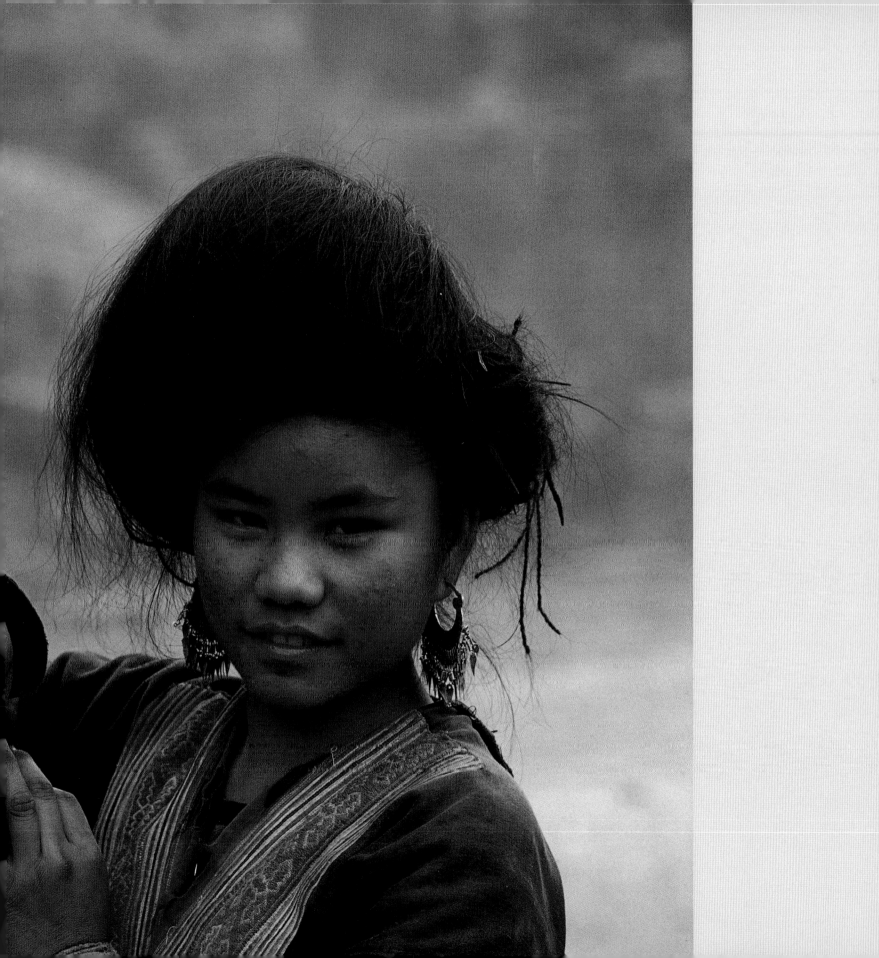

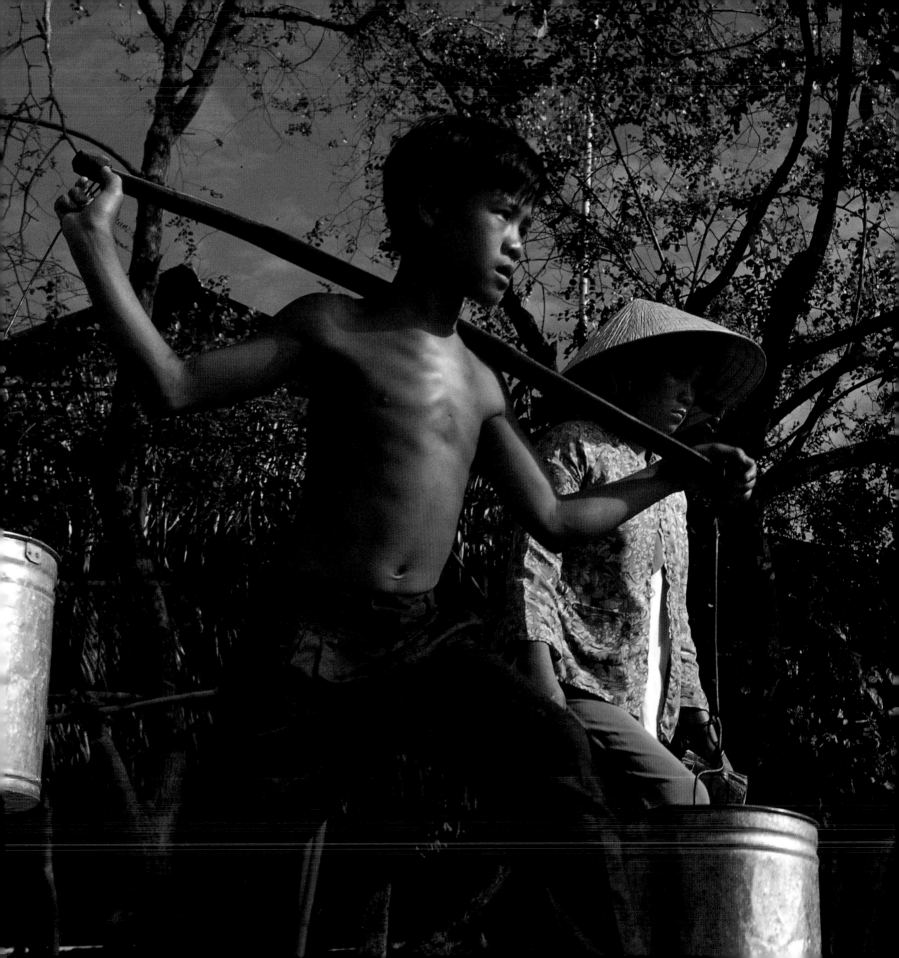

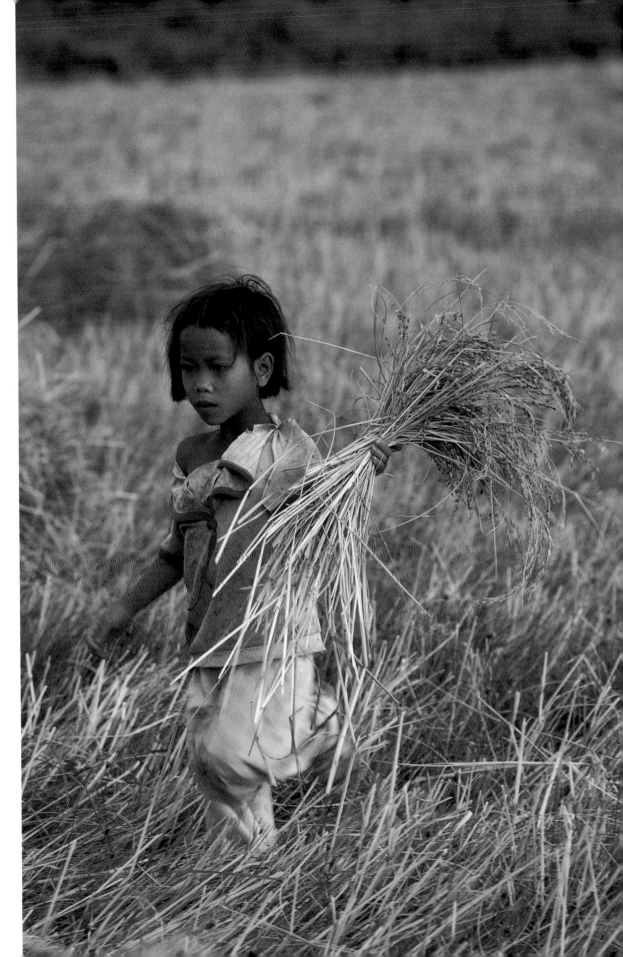

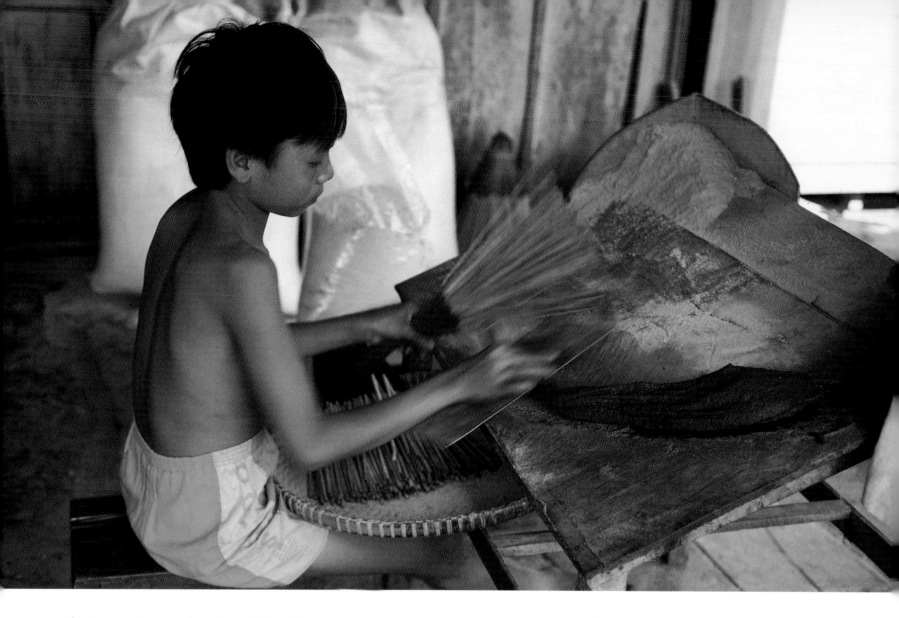

◀ Boy carrying water from the well. Chau Doc, Vietnam. Although Vietnam has opened its economy to the free market, it is still one of the poorest countries in the world. The desire for the American dollar is profound, and for local shopkeepers the fear of the doors of trade shutting again is immense.

◀ Girl cutting wheat in the fields outside of Dalat, Vietnam. Vietnam was the first Asian country to adopt the UN Convention on the Rights of the Child. Child labor has declined sharply in urban Vietnam in recent years, but it remains a significant problem, especially in rural areas and among girls.

▲ Boy making incense. Chau Doc, on the Mekong River, Vietnam.

▼ Girl enjoying her lunch in her parents' shop.
Hanoi, Vietnam.

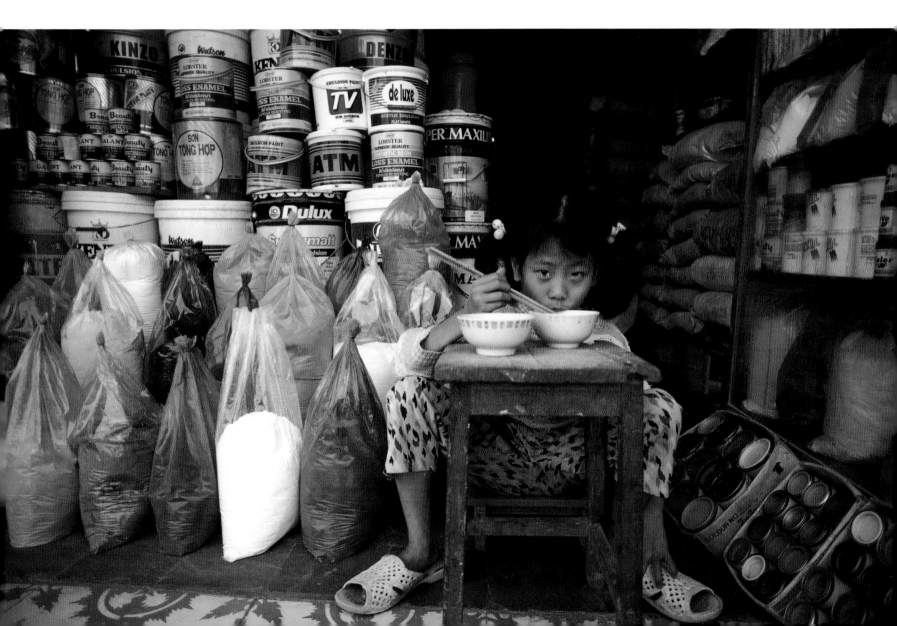

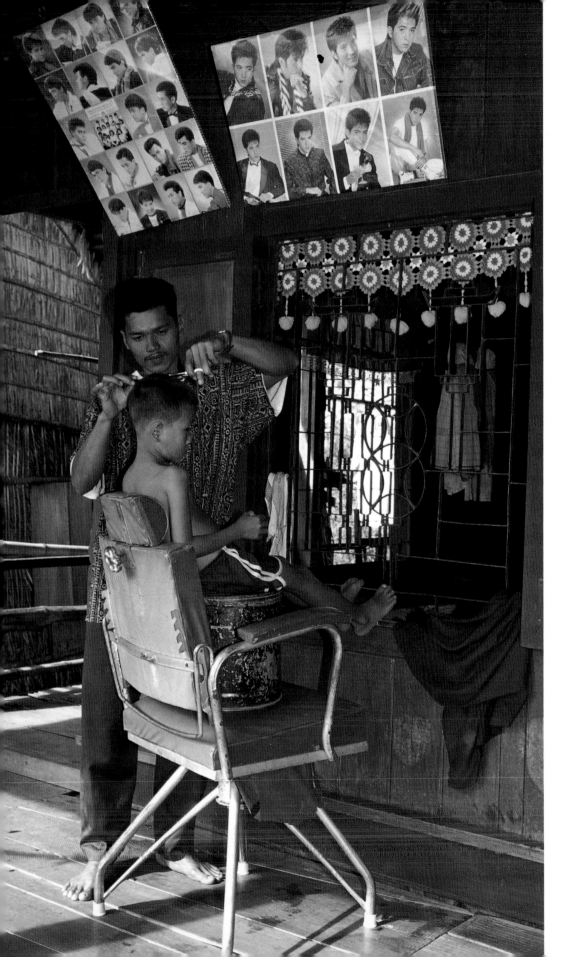

◀ Muslim boy nervously getting a haircut. Chau Doc, on the Mekong River, Vietnam.

▼ Girl holding a flower at the tomb of Ho Chi Minh. Hanoi, Vietnam. Faces like this reminded me that Vietnam is a place, not a war. As with many Americans, brutal imagery from the decade-long conflict shaped my preconception before I visited the country.

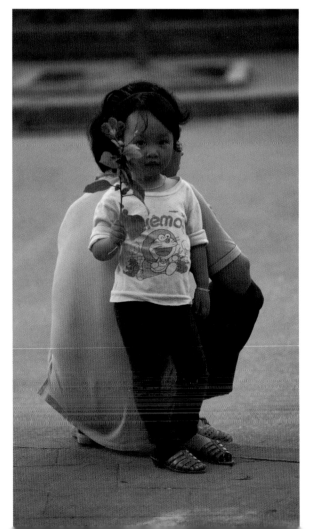

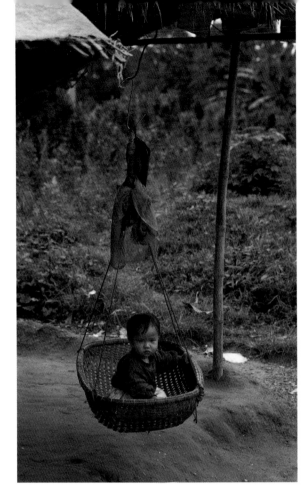

▲ Baby in her swing. Hue, Vietnam.

▶ Schoolgirl. Canlhu, Mekong Delta, Vietnam. Despite its economic struggles, Vietnam has always had a strong commitment to primary education.

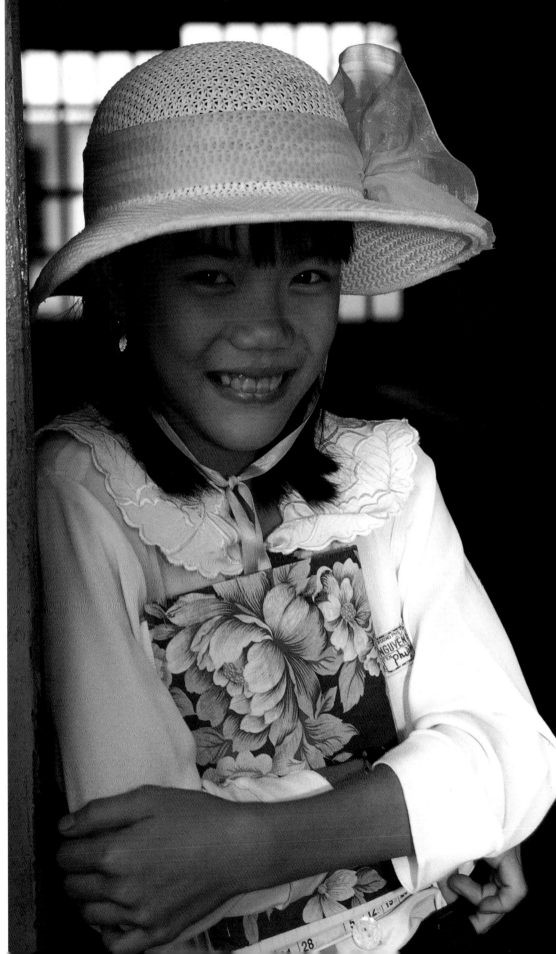

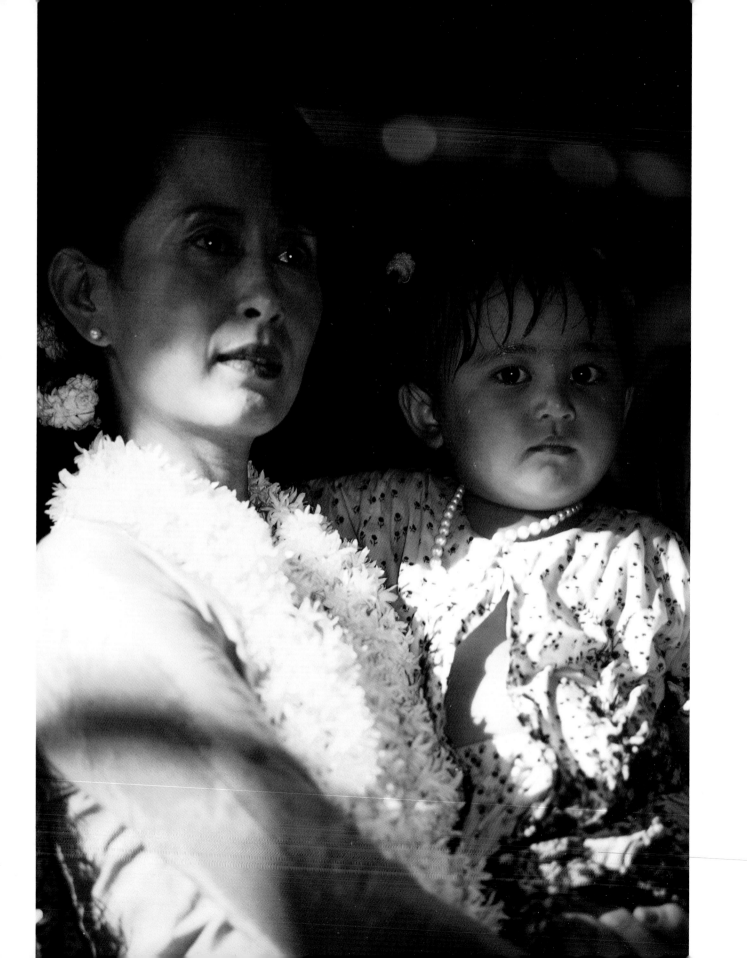

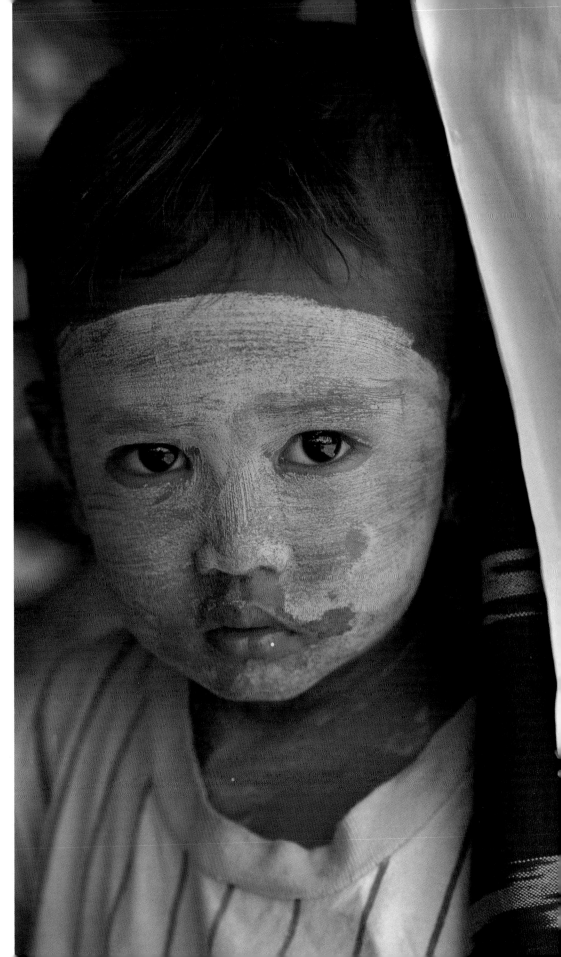

◀ Aung San Suu Kyi and a young friend after being doused with water in a New Year celebration. Rangoon, Burma. Although the politics of Burma have stabilized somewhat in recent years, the current generation is being raised under an oppressive regime. The Burmese military refused to recognize the elections won by Aung San Suu Kyi and her National League for Democracy (NLD) in 1990, instead seizing all power and putting her under house arrest for six years. While still imprisoned, she was awarded the Nobel Peace Prize in 1991, cited by the Nobel Committee as one of the most extraordinary examples in recent decades of civil courage in Asia.

I was able to meet Aung San Suu Kyi shortly after she was freed from house arrest and I was deeply impressed by her dignity and inner strength during her ongoing struggle for democracy. I took this photo the first time she had been able to leave her house for the New Year. NLD members swarmed her front lawn in joyous celebration.

▶ Child wearing tanaka. Maw Ker Burmese refugee camp, near Maesot, Thailand. This boy is wearing tanaka, a sandalwood paste, on his face to protect him from the harsh tropical sun.

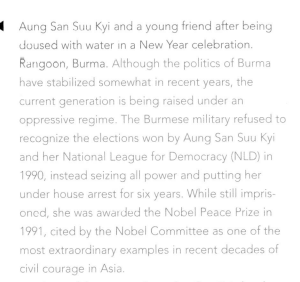

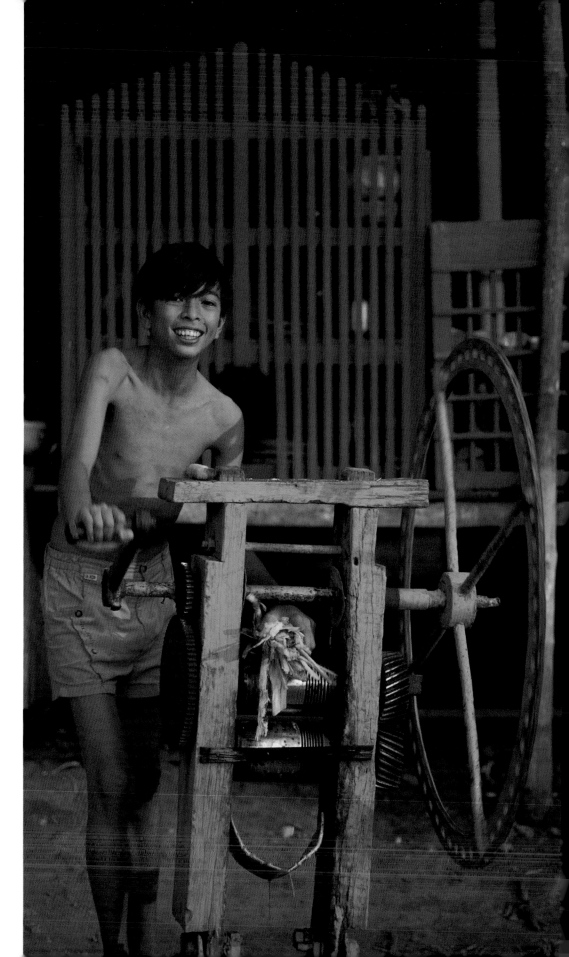

▶ Boy pressing sugarcane for juice. Upcountry, Burma.

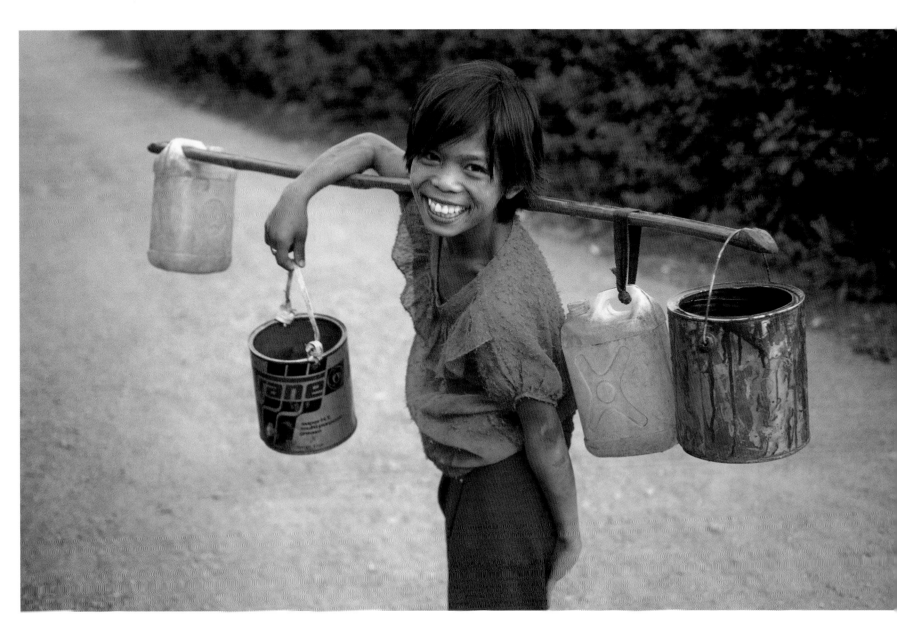

▲ Girl carrying water. Kalaw, Burma. As Aung San Suu Kyi told me, "Democracy is basically a concept: that all of us should have a say on how the society in which we live is shaped and administered. And I think that this is a concept that is not only acceptable but attractive to human beings because every human being wants to be able to have a say in how his destiny is going to be shaped, and as his destiny is inevitably going to be linked to the destiny of his nation, he would like to have a say in how the nation is going to be molded. It is a very natural thing to want."

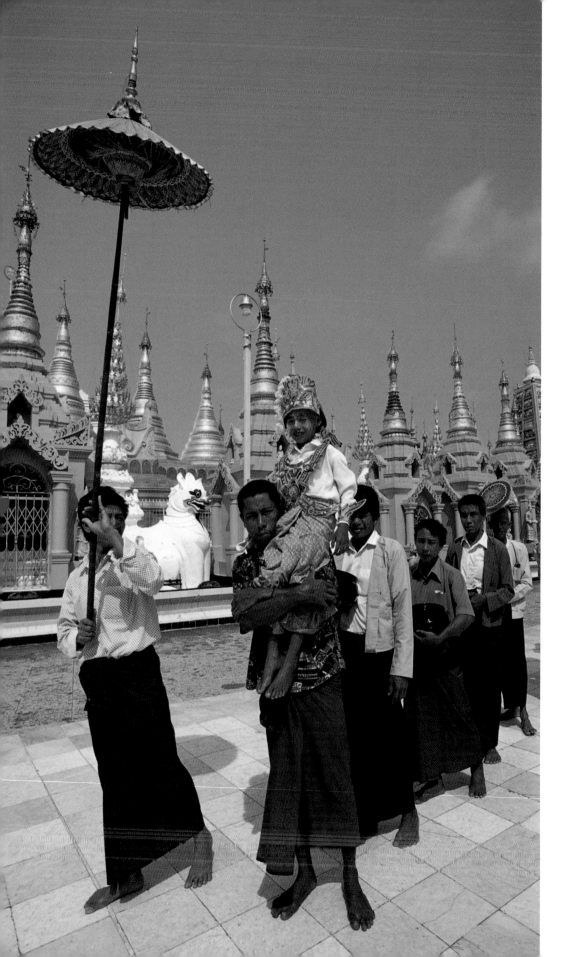

◀ Monk novitiation ceremony. Schwedagon Pagoda. Rangoon, Burma. In this Buddhist country, every Burmese male is expected to take temporary monastic vows twice in his life: once as a samanera or novice monk between ages five and fifteen and again as a pongyi sometime after twenty. Some spend a few days as a monk; others are ordained for life.

▶ Buddhist monk with begging bowl. Bagan, Burma. A family earns great merit when a son takes up robes and a begging bowl to become one of the country's two million monks.

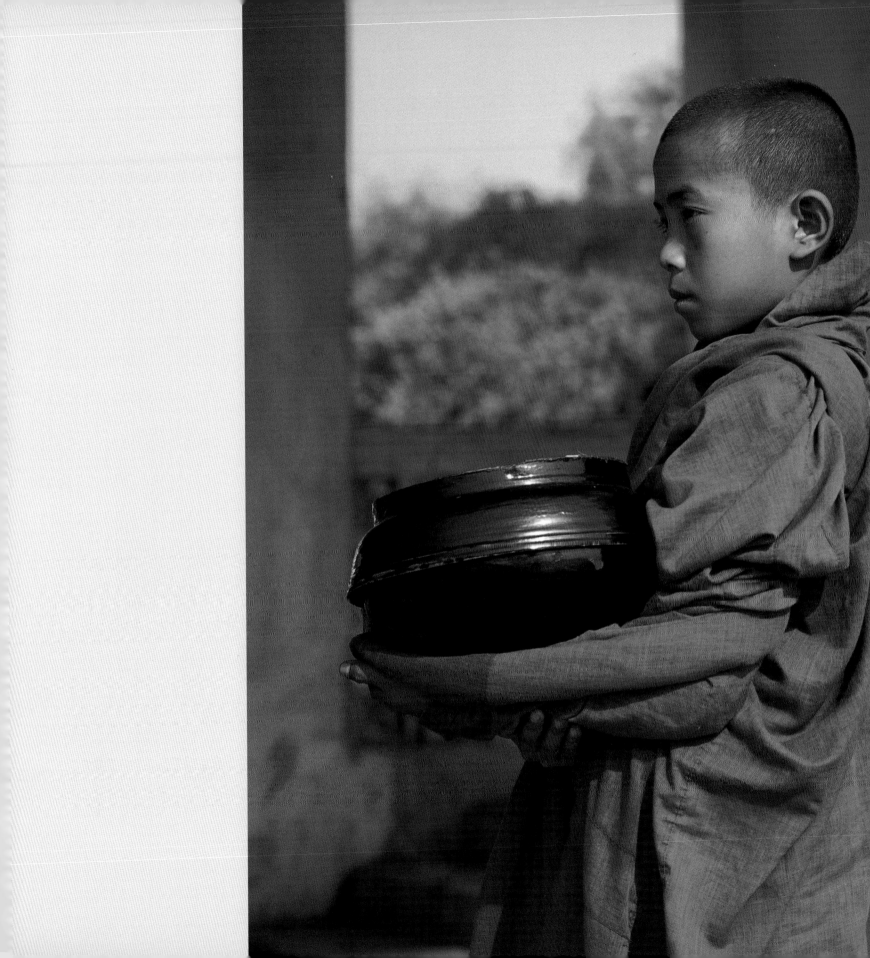

Children looking from the window of their house. Kalaw, Burma. The Burmese are some of the friendliest people in the world, yet it's not difficult to see the underlying hardships of their lives. Burma is a rich nation gone wrong. Its soil is fertile, its forests rich with teak, its mountains filled with precious gems, yet most of its 40 million people still live below the poverty level. Burma now produces half the world's supply of opium, and its trafficking proceeds are exploited by governments and warlords. "I don't think we should pretend that it is all beautiful," Aung San Suu Kyi said in our interview. "A country that cannot give its people a sense of security is not a beautiful country."

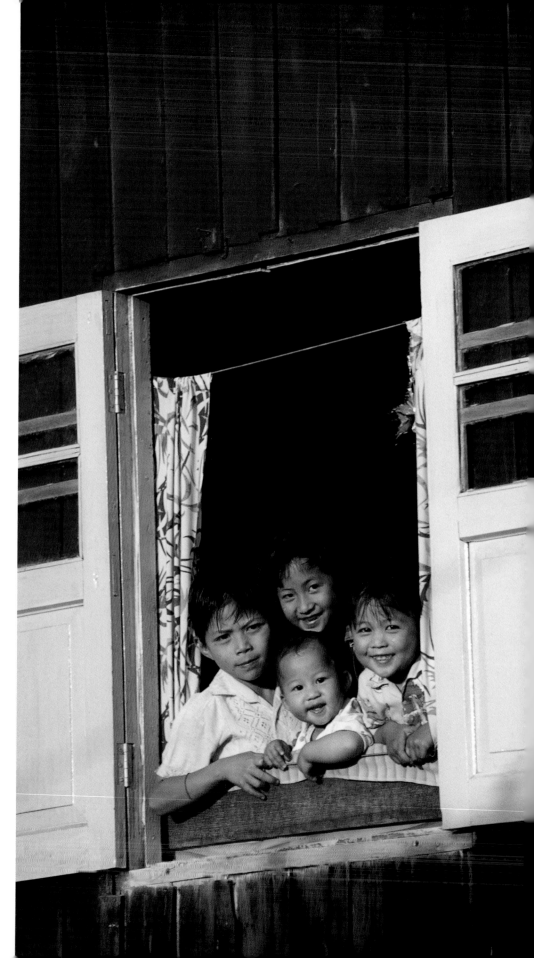

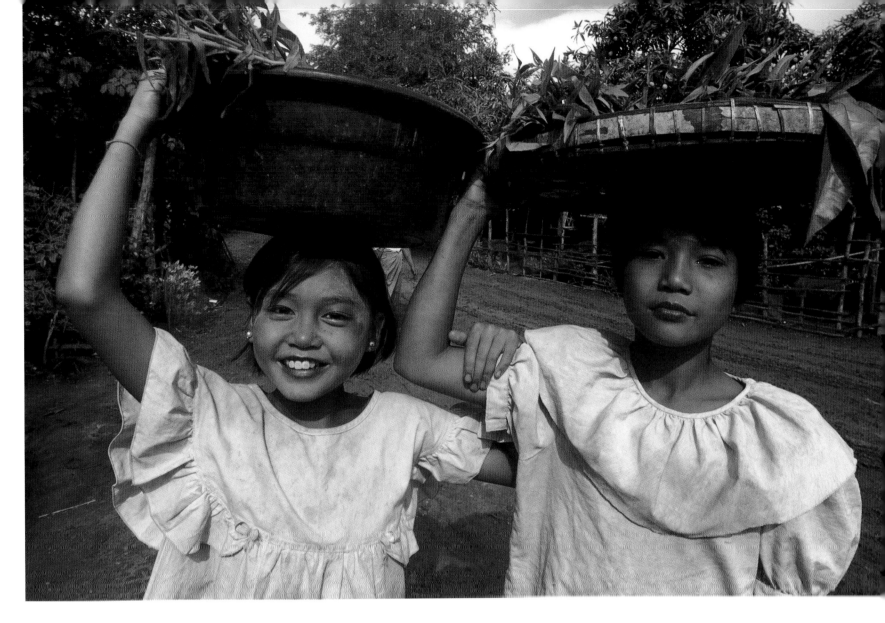

▲ Ethnic Karen refugee girls carrying vegetables. Wang Kha Burmese refugee camp, near Maesot, Thailand. Wang Kha is one of seventeen camps for ethnic Karen refugees on the Thai Burmese border. Since 1984, some seventy thousand ethnic Karens from southeast Burma have flooded into Thailand to escape Burmese military offenses against the Karen National Union, a separatist group that seeks an independent Karen state.

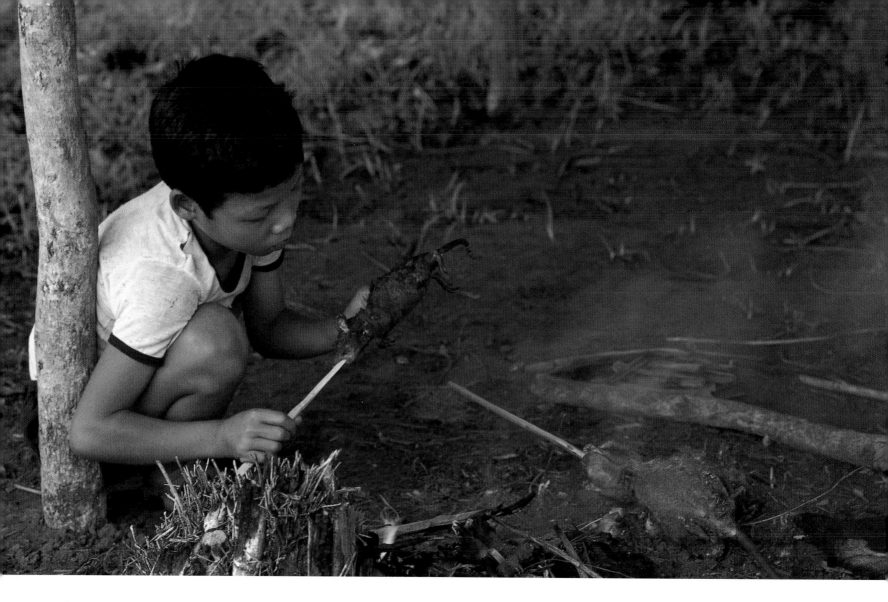

▲ Ethnic Karen refugee boy cooking rats for dinner.
Wang Kha Burmese refugee camp, near Maesot,
Thailand.

▶ Child receiving a vaccination. Wang Kha Burmese
refugee camp, near Maesot, Thailand. This child is
receiving a vaccination at the Médecins Sans
Frontières (Doctors Without Borders) clinic, which
treats patients despite the threat of continuing
attacks on the visiting physicians. Every year 1.7
million children worldwide die from diseases that
could have been prevented. Organizations like
these are helping to make vaccines readily
available.

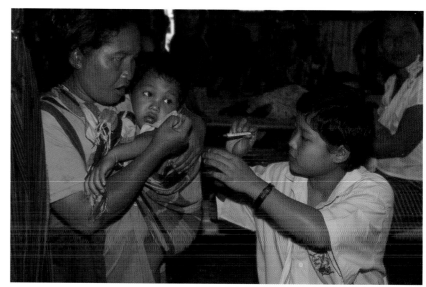

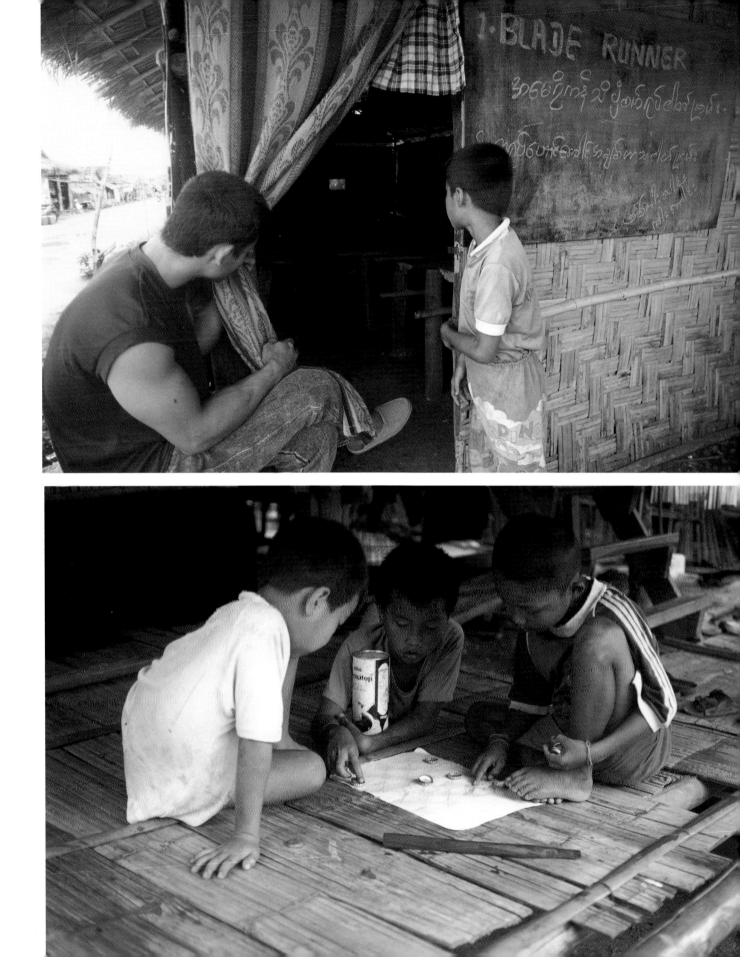

◀ Watching *Blade Runner* at the local video hall. Wang Ker Burmese refugee camp, Burmese border, Thailand. Although their homes seem temporary, after living here for a dozen years, these Karen refugees have made stable lives for themselves. They have started schools, set up markets, and opened video halls for entertainment. Still, land-mines dot the border, and I could hear artillery explosions while I was there. My original trip had to be postponed when a grenade landed in one of the other buses traveling in the area.

◀ Children playing a game with bottle caps. Wang Ker Burmese refugee camp, Burmese border, Thailand.

▶ Young girl carrying her sibling on her back. Bhaktapur, Nepal. With babies strapped to their backs, and an average of seven children per family, Nepali girls seem to skip childhood and move right into womanhood.

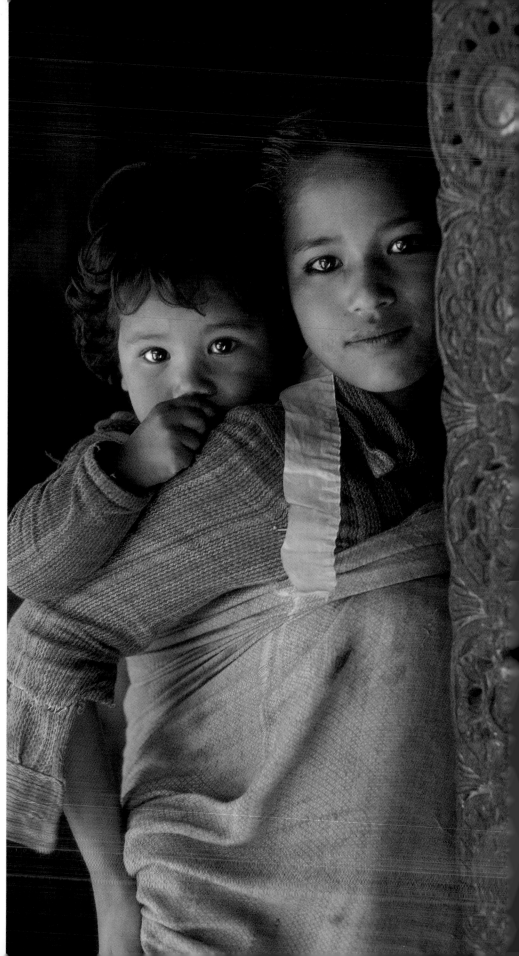

▲ Orphans at the Panchakal Social Welfare Center.
Panchakal, Nepal.

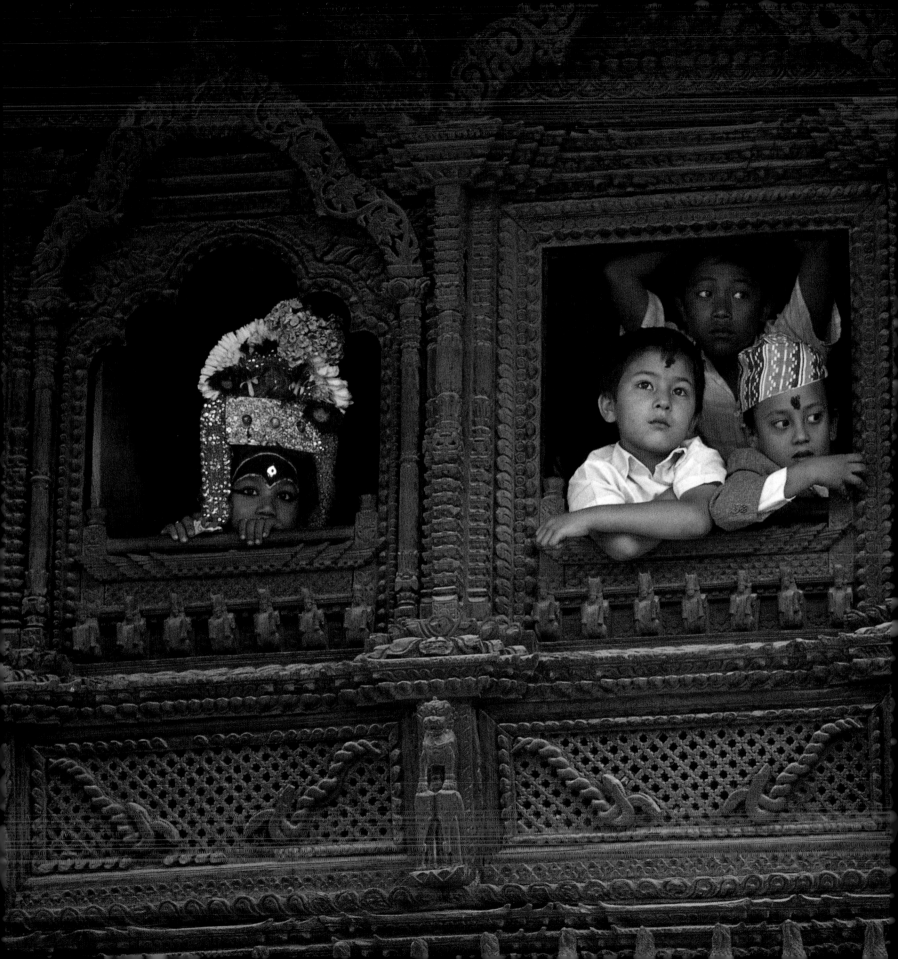

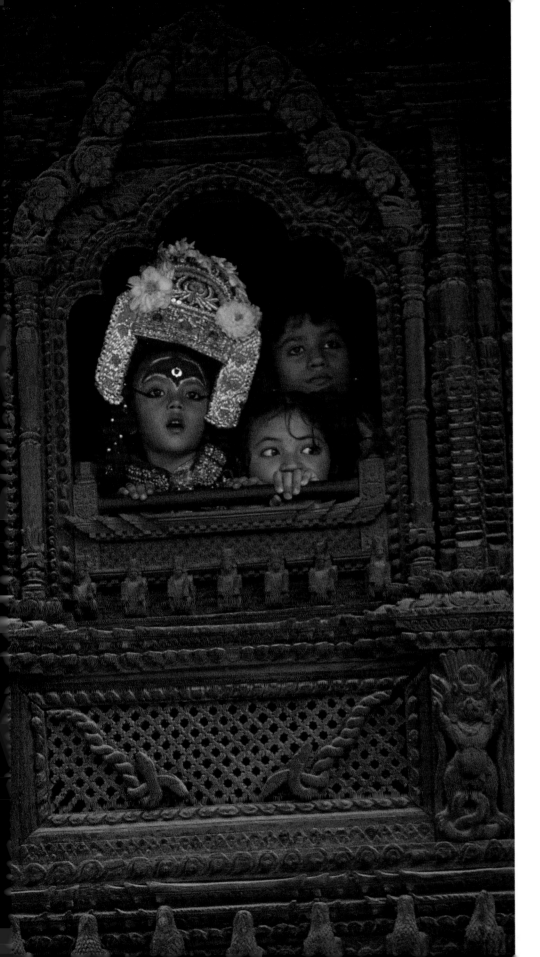

◀ Children watch a girl chosen as the Kumari Goddess from her temple in Durbar Square. Kathmandu, Nepal. The Royal Kumari, considered a living incarnation of the seductive Hindu Goddess Taleju, is worshipped by the high priests of Nepal, and even the king himself. The girl chosen each year as the goddess must now be carried by her protectors, for as a goddess her feet cannot touch the ground or she will lose her powers. Once she begins to menstruate she will be replaced by a new Kumari and forced to leave her life of royalty to live as an ordinary woman. Belief that the mortal man to marry her will die an untimely death often creates a life of isolation and loneliness for the retired Kumari.

Here, Bhairab and Ganesh, the ornately dressed consorts to the Kumari Goddess, watch as the goddess is carried from her temple to be placed in her golden chariot for the annual Indra Jatra Festival. One of several girls chosen from the Sakya caste, this girl possessed the necessary attributes decreed in ancient texts: a body like a banyan tree, thighs like a deer, neck like a conch shell, eyelashes like a cow. Most important, she showed no fear as she was taken into a darkened room or when she witnessed the slaughter of 108 buffalo and 108 goats.

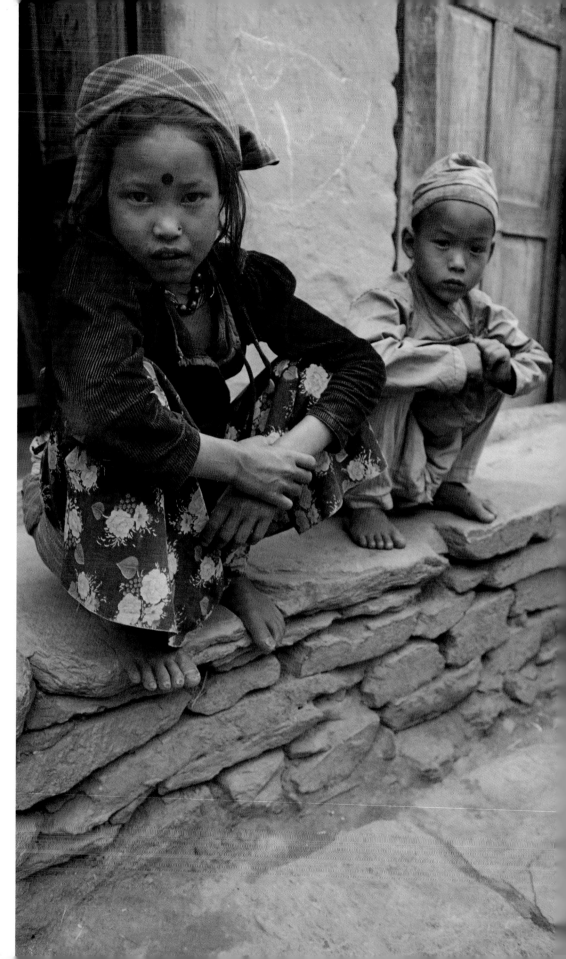

 Children visiting a health clinic in Jalbire, Nepal. I was hired by Save the Children U.K. to document their innovative and successful program of teaching children's healthcare to the Nepali traditional healers, or *Dami Jankris,* to whom parents bring their ill children. After a week in the field, a Save the Children truck was waiting for me at the bottom of the mountain to bring me back to Kathmandu. As we traveled a few miles down the road a man on the roadside spotted the vehicle with its emblem on the door and began frantically waving us down. His wife had been in labor for five days and he had carried her over the mountains from their remote village in a straw basket on his back. We placed them in the back seat and raced to the closest hospital, still about two hours away. I tried to explain that my black bag was actually full of cameras, not medical supplies, and that I typically can't even find my own pulse. The woman, screaming in agony, still insisted that I help her deliver the baby. During the long, tormented ride, only the baby's arm appeared. To alleviate my feeling of helplessness, the doctor assured me that the baby might have been dead for some time.

► Boy from the hills of Jalbire, Nepal.

► Girl marrying the Bel-fruit. Kathmandu, Nepal.
Before reaching puberty, in an ancient and sacred
ceremony, Newari girls marry a Bel-fruit, which
represents marriage to the god Narayan. The
fruit is washed and dressed and the parents
actually give their daughter away to the supposed
bridegroom. As Narayan is immortal, if the
girl's earthly husband dies, she will never be
considered a widow. Theoretically she would
also be allowed to leave or divorce her future
husband at any time.

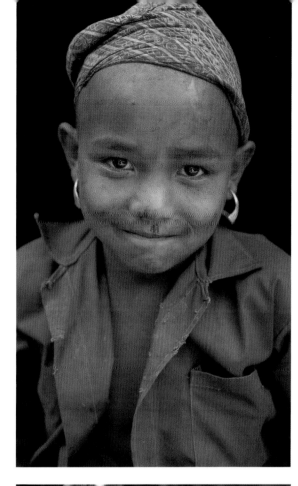

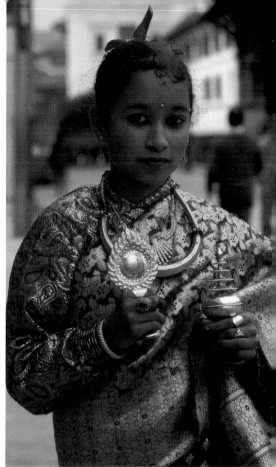

► Boy with goat. Dhulikhel, Nepal. Every year for
the auspicious Newari holiday Desain, hundreds of
water buffalo and goats are sacrificed to the
Goddess Kali. This boy has managed to save one
of his pet goats from the knife.

► Sherpa boy. Solu Khumbu, Nepal. On the high-
altitude trek toward Mount Everest, where no cars
can reach, everything from crates of soda to huge
metal drills must be carried on the backs of men
or yaks. The stream of tourists along these routes
has helped stimulate the local economy for the
Sherpa people, who have also come to covet the
fashionable fleece, expensive tents, and Walkmans
that trekkers carry.

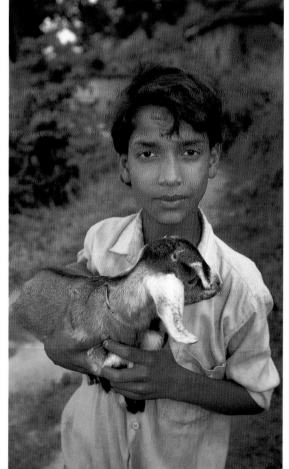

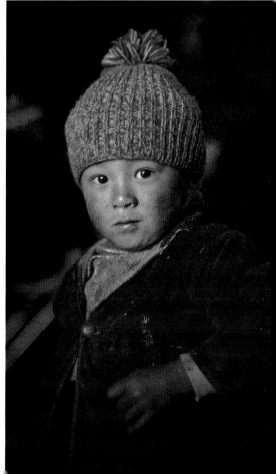

► Woman with her child awaits eye treatment. The Terai, Nepal. I took this photo in the Seva eye camp on the Nepali border of India, where visiting doctors perform up to sixty eye operations a day. Often people are reluctant to have the procedure as they feel it is their karma to be blind; others walk for days on a slim hope of regaining their sight. Many times it is a relatively simple cataract surgery, a common condition in the arid Terai region.

I played with a little blind girl at the camp who delighted in the squishy objects I was giving her but couldn't make out what they were. That afternoon an operation gave her sight. She was not only able to see her parents for the first time, she also saw the colorful balloons I'd been giving her. As a photographer, it was one of the most moving experiences of my life to watch someone being given the gift of sight.

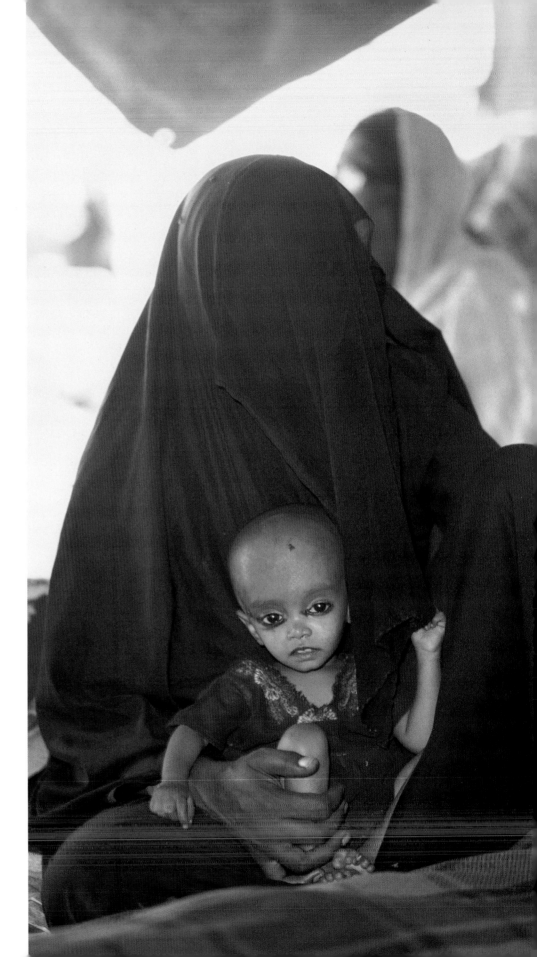

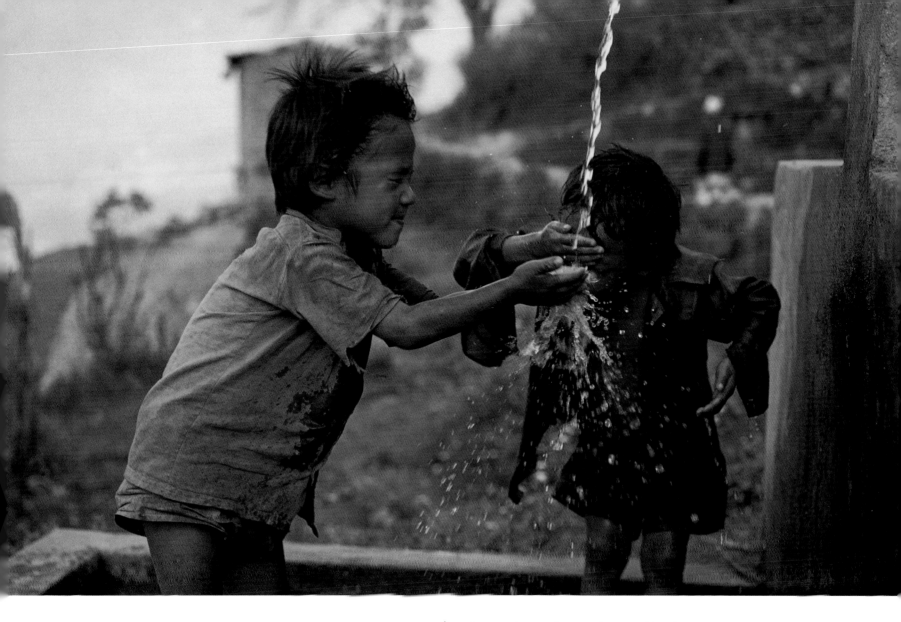

▲ Boys washing at faucet, Chataura, Nepal. Some 1.4 billion people lack access to safe water in the world, and Nepal has been rated as one of the most unsanitary countries in the world. One out of five children die in Nepal, often from waterborne illnesses, and aid organizations are working to improve these conditions. As part of a hygiene program, these boys at a Save the Children funded school have just learned how to brush their teeth using naturally antibacterial green neem sticks.

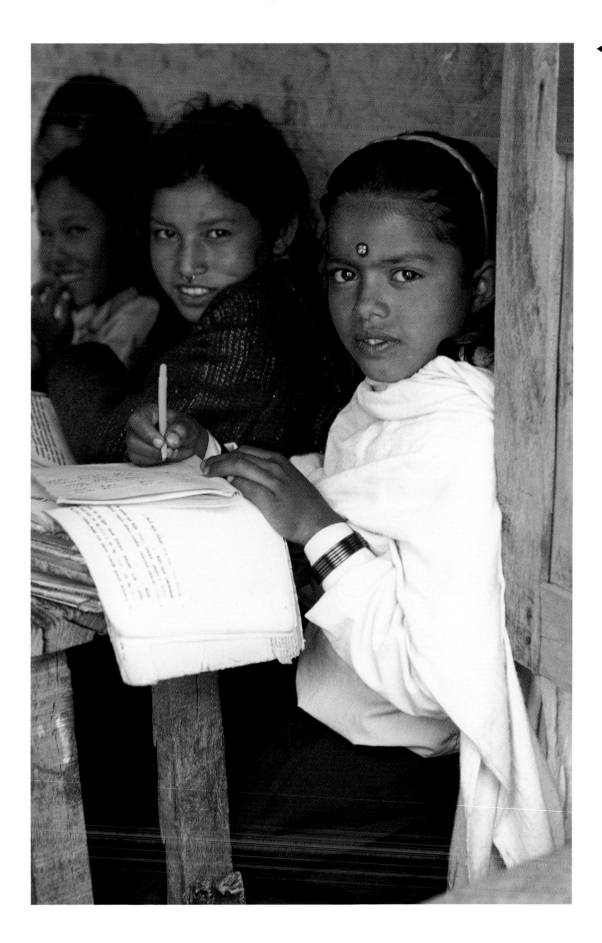

Girls in a village school. Tarakhola, Nepal. My first assignment when I arrived in Nepal for what would be a four-year stay was to trek into the mountains to photograph UNICEF-funded schools such as this one, as well as to cover mother-and-child-related issues. The U.N. had put up posters all over the mountain villages encouraging women to breastfeed and to give their ill children a *jeeven jal* solution of salt, water, and sugar for rehydration. Sharad, the Nepali artist traveling with me, had drawn illustrative posters without words as most people in these regions are illiterate. But the images weren't working and the U.N. couldn't understand why. As we traveled we administered informal visual literacy tests along the way. It was then we discovered that many villagers didn't know how to read an image. Even a familiar picture of a duck just looked like squiggles to them. It was my first realization that even recognizing images is a learned experience.

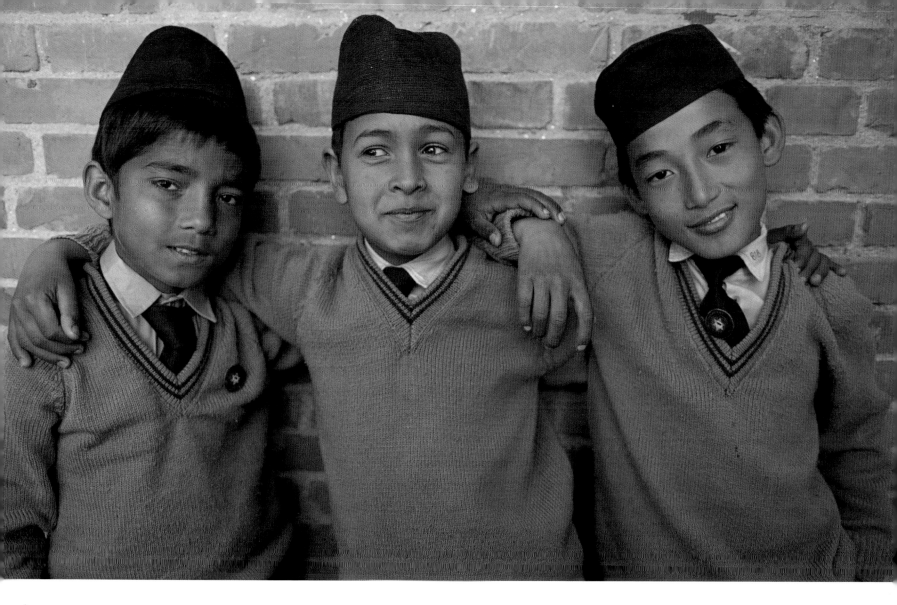

▲ Boys at Budhanilkantha school. Kathmandu, Nepal. This private boys' school, where the king's son was educated, is based on Eaton in England.

▶ Subarna, a blind boy, learns to read Braille in a school sponsored by the Helen Keller Foundation. Cavre District, Nepal. Instead of removing blind people from their homes, the foundation works to help integrate them into their communities.

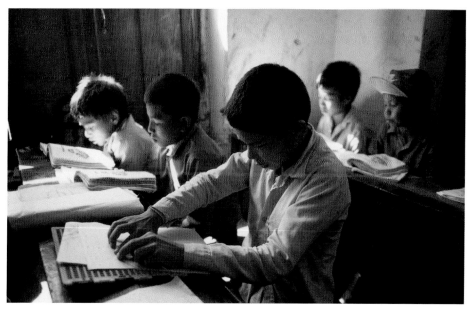

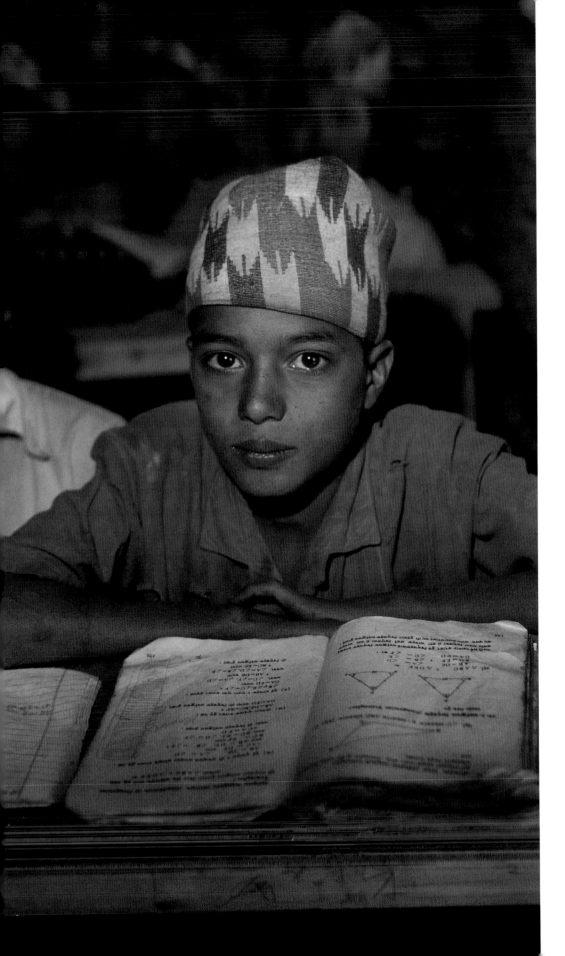

◀ Young boy in primary school in the remote hills of Bihun, Nepal. Children are treasured in Nepal, although boys are preferred over girls. Nepali boys are more likely to be sent to school, as a girl's labor is too valuable to do without. Many parents see no point in educating a daughter who will never do more than work in the field and house and then leave for a husband's family.

▶ Seven-year-old boy working in the tea fields. Ilam, eastern Nepal. Worldwide, one in six children work. The majority of these 246 million working children live in Asia and Africa.

As Nepal is a predominantly agricultural country, most of its children are involved with farming. In eastern Nepal, where whole families work in the tea fields, parents can earn up to fifteen dollars a month. Working children, often as young as five, earn nothing. They work to afford shelter: small run-down shacks in the tea fields, often housing many families in one room. This little boy wakes at five in the morning, works in the fields all day, and in the evening walks five kilometers to attend school for two hours before returning home at 9:30 at night.

I watched children as young as five cutting tea leaves with their scythes for up to fifteen hours a day. Many children work without pay through bonded labor in Nepal, repaying the money their parents owe for their land. Others are sold to work in India or forced to work as prostitutes.

When I arrived and saw the fields of children working I began a game of Simon Says with a small group. This welcome break evoked such laughter that even the parents laid down their hoes and scythes. Soon I had dozens of men, women, and children racing to touch their heads, toes, and the tips of their noses. With great reluctance they eventually returned to their backbreaking work.

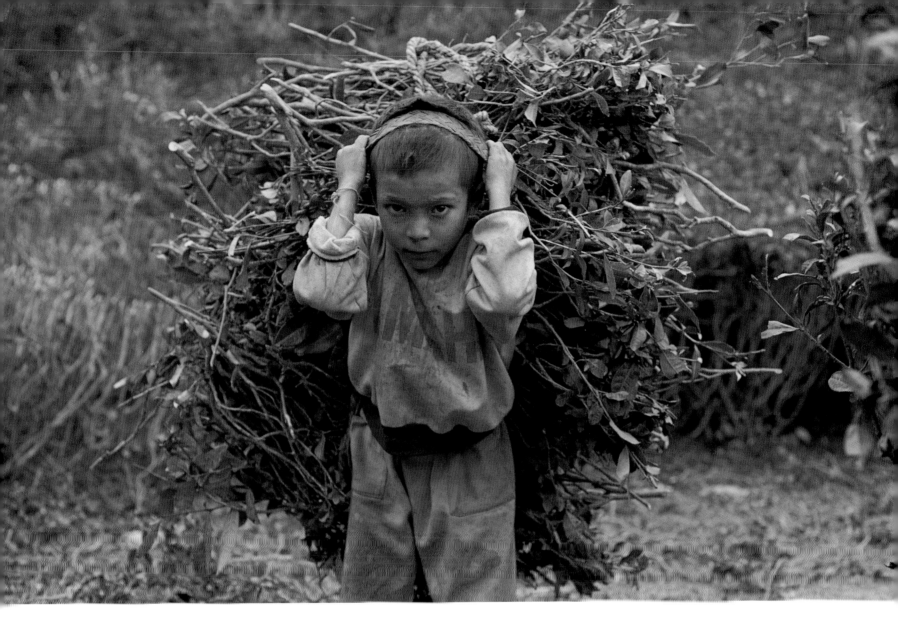

▶ Ragpicker living under the Kalimati Bridge, Kathmandu, Nepal. Thirteen-year-old Shyam Tamang and his fifteen-year-old brother, Deepak, live under the bridge in Nepal's capital, Kathmandu, where they both work as ragpickers. Every day the barefoot boys comb the city sifting through piles of garbage and picking out various pieces of rags, paper, metal, and plastics to sell. Unlike other street children who can sell to any junk dealer, these boys must sell to one specifically for the privilege of sleeping under the bridge at night. I was moved by the home they had created with Hindu posters and a sleeping platform amid this sea of rubbish. They average about fifty cents a day and eat food cooked by local people who make their living roasting peanuts under the same bridge. Grassroots organizations are cropping up throughout the city in an attempt to give these street children somewhere else to go.

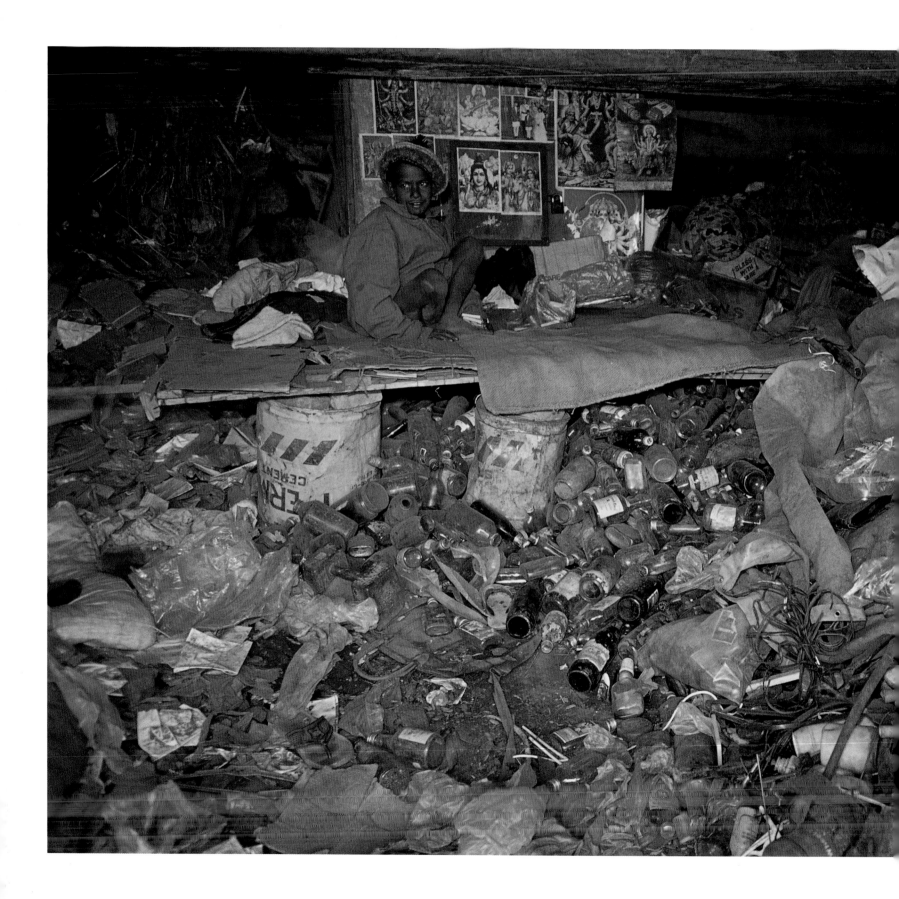

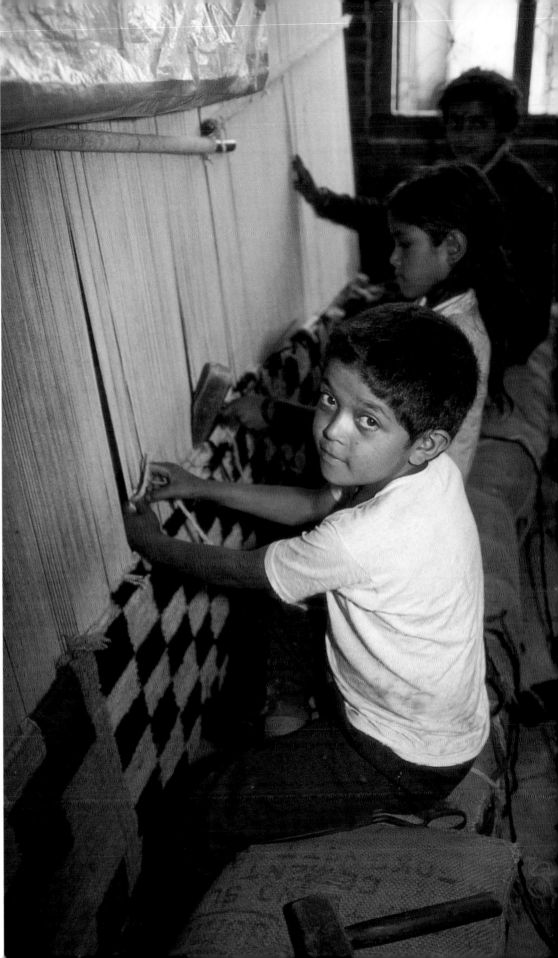

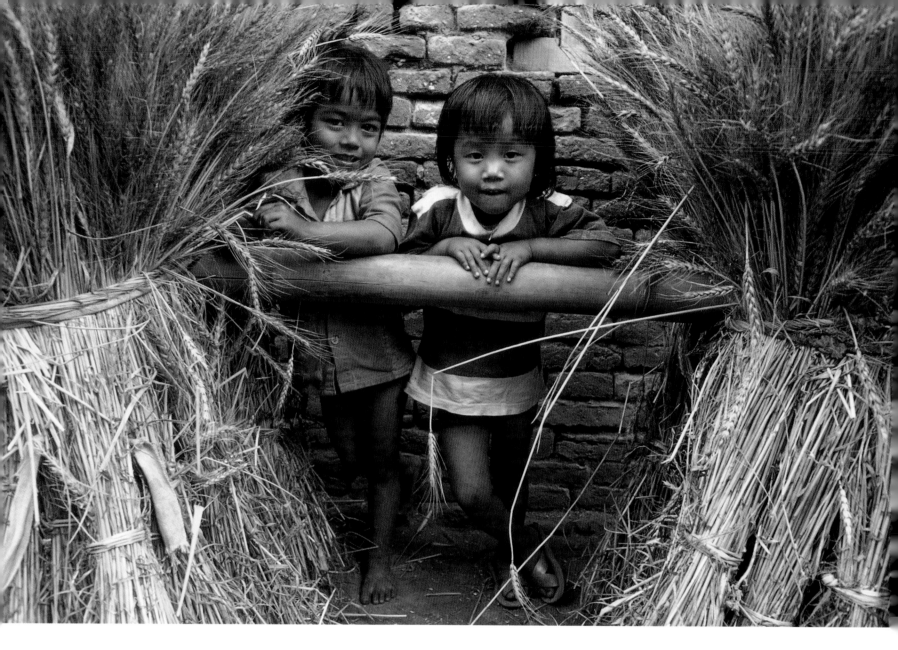

Eight-year-old carpet weaver. Jawlikhel, Kathmandu, Nepal. "I used to go to school," Padam Ranisaf, another young carpet weaver, tells me, "but with seven children in our family there wasn't enough money and I was told by my parents that I needed to find work. Our town in far western Nepal has such a scarcity of work that my younger sister Wan and I set out for Kathmandu alone.

"When we first came here we had no idea how to make carpets and learned slowly. It's difficult to work. The dust from the wool fills our lungs and there is so little light to work by. It's cold and uncomfortable sitting on hard wooden benches all

day but of course I like making carpets; it's good money. If I don't make them, we don't eat.

"You Westerners pay a lot for carpets, many rupees. We work from seven in the morning until eight at night every day, with no days off. We get paid by the foot so it's good for us. About fifty cents per square meter. We can finish a rug in two weeks with five men working or three weeks with four men working, so I make about five hundred rupees ($7.50) per week. It's enough to survive — to buy rice and clothes and maybe see a Nepali or Hindi film. I like this very much."

Girls playing in the straw. Kathmandu, Nepal. These are children from my neighborhood where I lived for years, the old pottery village of Hadigau in Kathmandu. My rustic flat was upstairs from a Nepali family, surrounded by lush green rice paddies that were rimmed by colorful rainbows during the monsoon season. Taxi drivers avoided this area, believing it to be haunted, so I rode my red Chinese Hero bicycle throughout the valley, speeding up through the packs of wild dogs, stopping to play with children along the way.

I was always amazed by the simplicity and creativity of their play, every object a toy: Yak-brand cigarette boxes were pulled on strings, rubber bands became hacky sacs and jump ropes, tire hoops were pushed with sticks, plastic bags became kites to catch the wind.

Boy in Kerala, Southern India. I met this boy, along with the other young men from his village, just as they were returning from bringing in their fishing nets from the Allepy backwaters. He was leaning against a tree flirting with the girls as they came in from the fields, laughing and carrying jugs of water on their heads.

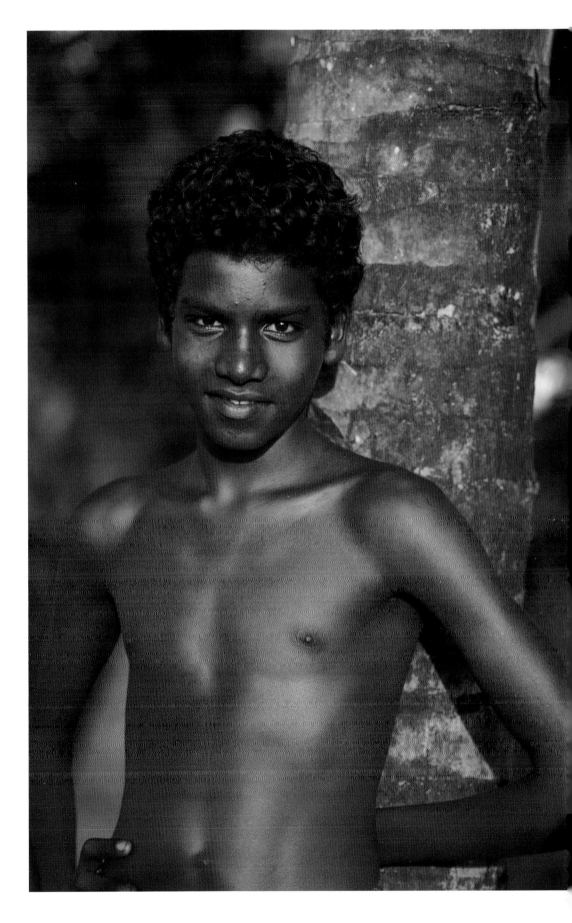

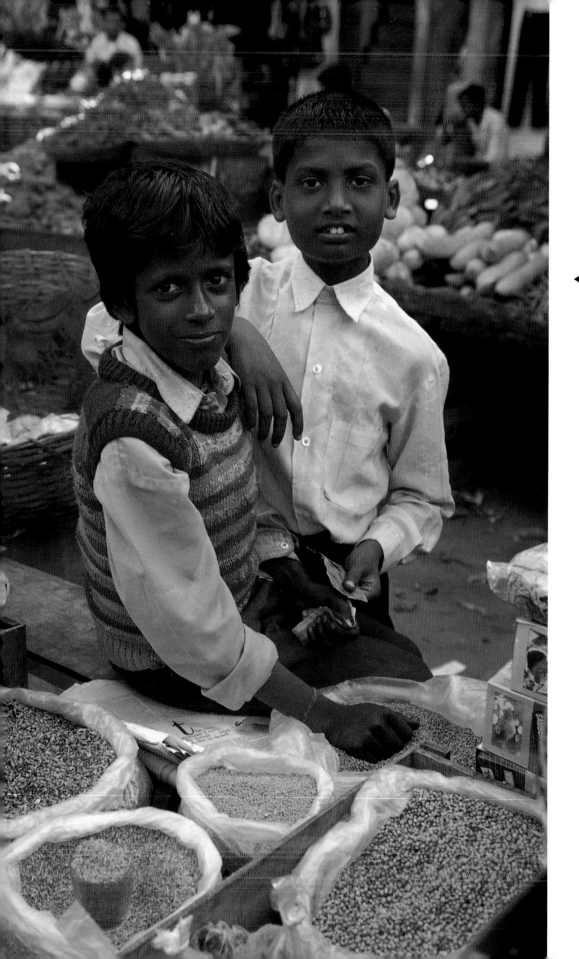

◄ Boys selling spices at the Gangtok market. Sikkim, India. If India's beauty is legendary, so is its poverty, an acute and widespread condition for most of India's 395 million children. India also has the most child labor in the world, a figure that is increasing dramatically as garment and carpet exports to the West expand. India is now second only to China in having the world's largest population, as families breed more children into the workforce.

► Girl visiting the Taj Mahal with her family. Agra, India.

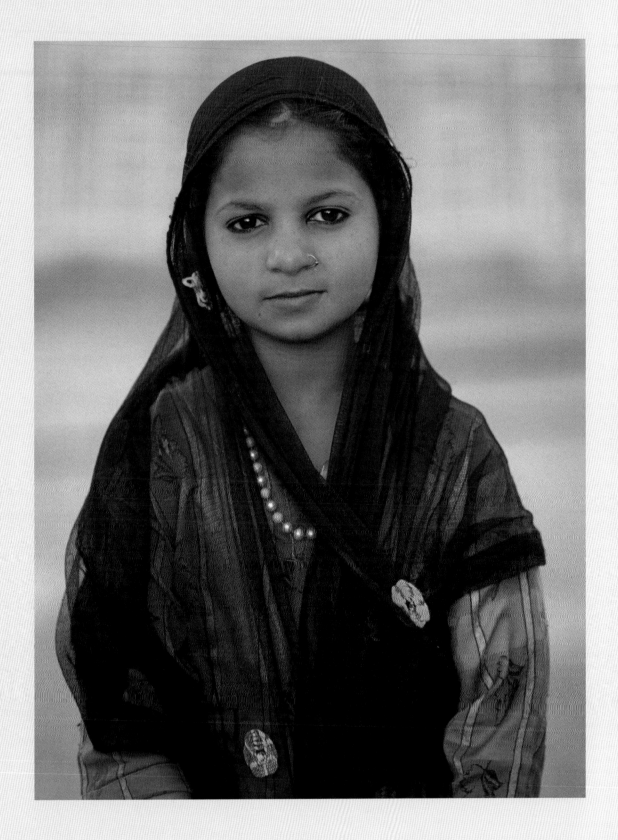

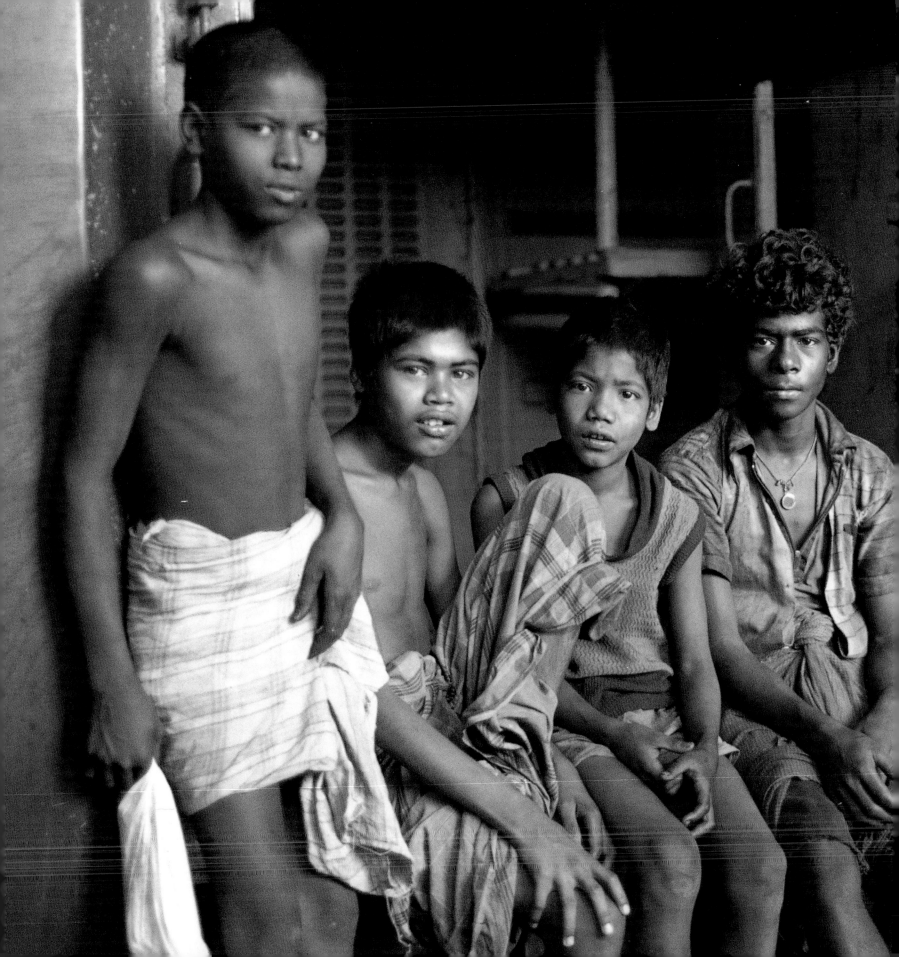

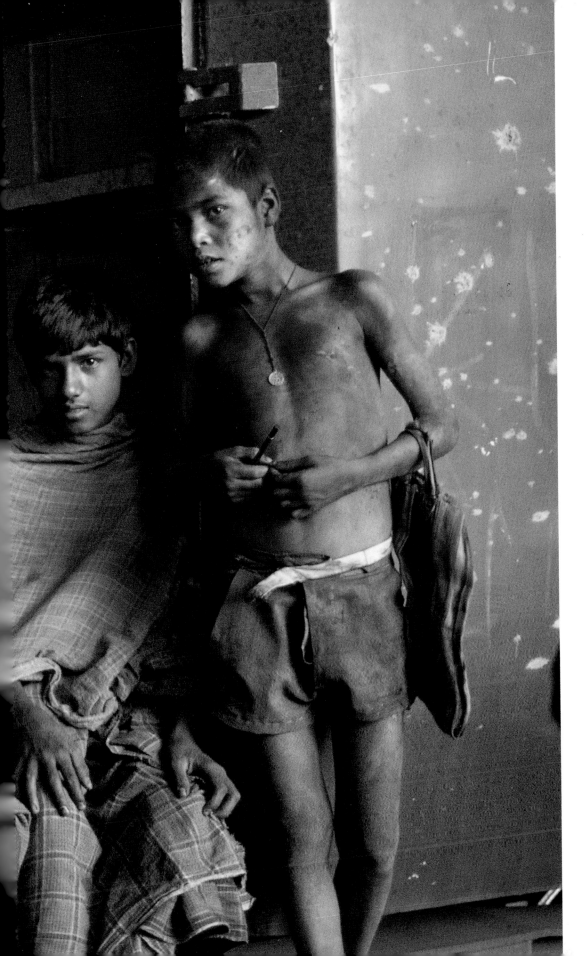

◀ Boys in the Calcutta train station, India. This is the very first picture I ever took in India, as I jumped off the train in Calcutta. These boys were covered in red powder from celebrating the Hindu holiday Holi, and I was as curious about them as they were about me, a blond woman coming off the train with a motorcycle. Calcutta is a celebration of the human spirit and every breath inhaled here seems hinged on survival. Just to be in this city begs a heightened awareness.

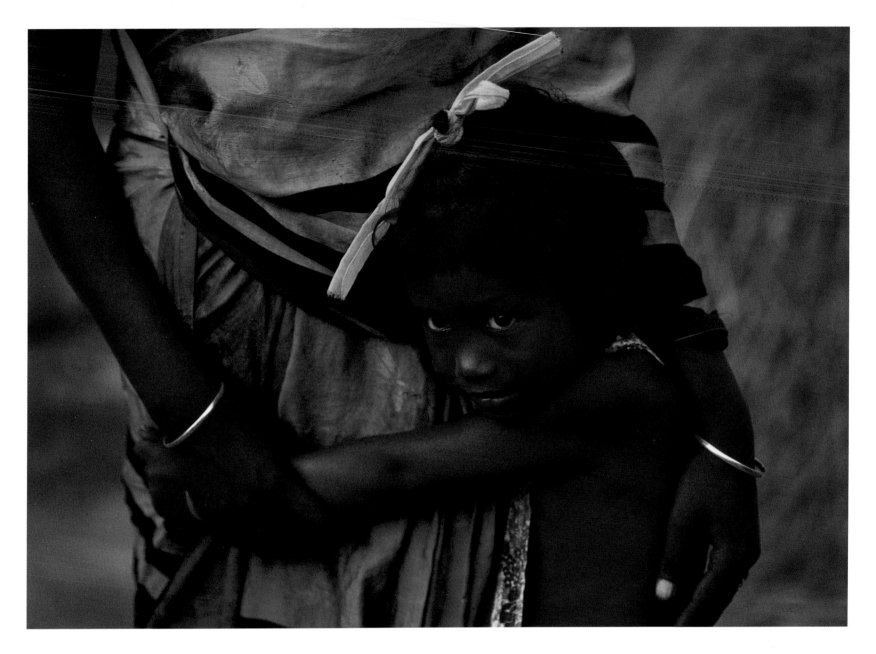

▲ Girl hugging her mother. Soorakathai Village, Tamil
Nadu, Southern India.

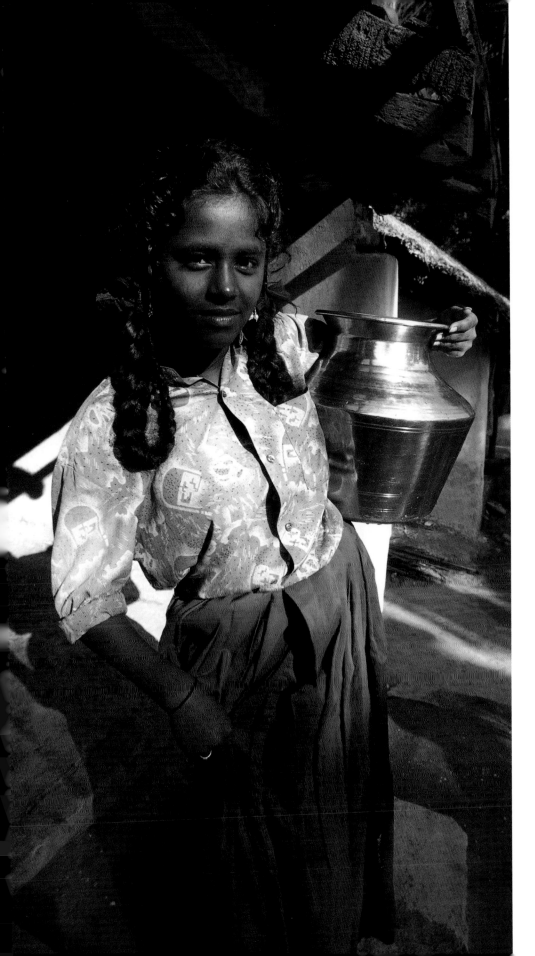

◄ Girl carrying jug of well water. Soorakathai Village, Tamil Nadu, Southern India. In parts of India, girls are sometimes called paraya dhan or "someone else's wealth" because tradition dictates that a dowry accompany a girl when she is married, putting an economic burden on her family. Three times as many girls as boys die, often from malnutrition or murder. Many are sold into prostitution or bonded labor to ease their family's economic hardship.

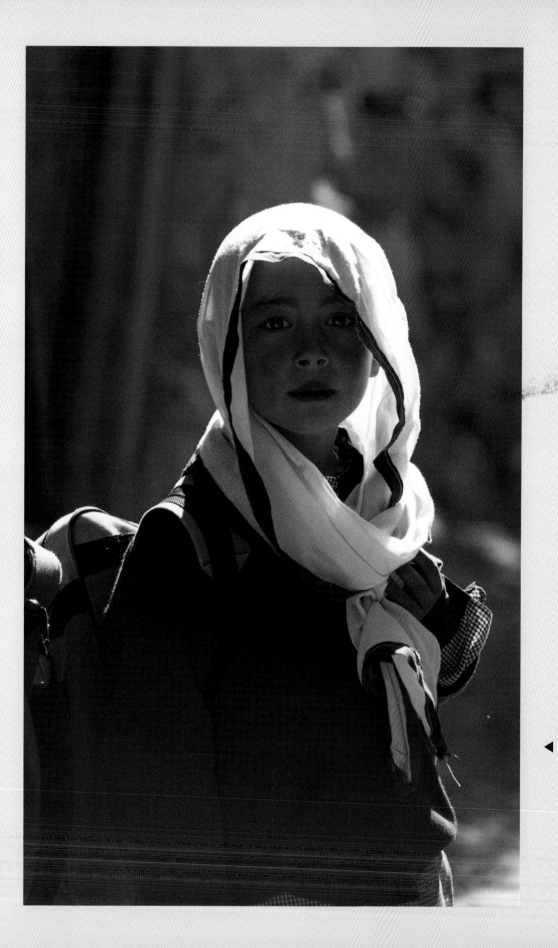

◄ Schoolgirl. Gulmit, Pakistan. I met this girl, who radiated both an innocence and an intensity beyond her years, while I was hiking in the remote mountains along the Karakoram highway. She was on her way to school, but not all children are so lucky. Although half the Pakistani population is under fifteen, only a quarter of its children are educated.

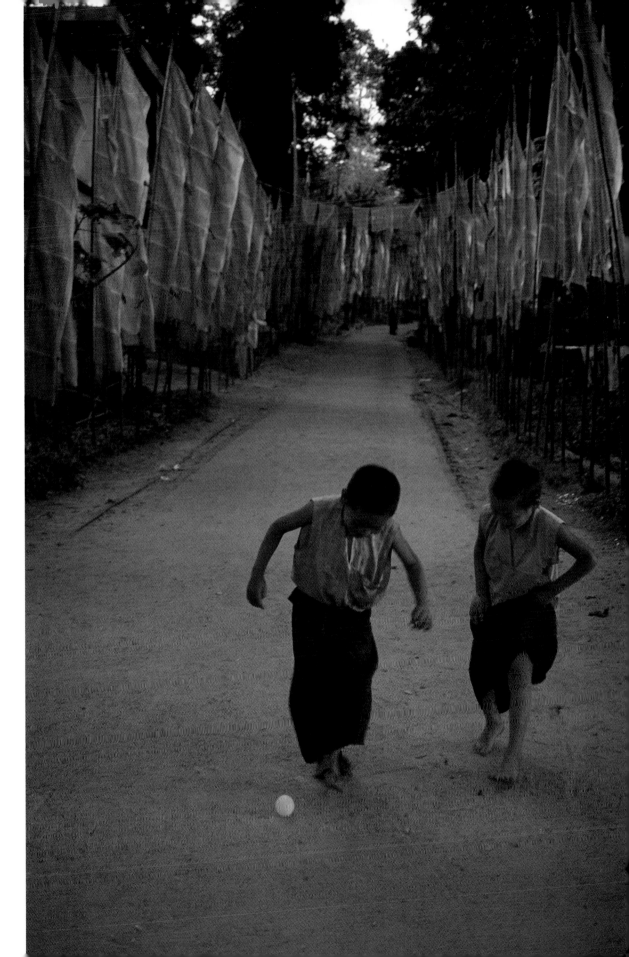

▶ Tibetan Buddhist monks playing soccer
with a tennis ball on the grounds of the
Sikkim Institute of Higher Nyingma
Studies, Gangtok, Sikkim, India.

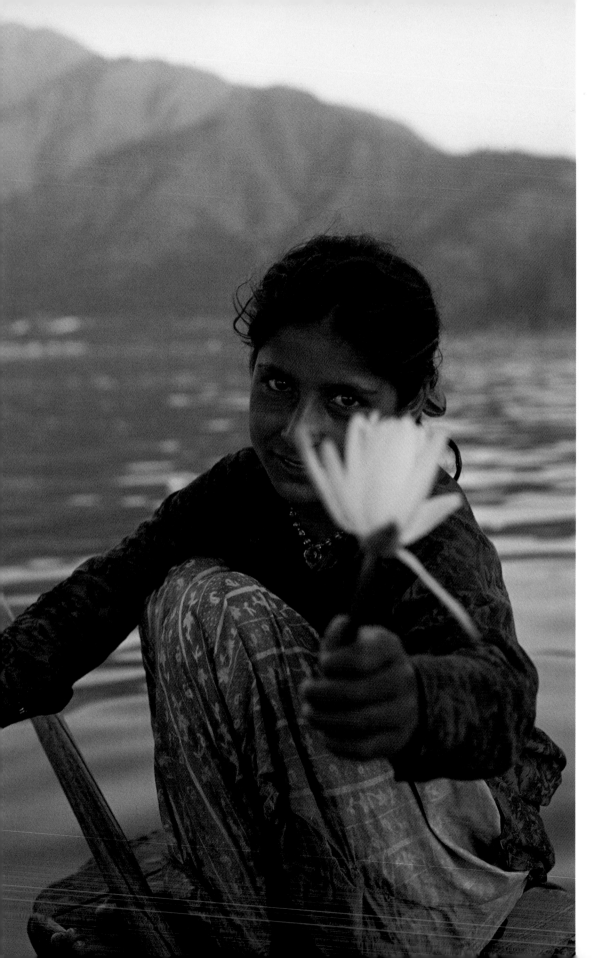

◄ Gift of a lotus flower on Dal Lake. Kashmir, India. Cradled in the lap of the majestic Himalayan mountains, the territory of Kashmir is considered one of the most beautiful places on earth, yet political tensions in recent years have all but closed the country to tourists. I had just left the town of Srinagar, which was packed with soldiers, to return to the houseboat where I was staying on Dal Lake. As this girl passed by on her small wooden boat, she handed me a flower and with a whisper thanked me for coming to her country.

acknowledgments

This book almost never saw the light of day. While I was photographing in Laos, the local bus I was riding along a treacherous mountain road was sheared in half by a logging truck and I suffered major injuries. I owe my life to the laotion boy who sewed up my shredded, bloody arm after it went through the window. I'm also indebted to Alan Guy, the British aid worker who ten hours later found me lying on the road with a broken back and drove me seven more hours in the back of his pickup to Thailand for medical care. It was there that Dr. Bonsoon, amazed by the extent of my wounds, was able to perform the surgeries I needed until I was medevaced to the U.S. three weeks later.

I owe my life to these men, for without them there would not only not be a book, there would be no me. It would be over a year before I could properly walk or lift a camera again. After more than seventeen operations and numerous procedures I was able not only to make it to the top of Mt. Kilimanjaro (my daily mantra in physical therapy), but I have been able to continue my work, traveling the world and finishing this book. For that reason completing this project has been even a greater gift, as is meeting all the people I've encountered along the way. After an experience like that I can't help but feel this was all meant to be.

I am grateful to Jason Gardner, senior editor at New World Library, who believed in this project and took it on while it was still in its vague early stages. Thanks to Jason's insightful editing and encouragement and art director Mary Ann Casler's creative design and grace under pressure, we were able to construct something powerfully concrete from nothing more than a heartfelt concept. Thanks also to publisher Marc Allen and the rest of the staff at New World Library for their support.

I had an incredible amount of help from people during my travels: Maddy Cohen with the South African Tourism Board, who always had unwavering faith in this project; Frick Van Zyl; Sizwe Jantjie of Kwazulu-Natal; Angelo D'Agostino of Nyumbani Orphanage in Kenya; Mouse and Charlie McDonnell in Nairobi;

John Wawero, my seven-foot-tall Kenyan driver; Colin Urquhart, a South African photojournalist who has seen things during apartheid that no human should have witnessed and who certainly opened my eyes; Philip Ndeta from Kenya Learning Development Center; Project Heartbeat in South Africa; Johannesburg photographer Willem de Lange; John Isaac at UNICEF; His Holiness the Dalai Lama; The Jordan Tourism Board; Aung San Suu Kyi and the National Democratic Party of Burma; and Lonely Planet Publications and Insight Guides for their valuable guidebooks. Special thanks to all the people around the world who have opened their homes and hearts to me.

My friends and family have been wonderfully supportive during this circuitous journey. Heartfelt thanks to the Wild Writing Women, especially to Lynn Ferrin and Linda Watanabee McFerrin, Olga Murray with the Nepalese Youth Opportunity Foundation, Scott Hunt, Larry Habegger, Julie Evans, Richard Gere, the Lowells, Albert Chiang, George Olson, Ted Streshinsky, Maureen Wheeler, Carmine Giordano, Hideo Yoshido, Karen Shimada, and Kerry Moran, who helped me brainstorm ideas over floating sushi dragons.

I am grateful to my brother, Andrew Wright, one of the most gracious human beings on the face of the planet, who has had to bail me out of difficult situations more than once; his wife, Beth, who puts up with the midnight phone calls; and to their daughters, Claire (who was born while I was in Nepal), Hannah (while I was in Sikkim), and Lili (while I was in Jordan). To my mom, Sonia, who as a flight attendant instilled in me a love of travel and adventure while I was still in the womb. And in loving memory of my dad, Frank, who suddenly passed away while I was shooting in Africa and never got to see this book. We had no idea that faraway phone call from Mombasa would be our last, but he told me that he couldn't wait to see the pictures and had the bottle of Sancerre wine chilled for when I got back. I raise my glass to you, Dad, for all your years of encouragement and giving me the wings to fly.

▶ To get involved, sponsor a child,
 or for more information:

Adopt-a-minefield · www.landmines.org

Amnesty International · www.amnesty.org

Alliance for Childhood · www.allianceforchildhood.net

Childreach · To sponsor a child: www.childreach.org

Free the Children · www.freethechildren.org

Free Tibet · www.freetibet.org

Global Exchange · www.globalexchange.org

Heartbeat Center for Community Development
To sponsor a child in South Africa, e-mail:
heartbeat@mweb.co.za

Kids to Kids
To sponsor a child in Kenya, e-mail:
kidstokids@nbi.ispkenya.com · www.ispkenya.com/k2k

Learning Development Kenya
To sponsor a child in Kenya, e-mail
Philip Ndeta: learning@africaonline.co.ke

Nepalese Youth Opportunity Foundation
To sponsor a child in Nepal: www.nyof.org

Save the Children · www.savethechildren.org

Seva Foundation · www.seva.org

South Africa Directory of AIDS/HIV Organizations
www.childaidsservices.org

Sweatshop Watch · www.sweatshopwatch.org

Students for a Free Tibet · www.tibet.org

Tibet Fund · www.tibetfund.org

UNICEF · www.unicef.org

World Bank · www.worldbank.com

NEW WORLD LIBRARY

is dedicated to publishing books and audios

that inspire and challenge us to improve

the quality of our lives and our world.

Our books and cassettes are available

at bookstores everywhere.

For a complete catalog, contact:

New World Library

14 Pamaron Way

Novato, California 94949

Phone: (415) 884-2100

Fax: (415) 884-2199

Or call toll-free: (800) 972-6657

Catalog requests: Ext. 50

Ordering: Ext. 52

E-mail: escort@nwlib.com

www.newworldlibrary.com